THEORIZING
MODERNISM

VISUAL ART AND THE
CRITICAL TRADITION

Interpretations in Art

INTERPRETATIONS IN ART
A series of Columbia University Press

THEORIZING MODERNISM

VISUAL ART AND THE CRITICAL TRADITION

Johanna Drucker

Columbia University Press
New York

Columbia University Press wishes to thank Edwin Robbins
for his contribution toward the costs of
publishing this book.

Columbia University Press
New York Chichester, West Sussex

Library of Congress Cataloging-in-Publication Data
Drucker, Johanna
 Theorizing Modernism : visual art and the critical tradition /
Johanna Drucker.
 p. cm. — (Interpretations in art)
 Includes bibliographical references and index.
 ISBN 0–231–08082–4 ISBN 0–231–08083–2 (pbk.)
 1. Modernism (Art) 2. Art, Modern—19th century. 3. Art,
Modern—20th century. I. Title. II. Series.
 N6465.M63D78 1994
 700′.1—dc20 93-23718
 ∞ CIP
Casebound editions of Columbia University Press books are
printed on permanent and durable acid-free paper.

Printed in the United States of America
c 10 9 8 7 6 5 4 3 2 1
p 10 9 8 7 6 5 4 3 2 1

CONTENTS

ILLUSTRATIONS

ACKNOWLEDGMENTS

I feel a strong sense of gratitude toward the graduate students who participated in the seminar of the same name as this book, in the fall of 1989, at Columbia University. They took seriously the challenge of these ideas in that first formulation, and were enthusiastic and tolerant of my working them out with their assistance. Bridget Goodbody and Gordon Simpson made additional contributions, including reading the first draft manuscript, and the latter provided invaluable assistance in securing photographs and helping with bibliographic details. The writing was partially supported by Faculty Research Grants for the summers of 1990 and 1992, awarded through the Office of the Dean of Graduate Studies at Columbia. My thanks to Ann Miller and Sara Cahill, who did their best to expedite a not always easy course toward publication, and to Joan McQuary, who carefully checked the final draft. Thanks are also owed to the anonymous readers whose insights and comments pushed this work toward greater resolution. Geoff Young and Louise Heinze provided shelter, companionship, and debates during the writing of the first draft in summer 1990, and Brad Freeman supplied encouragement at every subsequent stage.

THEORIZING MODERNISM

VISUAL ART AND THE
CRITICAL TRADITION

ONE

Reviewing Modernism: An Introduction

This book proposes a reconsideration of the received tradition of modern art and its history. It draws upon the established critical lineage of modern art, well-known figures, and frequently referred-to texts. It is a review in two senses—a survey and a reexamination—of that received tradition. Very simply, this book puts forth a metacritical reexamination of canonical works: anthologized texts (often in the form of the familiar excerpt) and the images that form the bases of survey courses. My assumption that it is precisely through such anthologies, collections, and selections that such a tradition has been codified.

In writing these essays, I had two purposes. Again, the first was to review the history of modernism *as a received tradition*. The second was to trace certain aspects of modern art as they developed and transformed in both visual works and in criticism from Charles Baudelaire and Constantin Guys to Jean Baudrillard and Peter Halley. I organized my approach around three themes: attitudes toward the space (social, literal, metaphorical) of modernism as representation; assumptions about the ontology of the object (from aesthetic formalism to deconstructionist interpretation); and theories of the

production of subjectivity (from artist and viewer to subject position).

The justification for my first purpose was that no such analysis exists. There is no synthetic review of the development of criticism in modern art except what is implicit in textbook formulations where the twin traditions of the avant-garde and formal stylistic innovation are the machines that are perceived to drive the modernist project. My second purpose, deeply integrated with the first, was to propose that through these three themes, modernism—in its most standard, almost clichéd form—could be read through a rhetoric of representation rather than according to the entrenched critical legacy of formalism and the avant-garde.

This project, then, was conceived in relation to the assumed existence of both a critical legacy and a received tradition. Since I take these as givens throughout the rest of this book, it seems useful to explain fully the nature of my assumptions at the outset. Most importantly, my intention was to shift the terms of analysis slightly—not by denigrating the traditions of either modern art or modern art history, but to look at them from a different, suggestive point of view.

My concept of a critical legacy is grounded in the belief that there is an ongoing internal dialogue of both visual art and critical theory with its own precedents. Whatever other factors continually assert an influence on criticism in visual art (such as specific aspects of the historical context of production, individual artistic profiles, and cultural conditions of reception) I believe that the definition of critical concerns takes place within an ongoing dialogue of both authors and artists with their predecessors and contemporaries. For example, there are many historically specific reasons for the transformation of Clement Greenberg's prescription for the forms and activities of modern painting between his 1940 essay "Towards a Newer Laocoön" and the 1965 "Modernist Painting" (e.g., the change in the status of Soviet communism, the war, McCarthyism, and the cold war, etc.).[1] But it is equally significant to realize that the body of texts to which the name Greenberg attaches became reduced to concepts of flatness, self-critical investigation of media, and an intractable formalism. The full spectrum of Greenberg's career as a critic can in no way be reduced to such notions, but the

name *Greenberg* as a reference, and the term *Greenbergian* as an adjective, invoke precisely such reduced versions of his position. It is, for instance, largely these concepts which are referred to in the body of literature that attempted to define postmodernism by setting Greenberg the modernist up as a straw man.[2] To some extent this was a necessary strategy, and one justified by the literature in which the monolithic myth of high modernism had become codified. But the example serves more importantly to demonstrate the peculiarities of a historical process whereby a tradition becomes defined through intertextual practice rather than by a review of the original texts and images from a fresh perspective.

It is with precisely such a lineage of such reduced concepts, and their persistent influence as an effect of intertextual reference, that I am concerned here. My intention is on the one hand to render explicit the premises on which such a legacy was capable of functioning. To do this, I summarize and paraphrase this tradition, citing its place within survey and textbook formulations, while on the other hand mounting an analytic critique through the lens of the rhetoric of representation. While it would be interesting to delve more carefully into an analysis of the historical and historiographic processes by which this lineage came into being, I am instead simply using as my point of departure the assertion that it can be taken as *received*. After all, the process by which such criticism builds on precedent is not particularly mysterious, and certain aspects of the history of twentieth-century criticism can be charted through rather clear genealogical patterns: Clive Bell and Roger Fry were read by Alfred Barr and Clement Greenberg who were read by Michael Fried and Rosalind Krauss, by Tim Clark and Victor Burgin. These references continue to be read—by myself and my students— because they form the history of a certain strain of thought within the history of modernism. My contention is that despite the many other influences on art history there is a primary context that is textual, that consists precisely in that lineage of precedents and responses, dialogues, and disputes, internal to the history of modern art.

In addition, however, it is clear that my project is being written at a time in which the revision of mainstream modernism has already acquired a substantial history. The concept of a unified

modernism has been under considerable reinvestigation for almost twenty years, with increasing intensity within the last decade. The lineage of formal innovation, the legacy of the avant-garde, the place of so-called high art within European and American twentieth-century cultural history—all these have been held up for question through the methodological tools of feminist theory, deconstructive approaches to history and textual analysis, and the rigorous interrogation of cultural studies.[3] Because of this active rewriting, re-researching, and reconfiguring of twentieth-century culture, high art modernism is no longer unquestioningly granted a privileged place by virture of aesthetic concerns.[4] But, I would argue, that even these rewritings contain critical assumptions that are the legacy of modern art and theory.

The undoing of the hegemonic unity of modernism has been a complex process, the result of work in diverse fields. The work of cultural studies scholars (Stuart Hall, Dick Hebdige, Jim Collins, Frederic Jameson) has intersected with that of historians and critics (Andreas Huyssen, Carol Duncan, Griselda Pollock, Marjorie Perloff), and theoreticians (Jacques Derrida, Mary Kelly, Norman Bryson, Michael Newman, Francis Frascina, John Tagg). In addition the concept of visuality in modernism continues to be explored in terms concerned with the form, formalism, and aesthetics (Yves-Alain Bois, Rosalind Krauss) which take poststructuralist criticism as a basis.[5] All of this work has informed my own, and the concept of a rhetoric of representation is derived in large part from the influence of structuralist and poststructuralist theory on the study of modernism and visuality. It is evident that the mid-twentieth-century analysis of modernism in the work of Alfred Barr or Clement Greenberg, which literally mapped a succession of stylistic developments in a this-begat-that mode has long been abandoned. But even so, the emphasis upon formal innovation and upon the oppositional role of the avant-garde remains central to survey texts as well as to some works of sophisticated critical theory.[6] While it can be demonstrated that the phantoms of received tradition against which this text is composed have largely been eclipsed at the cutting edge of thinking about modernity, concepts of form, formalism, subjectivity, and history remain insidiously tenacious as assumptions about modern visual art. This fact was made strikingly clear to

me when I led a panel on the legacy of Clement Greenberg at the 1991 College Art Association meeting and found that the idea of rethinking high modernism could still provoke heated reactions along a full spectrum of positions.

In contrast to the many deconstructions of the hegemony of a fictive modernist autonomy and unity in the art historical field, this book is unabashedly concerned with analysis of the canonical mainstream.[7] I am indebted to the existence of this work, much of which reconsiders the history and cultural activity that high modernism worked to repress. But my project is to consider certain positions *within* modernism that have been kept from consideration as well. Therefore, this project is distinct from the methodological or philosophical disposition of the two major traditions of art historical method: formalism—which is primarily concerned with the aesthetic issues appropriate to understanding the visual characteristics and activity of works of art (in either its conventional, oldstyle mode, or in its neo-deconstructively influenced methods); and social or cultural art history—with its powerful emphasis on the dynamic relations between ideology and representation, between the economic basis of power and the activity of visual production and reproduction. This project proposes a complement to both the diachronic lineage of formalism and to the synchronic analysis of art as ideological formation—namely, an examination of critical issues in modern art according to a rhetoric of representation.

In other words, I intend to survey modernism as a series of strategies of representation, to trace a chronological succession of formulations in critical discussion and visual arts practice. My approach stresses the materiality of images, the visual specificity of their codes of production, and their participation in the construction of cultural values through and as representation—rather than proposing an analysis of iconography or subject matter. My intention is not to discount the value of social or historical context for understanding the motivation or effect of the practices of criticism in the visual arts, but to suggest that there is a domain specific to this joint discourse which can only be understood through an analysis of the codes that operate *within* representation. Whatever the function of contexts, social forces, or individual character, the formulation of visual arts discourse (by which I mean both critical activity

and visual arts production) is necessarily from within the codes of representation. For visual arts to be fully understood as an ideological apparatus, the specificity of its representational rhetoric needs to be made explicit. Thus the fact that the concept of space *as* represented becomes renamed, reconceived, in the concept of an autonomous *espace* of the canvas at the turn of the century is a vital index to understanding the activity of visual arts in its social dimensions. The parameters of this rhetorical strategy are not incidental or reflective, but essential aspects of the means by which representation serves a function—that of framing the conceptual terms by which experience is mediated. This, obviously, is an Althusserian construction of the role of representation, making it primary in both ideological and psychoanalytic activity. From such a perspective, the means of representation—formal, structural, and conceptual—are a primary domain for the production of experience in cultural terms. This is hardly news, and the foundation of my project is easily traced to critical discussions of poststructuralism and cultural theory.

I have chosen to organize this project according to the three themes mentioned above. To repeat, these are the representation of space, or space as representation, the ontology of the object, and the production of subject positions. As just stated, I begin by examining the concept of space within modernism: as a cultural sphere which is structured through representational strategies.[8] I then describe a series of models developed for both the ontological status of the art object and subjectivity. The theme of ontology of the object traces a conceptual transformation from a belief in the a priori existence of the object, to a highly qualified sense of its value as always contingent and linked to circumstances of reception. The theme of subjectivity is twofold: on the one hand I treat the changing conceptions of the artist as producer, and on the other, the gradual eclipse of this concept by the increased attention to the role of the audience, or, in critical jargon, the produced subject of artistic work. Subject, object, and place of representation within modern life—these are the three themes of these essays, all of which are premised on the belief that the changing conceptual terminology of critical rhetoric changes the conceptual basis on which visual art, as representation, is understood to function. While this study is

chronological, I am not suggesting a deterministic teleology. What I am examining is most emphatically to be understood as *effect*, and not cause. This is as much a descriptive project as an analytic or historical one.

The literature on the history and theory of modern art is so extremely vast, and the field of study of modern art history requires such a degree of specialization, that at every point in my discussion scholars whose areas of expertise I touch upon will no doubt question my selections and omissions. This is inevitable in a work combining broad historical scope with textual brevity. My intention is to be suggestive and provocative, rather than in any sense definitive.

Finally it should be understood that I am not positing the existence of a series of *cultural* paradigms, but a sequence of *rhetorical* paradigms whose relation to art is and has been both descriptive (proposing an analysis of the functions of artistic process) and prescriptive (affecting the critical terms on which artists refine, even define, their projects, and certainly on the process by which the history of art is continually rewritten). This book is not an analysis of modern visual culture, nor of modernity through the visual arts. It is a study of the changing strategies of visual arts and critical writing according to a rhetoric of representation through three themes that examine concerns central to the cultural production known as modern art.

TWO

The Representation of Modern Life: Space to Spectacle

The relation between modernity as a cultural phenomenon and representation as an arena in which the conceptual terms of modern life are structured has been a focus of critical writing since Baudelaire's responses to the Salons of the 1840s. This chapter investigates the transformations in the representation of space, particularly as the formal means by which the visual conception of space becomes a basis for conceptualizing the social space of modern life. The term space carries several meanings here since the literal and figurative space (street, city, suburbs) of modern life becomes defined as a cultural category in part through the activity of representation.

The role of visual images in this discussion is taken to be active, productive, and reproductive rather than merely expressive or reflective.[1] Representation, of which visual images form a part, is taken to be the instrumental means as well as the active domain, by which cultural significance is produced. Such a role is available for analysis in the thematics of these visual images (as images of that modern life and cultural sphere) and in the structure of images (the ways in which they represent, mediate, efface or in any other of a

number of ways perform an active role in structuring the conceptual premises on which modern life is understood). The images under analysis here, and the critical texts, assume that the conceptualization of modernity as a cultural sphere takes place, from Baudelaire's mid nineteenth-century essays to the work of late twentieth-century cultural critics, in terms of spatial metaphors. This essay traces the spatial models of modern life put forth by a series of frequently cited writers and critics and a parallel examination of canonical images which complement their concerns.

The Image of Modernity as Urban Space

Baudelaire and Guys: Artifice, Fashion, Recollection

Of Charles Baudelaire's extensive writings on modern painting and culture, the most frequently cited is his essay on "The Painter of Modern Life" of 1863. In anthologies outlining the history of critical thinking on photography in relation to modernity, it is his 1859 Salon Review known as "The Modern Public and Photography" which appears. These are frequently reduced to excerpts, so that the contribution becomes pointedly clear: the painter of modern life is a flaneur and photography is a banal and inadequate mode of representation. While in this case (as in the case of many critics I will cite below) the more developed, qualified arguments which come out of specialized scholarship have taken their place beside such reductive ideas—not necessarily dislodging the latter from their entrenched position. Between these two positions, that of specialized research and that of the received tradition, I propose a rethinking of Baudelaire's essay on modern life in combination with his observations on photography and of both in relation to the work of Constantin Guys, the artist who served as the model for Baudelaire's "Painter."

Charles Baudelaire's concern to establish the terms of a characteristically modern mode of painting is frequently reduced to a discussion of the urban space of modernity as experienced by the figure of the flaneur on which part of his essay focused.[2] However, Baudelaire's "The Painter of Modern Life," can be read more broadly for its suggestion of the terms by which the image of modernity could be constructed in and through painting.[3] This work also

established the conceptual premise that there was a necessary rela-
tion between modernity and representation such that modern life
was as much the result of visual constructions as it was their source.
Baudelaire chose the engraver/illustrator Constantin Guys as the
exemplar of the modern artist, and in describing Guys' work pre-
sented a model of modern life which was both spatial and themat-
ically concerned with artifice and transformation as a role for rep-
resentation.

Baudelaire constructed his model of modernity around the
themes of fashion and ephemerality. The very frequently quoted
passage of Baudelaire's essay reads: "By 'modernity' I mean the
ephemeral, the fugitive, the contingent, the half of art whose other
half is the eternal and the immutable."[4]

The ephemerality of fashion, however, was dependent upon a
spatialized existence for its perception: the space of display and the
space of spectatorship. The social space of modernity depended
upon a well-organized orchestration of this display so that it could
benefit strategically from observation within the field of social
activity.[5] Baudelaire's discussion focussed on several figures whose
relative positions mark the coordinate points of the modern space
he is at pains to describe. He derived these figures, however, and
their description, from fashion plates, printed illustrations. At the
very outset of his essay, he noted "I have before me. . . " thus call-
ing attention to the fact that he was describing the already repre-
sented image of modern life.[6] In addition, the figures Baudelaire
chose—the flaneur, the dandy, the prostitute, the military man,
etc.—were all described in terms of their elaborate construction *as
images*, so that he analyzed their identity through an articulation of
their strategies for self-representation.[7]

At the outset Baudelaire also elaborated his assertion that fash-
ion required a distinction between the *particular* and the *general*,
the *past* from the *present*, and the *passing moment* from the *eternal*.
By using these structural oppositions, Baudelaire insisted that each
term in the pair depended upon the other for its identity. Thus any
attempt to state that a characteristic quality was inherent in a par-
ticular feature of modernity (e.g. the eternal *or* the ephemeral) was
contrary to Baudelaire's purpose. Baudelaire emphasized the
ephemeral as a perpetual condition of modernity.[8] The nature of the

image which fixed such ephemeral moments thus had to function in recognition of the continual process of change which Baudelaire put at the center of modern life.[9] At issue was not merely the information communicated in the visual image, but the manner in which that communication took note of and engaged with the transient, fleeting character of modernity.

Baudelaire prefaced his discussion of the painting of modern life by praising various artists whose observations had participated in journalistic image making—Daumier, Gavarni, and others were lauded for the critical insights of their etchings and lithographs.[10] But the bulk of his essay focused on the work of the curious figure Constantin Guys, an artist whose work could not support any characterization as universal.[11]

Guy made his living through commercial work, providing journalistic sketches of daily events, noteworthy and otherwise.

To a late twentieth-century eye, the work of Guys has a vapidity and lack of specificity which momentarily baffles the reader looking to the visual materials to support assertions of specific and particular modishness which were the conspicuous motifs of Baudelaire's essay.[12] His work was largely distinguished by its blandness, lack of detail, peculiar absence of exactly the kind of specific information which Baudelaire seemed to have called for in his description of the painter of modern life.[13] The image conjured by Baudelaire's invocation (particularly the charged to "specificity") seemed more like that of the deadly accurate and relentlessly informative Daumier than of Guys, whose bland shorthand sketches seem to eliminate more information than they provide. The figure of Guys was at once banal and enigmatic. Baudelaire immediately contrasted Guys with his peers by announcing this artist's desire for anonymity—both as an object of discussion by Baudelaire, and in his published work: "Not a single one of his drawings is signed, if by signature you mean that string of easily forgettable characters which spell a name and which so many other artists affix ostentatiously at the foot of their least important trifles."[14]

The choice of an artist who effaced his identity in the process of making images, recording and communicating the spectacle of modern life, was important to Baudelaire's model of representation. For this model functioned through a loss of distinction between the

artist/eye and the scene.[15] The artist was to be "plunged into the crowd" and "bathed" in the experience of the passing spectacle, gathering impressions and sensations without critical distance through the course of the day, and then to produce works from the recollected image of these scenes.[16] Modern life was not to be drawn directly, but from the images made as impressions, memories, in the mind of the artist.[17] The themes of these images, the figures, scenes and spaces of fashion, were to be communicated in a shorthand which was the very opposite of informationally dense or replete. The mechanics of recollection (which implied that life was already an image and modernity a spectacle) combined with the conceptual strategy of a communicative code dependent on acquaintance with the very fleeting images which were being recorded. The images were so sketchy as to be meaningful only within the ongoing stream of other fleeting, equally ephemeral, images. (figure 1)

Where is the near-photographic richness of detail seemingly called for in Baudelaire's exhortation to a manner of painting appropriate to the fleeting particularities of modern life? One passage in "The Painter of Modern Life" described the modern artist/spectator's visual experience in a model so mechanistic that it suggested a photographic apparatus:

> Or we might liken him to a mirror as vast as the crowd itself; or to a kaleidoscope gifted with consciousness, responding to each one of its movements and reproducing the multiplicity of life and flickering grace of all the elements of life. He is an "I" with an insatiable appetite for the "non-I," at every instant rendering and explaining it in a picture more living than life itself, which is always unstable and fugitive.[18]

But in fact, in "The Modern Public and Photography" (1859), Baudelaire disdained and condemned indiscriminate realism of photography.[19] He mocked those of his contemporaries who said, " 'Thus, if an industrial process could give us a result identical to nature, that would be absolute art.' And then they said to themselves, 'Since photography provides us with every desirable guarantee of exactitude,' (they believe that, poor madmen!) 'then art is photography.' "[20]

These positions—of visual specificity and anti-photography—

though seemingly contradictory were actually complementary. The condemnation of photography called for an imagery of memory, a making of images provided out of the recollection of experience, not in direct observation. We know, in fact, that this was the way in which not only Guys, but Daumier and other renowned artist/illustrators worked at that time. Guys submersed himself in the spaces of modern urban life—the activity of the street, the crowd. He disappeared from notice like the public flaneur, and became the neutral, almost invisible presence essential to Baudelaire's model of the activity of spectatorship. He then went home to draw, to spill out the images at the remove of recollection in a manner paradigmatic to Baudelaire's idea of what was a representational strategy appropriate to modernity.

The flaneur was a kind of camera eye, but Baudelaire's model of representation stressed mediation and subjectivity not mechanistic objectivity. The "I" with "an insatiable hunger for the non-I" consumed experience as image, already mediated and vicarious. While carnivorously devouring space through a compulsive voyeurism, the artist was not to make a photographic rendering of the passing scene. The photographic, with its automatic writing of the world, mechanical, neutral, and supposedly documentary, did not represent the image of modernity to Baudelaire. Instead, his notion of the modern spectacle was very directly and importantly mediated through the social realm, and subjective filter, as a constructed image of remembered experience. What was recalled by Guys in the studio, what was recollected as significant out of the mass of information experienced in the street, was a shorthand of communicable and recognizable *signs* of shared experience. This is the key to grasping the very vacuous seeming quality of Guys' work. Much was absent because it did not need to be present. So accurately did he inscribe the shared, social images of ephemera that the merest hint of specifics was sufficient for a contemporary viewer. The least bit of visual information sufficed to index the body of referential material shared as the social experience of the time.

Thus, for Baudelaire, the *image* which was accurate was not the mechanistic and replete document of visual information. Instead, he emphasized the reduced, schematic, indexical sign whose repleteness lay in the domain of shared knowledge, itself transient,

ephemeral, changing. This body of reference is to a great extent lost. Consequently Guys' work has the look of emptiness. It seems to be without sufficient information to conjure a specific, particular, and rich image of the moment in which it was executed. Herein lies its validity. There is no *eternal* or *universal* modernity fixed in Guys' inscribed lines and articulated forms, rather, they remain phantom traces of a rapidly passing scene. Who could tell, looking at the bonnet ribbons or hemlines of Guys' "Meeting in the Park," what distinguished one year's fashions from the last without additional references? And yet, to the eye contemporary with those images, the merest hint of such variance would have been sufficient to mark the shared field of observations within which the image itself would have served as viable currency, trading on its capacity to mark with very minimal means the nuances of shared visual knowledge.

The roles of flaneur as spectator and spectator as artist proposed by Baudelaire were decidedly biased toward a male and bourgeois characterization.[21] Within the social codes of the mid nineteenth century only men of a certain privileged class could offer to Baudelaire the image of such freedom—this capacity to roam at liberty and at the instigation of their whim through the streets of the modern/urban world as a form of diversionary pleasure—since they had leisure, means, and disposition to do so. Baudelaire's description of the flaneur's movement was immediate, present, and vivid, and we vicariously inhabit that position. By contrast, the roles he presented for women were all objectified, distanced, observed through and across a space, physical/literal and social/metaphoric. Once again, the terms of representation became, for Baudelaire, the terms of the social construction in this case collapsing the women's roles with the images of femininity.

Relying, again, on the illustrations derived from Guy's work, Baudelaire offered two images of women and the contrast between them and the male figures described conform to familiar conventions. On the one hand he put forth the description of Woman as other, as objectified, rendered and kept mute by a supposed stupidity attributed to her as inherent. But she was dazzling, bewitching, and seductive through her manipulative machinations. Woman was inseparable from her dress: she had no character, no

self, no essential being, and thus had to be made through a construction of identity which collapsed her signifying clothing into the signified of her otherwise nonexistent being. Her appearance must serve to substitute for content in an "indivisible unity" of fashion and female. By contrast, the description of the dandy provided earlier maintained that the exquisite articulation of fashion on his part was the mere evidencing of his essence, a symbolic manifestation of his superiority of spirit, his discipline of manner and form, his capacity to cultivate his self beyond any possibility of judgment or satisfaction by others, and his conformity with and embodiment of the very boundaries of propriety itself. He was using the signs, to signal his place in the cultural order, but She was a sign, and no more. For the male figure the role of clothing/fashion was as the image *of* his self, for the woman, the image *was* what she *was*. Thus Baudelaire extracted from Guys the point of departure on which to base his own construction of gender categories *as* images.

As Baudelaire's discussion of Guys worked progressed, each of the figures under investigation was described according to their relation to a physical, literal space—itself, in turn, accorded a certain symbolic value. For instance, the views and glimpses which Guys provided of the woman, the correct and "good" woman, were all physically, spatially, distant. In both the plates and Baudelaire's descriptions these women appeared confined within well-demarcated spaces—in carriages, passing, remote, or in a theater box, or, at the most intimate, within a large and well-socialized room—outdoors in bonnet and cloak, indoors in evening décolleté. All formal images, these were not the glimpses of women as available flesh (according to the conventions of nineteenth-century painting), nor were they the images of women as domestic creatures so prominent in later nineteenth-century observation by Morisot, Cassatt, or Degas. These were the women of modern public life, of street and salon, of theater audience and illustrated journals.

For contrast, Baudelaire focused on images of prostitutes. While women of station exposed their busts and cast their eyes downward, prostitutes displayed their legs and looked forward from the frame of the sketch to meet the viewer's eye. Confrontationally acknowledging the shared space of the look, these images closed

the space into a literal one, shared, physical, and permitting access, as opposed to deferred, detoured and inaccessible.

Women were *positioned* in both Guys' images and Baudelaire's texts: they occupied fixed stations within the written or drawn surrogate of spatialized male observation. By contrast, Baudelaire granted mobility to the male figures and charted their movements to draw his map of modern space. The first example was that of the flaneur/artist figure, whose movement through the public spaces of urban Paris became the essential model of a relationship of surveillance, control, and nearly invisible, but omnipotent, spectating activity.

The flaneur was the essential instrument, apparatus, for observation of modernity, and this instrumental aspect served as point of reference for later critics' work. But Baudelaire ultimately selected the *military man* as the most characteristic symbol of his era. A radical shift in tone occurred in his essay as he switched to present tense to describe the military man's exploration of the geography of France's military activities. In introducing this military persona and his disposition (in visual terms) toward the world, Baudelaire gave a swift survey—with on the spot, journalistic, telegraphic immediacy—of the scope and extent of France's recent military campaigns. As an amplification of the metaphor of surveillance and control available to the male gendered flaneur, this description only reiterated the image of visual domination of space evident throughout the essay: and that control could best be effected in the discipline of representation.

By the end of the essay it was clear that the only universal feature of modernity in Baudelaire's conception was the activity of imaging, of artifices of representation and contrived construction. Not incidentally, one of the final sections of this was a discussion of cosmetics. He praised them, of course, because they were opposed to nature, not a part of it. The attention to what was represented, rather than what "is," to what could be signed through the codes of image production, rather than made real through the referent, dominated his conception of modern life. The images functioned as signifying elements dissociated from their "natural" relation to experience by means of representational strategies. This foregrounding of artifice, of representation as such, lauding its ploys and devices,

was consistent with the fugitive image of ephemeral life as modern. Such self-conscious attention to representation and, thus, to the nontransparency of the sign, was probably the single most characteristic feature of modern arts practice in visual arts, literature, music and architecture. Baudelaire, formulating this concept of representation, found in the work of Guys, in its refusal of repleteness, and lack of superabundant detail which was necessary to the rules of *realism*, the demonstration of a modern sign system, also fugitive and ephemeral.[22]

The image of cosmetics, as something which was *applied*, and then served to signal the visage, became the refined extension of Baudelaire's argument: the image was not the instrument whereby consumption could be achieved, rather, in modern life, the image was precisely what was itself consumed in place of and without regard to any "real" referent. This is strikingly clear now that the referent which rendered the image functional, operational, consumable, has vanished, showing the signs for what they were: mere traces, not even, in the case of Guys, full signs, but suggestive traces of once significant elements.

Baudelaire was concerned with what could be represented, with image as artifice and construction, bearing the visual codes of ephemeral modernity. Similarly, Guys' work was never about the real, but about the image, its viability, consumability, and readability as a set of signifying elements. The character of that representation—its mediating and constructive function—was as significant as the themes of modernity which it presented. Thus Baudelaire's essay was never about some supposed actual, eternal, modernity, but about its existence in, as, and through representation. Space was inhabited as the social arena for the imaginary representation of real existence, produced as a spectacle in and through the ongoing production and consumption of images.

Benjamin and the Social, Ideological Space of Modernity

In the essays in which he was concerned with Baudelaire's work, Walter Benjamin transformed the poet's engagement with the urban spaces of modernism into a critique of the ideological formation of modern life.[23] Benjamin created a new analysis of the

way the image of modern life was constructed within that urban context, transforming the voyeuristic spatial surveillance of Baudelaire's flaneur into the alienating effect of urban life on the "man of the crowd." Benjamin's work forged a link between the mid nineteenth-century experience of the modern city and the twentieth-century critical study of representational strategies as cultural form. While for Baudelaire the ephemerality of fashion and the construction of artifice were characteristics of both modernity and its representation, for Benjamin the distance between the image and the "truth" of experience called attention to the gap between real conditions and their representation. For Benjamin the representation of modernity in the texts of Baudelaire is always coded in ideological terms.

Benjamin's reading of Baudelaire, and of the city of Paris as a physical and cultural site for the emergence of modern life, have provided a springboard for subsequent Marxist based considerations of the relations between modern French painting and Paris as a modern city. His work thus provides an important link between aesthetic considerations of strategies of representation, and a cultural analysis of these same strategies.[24] As in the case of Baudelaire, these works are excerpted and republished along with the other oft-cited essay on mechanical reproduction. They have come to be the token pieces whereby Benjamin's charge to read culture as ideology can be interjected into the history of art as part of its critical methodology.

"On Some Motifs in Baudelaire" was first published in 1939. In this essay Benjamin reconfigures Baudelaire's spatializing description of modernity and concern with the ephemerality of fashion by focusing on slightly altered themes: the crowd, the experience of modernity, and the concept of "shock" as a structuring element of that experience. Benjamin's intention—to suggest in Baudelaire an analysis (albeit unarticulated, or at least, not explicit) of the lived conditions which embody features of emerging capitalism at the center of modern life—continually returns to the role of the image of the modern urban experience. A central issue for Benjamin, of course, is the philosophical understanding of history. The trajectory of the reception of Baudelaire's work as a lyric poet provided a point of departure from which Benjamin felt he could develop both

an insight into the cultural changes wrought by the emergence of capitalism and some grasp of the role of memory in that historical process.[25]

Central to Benjamin's rereading of both Baudelaire's work and the city of Paris of the nineteenth century in terms of an analysis of representation is his transformation of the concept of literal space into a site for the production of ideology. Seventy years' separate "The Painter of Modern Life" and "On Some Motifs in Baudelaire," and a significant range of visual and critical practices had emerged in that interval.[26] In particular, both psychoanalysis and Marxism had become developed tools for cultural analysis in critical theory. The type of image whose consideration had been central to Baudelaire's essay on "Modern Life"—feuilleton pages and fashion plates—had been replaced in Benjamin's experience by an expanded rhetoric of display, in the proliferating mass media of print, in the reworked spaces of the urban street, in department stores and amusement palaces. The sense of "image" which is significant to Benjamin is that which is produced in the encounter with these spaces. Easel paintings and journalistic drawings of depicted space are far from Benjamin's mind as he describes the operation of representational modes, even as he projects them into Baudelaire's Paris. Constantin Guy remains in the wings however, way beyond the margins of Benjamin's prose.

The most dramatic transformation Benjamin effects upon the conception of the image and role of representation is to reformulate its primary mode of production from one of recollection to one constructed in a moment of shock. Benjamin is concerned with the function of representation as a link between the mode of apprehension of experience and the substantive content of modern life. To begin his investigation, Benjamin departs from the work of Baudelaire and charts a path through philosophy: "Since the end of the last century, philosophy has made a series of attempts to lay hold of the 'true' experience as opposed to the kind that manifests itself in the standardized, denatured life of the civilized masses."[27]

While the substance of "true" experience is significant, Benjamin recognizes that that experience is only available through the mediation of representation. The opposition stated in the above excerpt underscores his entire reading of Baudelaire: Baudelaire's conception

of experience and its representation, must, according to Benjamin, be read as a counter to an activity of denial (or repression) which capitalist modernism reinforces to assure its success.[28] Henri Bergson's model of involuntary memory provided Benjamin with the tool to counter the "shutting out of experience" which he perceives as both the result and the instrument of the repressive forces of mechanization in modern life. The concept of "shock" which Benjamin extracts from the various memory production models of Proust, Bergson, and Freud, offers a tool to counter this repression, break through the patterns of habit, and approach the condition which Benjamin attributes to Baudelaire's encounter with modernity.

For Benjamin, the "allegorical genius" Baudelaire is the quintessential modernist, structuring the image of Paris as the social site/space of a modern life appropriate to Benjamin's model of a capitalist, consumer-oriented social structure. Referring briefly to Baudelaire in a section of "Paris, Capital of the Nineteenth Century" Benjamin emphasizes the poet's concern with the image of the crowd and an experience of the city—both themes so dominant they don't even need to be mentioned explicitly, according to Benjamin. By contrast, he attends directly to the concrete topos of street, arcade, city landscape, turning these forms into metaphors for the mechanism of consumption and display essential to the function of the "phantasmagoria" intrinsic to both "cultural history" and modernity. For Benjamin these spaces are both literal and symbolic, instrumental and figurative manifestations of capitalist ideology.

Benjamin, reassessing the role assigned to the operation of images in the production of modern life, sharply criticizes the idea of fashion which fascinated Baudelaire. Benjamin points out that fashion is the ideological machine which drives consumption by continually fetishizing the commodity as new. The very concept of newness is bound up with an image, illusion: "It is the quintessence of false consciousness, whose indefatigable agent is fashion."[29] Benjamin's concept of image is that it is collectively produced, intangible, and structured within the city, most specifically, within the arcade site whose architecture produces the spectacle of display. This reading of Benjamin is, again, well-known: the descrip-

tion of an apparatus of consumer culture within the social space of the city is a fundamental feature of his unfinished arcades project.[30]

But, while he reinforces the privileged place of visual experience in Baudelaire, Benjamin reformulates the conceptual basis for *production* of images. Taking Baudelaire's flaneur as the central figure moving through and being produced by that city space, he conceives of an image which is the effective production of a moment, of a shock. In Benjamin, the "image" is no longer to be understood as the aesthetic production of a subjective visual recollection. Instead, the image is a device for producing insight, awareness, and for breaking through the blindness of habit and ideology. The image which Benjamin connects to the concept of shock is produced through exposure to the fragmentary, disjunctive elements of daily urban life. From Benjamin's perspective: "Baudelaire placed the shock experience at the very center of his artistic work."[31]

Elsewhere in his discussion, Benjamin makes a link between this experience and the implications of its form: "The shock experience which the passerby has in the crowd corresponds to what the worker 'experiences' at his machine."[32]

On the one hand the sense of dislocation necessary to provide insight is a replication of the fragmented isolation characteristic of the place of the worker within a system of mass production—on the other hand, this isolation is similar to the fragmentary, disorienting experience of the urban environment, especially, in terms of an interaction with the "crowd." Benjamin transforms the aloof and distanced practice of the flaneur into an alienated eye ("I") continually engaged in the unassimilable and indigestible experience of modern life, a person jostled by the crowd, both of it and at odds with it. For this figure, even more than for the flaneur, Benjamin wants the production of image to produce critical insight.

> Historical knowledge of the truth is only possible as the transcendence of illusion. But this transcendence should not signify the evaporation, the actualisation of the object, but rather, for its part, take on the configuration of a *rapid* image. The rapid, small image in contrast to scientific leisureliness. This configuration of a rapid image coincides with rendering oneself sceptical of the "now" in things.[33]

The technology metaphorically invoked here is that of photogra-

phy, a technology which, as per above, was explicitly condemned by Baudelaire, who insisted on the filtering of images through both recollection and the artist's hand. The particulars of the images of Constantin Guys are conspicuously eliminated from Benjamin's reading of Baudelaire. For Benjamin photography (he refers to Daguerre and Nadar) produces the necessarily alienated images of both modernity and its *spaces*—that is, the "true experience" and its lived reality (and illusions). Benjamin conceived of photography as doubly alienated: in its relation to experience (fragmentary, rapid, an afterimage) and in its mechanistic replication (the image it produces is already an illusion—specifically, the illusion produced in the structure of modern, urban space). Photography was a phantasmagorical conceit participating in the spectacle required for the successful operation of bourgeois capitalism.[34] Benjamin's concept of this photographic production found its precedent in the mode of apprehension of experience described by Bergson: "In shutting out this ['true'—that is, of modern life] experience, the eye perceives an experience of a complementary nature in the form of its spontaneous afterimage as it were. Bergson's philosophy represents an attempt to give the details of this afterimage and fix it as a permanent record."[35]

The implications of this shift are many and various. The pictorial characteristics of modernity available through photography have a repleteness which was distinctly absent from Guys' work. For the traces, small signs of an ephemeral moment relying on shared reference for its significance, Benjamin substitutes the densely filled and literally complete image of the photo, with it surplus of unedited, uncontrolled recorded information. The opposition here is not that of realism vs. subjectivism. It should, more productively, be understood as an opposition of apprehension vs. censorship. The concept of the photography, with its afterimage of shock, works against the process of censorship (whether conscious or not) produced in individual experience within capitalism. Benjamin is well aware that repleteness of visual information cannot be equated with truth value in representation, but the process by which such photographic images are made seems more likely to offer insight than the recollected image in which the censoring process plays such a strong part.[36]

The contrast between the images produced by Guys and a photograph of the same scene would make clear the implications of these two positions. Baudelaire, much as he identifies his flaneur artist with the crowd, city, and sight, gives prime place to Guys' filtering recollective activity. Guys' images inscribe the artistic subject in the image as part of the process of editing, eliminating, reducing, transforming. For Benjamin, the subjective function is inverted—the subject does not merely or simply produce the image, but *is produced by it.* The image is an instrument to create consciousness, rather than being its result.

The "man in the crowd" is thus to direct his [sic] gaze into the space which imposes an image through the shock effect of the moment. For Benjamin this is the quintessential "sensation of the modern age."[37] The moment, the instantaneously ephemeral, is no longer recorded in a code (like that of Guys) which requires the viewer understand its meaning through a social collective memory. Instead, the moment passes itself off onto the surface of the eye as it would onto a photographic plate, carrying both too much and too little information.[38] And while Benjamin invokes the notion of delay in the production of the image, it does not prevent the image itself from being mechanistically replete rather than subjectively filtered.

Benjamin's image was social and ideological; he transformed the image of modernity from that of a recollected subjectivity to mechanistically exposed inscription. In so doing he shifted the site of modernism from a literal (if metaphoric) *space* to a concern for and emphasis upon the *espace* contained within representation itself. For Baudelaire, the subjective recollection of public space and ephemeral experience created an illusion which served as both representation and production of modern life. Benjamin read Baudelaire retrospectively as a critic of capitalism, interpreting his experience of modernity as an insight into the lived conditions of modern life. With both of these models in mind, the subjective/recollected and the mechanistic/replete, let us turn to a brief analysis of two well-known paintings of modern life: *Luncheon on the Grass* (1863) and *The Bar at the Folies Bergère* (1881) by Edouard Manet, and investigate the structure of representation of nineteenth-century modern life through the thematics of space as it appears in these two images.

Manet: Conventions of Representation / Constructions of Space

Before continuing discussion of the refinements to analysis of the urban space of modernity in the critical writings of later twentieth-century historians, it seems useful to consider two paintings by Edouard Manet which offer a radical contrast of representational strategies. Both have been subject to innumerable analyses and much research, and my intention is to use these indisputably canonical works as constrasting models of representation with respect to the structure of space. The first of these, *Luncheon on the Grass*, dates from 1863, making it contemporary with the publication of Baudelaire's "The Painter of Modern Life." The *Bar at the Folies Bergère*, painted nearly twenty years later in 1881, evidences the considerable evolution in attitude toward the structuring and representational operation of space in Manet's work.

The space of *Luncheon* is one of artifice and convention self-consciously confronting "the tradition of demonstration pictures showing figures in a landscape."[39] Self-conscious play with the expectations of the spectator with respect to those conventions contributed to the effect of the picture, whose thematic confrontations with those conventions (such as juxtaposition of female nudity and male casual relaxation) are generally given credit for its scandalizing value. The mode of representational manipulation, however, can also be credited with contributing to its disturbing impact. The work has the character of a collage: it has fundamental disjunctures which cannot be reconciled with the illusionistic space depicted.

The main spatial peculiarity of *Luncheon* is that it collages the space of an Arcadian landscape into the space of the social domain. The atmosphere and ambience created among the figures is leisured and diversionary. But the group is sutured into a backdrop, which calls attention to the landscape painting as a motif. This Arcadian space is as conspicuously artificial in its setting as the painted curtain of a photographer's studio. These two spaces are irreconcilable within the frame of the image. The women are cut out and pasted onto, rather than into, that space. The high-toned flesh of the foreground, nude, figure casts her forward from the pictorial backdrop which functions as the symbol of traditional painting and its disjuncture with the demands of contemporary life.[40]

The depicted landscape, conforming as it does to the conventions of illusionistic depth, is reduced to the signs of such convention, serving to resonate with its clichés and categories, rather than to participate in the their myth of transparency. The space is a studio space, dimensionless, illusionistic, mannered and self-conscious, calling clear attention to its conceits, but still maintaining the structure and relations of monocular perspective, with all its objectifying and distancing activities.

By invoking the system of codes which properly belong to the domain of painting, *Luncheon* establishes the visual tradition within which its own transgressions become meaningful. In this sense it partakes of the play with and recognition of codes of representation which was central to Baudelaire's concept of shared reference. But the work has none of the vagueness, absence of specificity or detail, which is characteristic of the work of Guys. More importantly, as a painting, the work was evaluated within very different parameters than the images of the illustrator or engraver. Manet's play with the traditional codes of painted space involves both nostalgia (for painting) and transgression (of its norms) in a manner which calls attention to the artifice of painting's representational strategies. By contrast, the *Bar at the Folies Bergère* has abandoned the structuring conventions of painting for those of photography—internal montage, density, mirroring. *Luncheon* recollects painting through nostalgia for its forms: it makes use of painting as recollection, as the finely constructed *image* controlled by choice, arrangement, and composition, as it could be made in accordance with classical rules and modes through a studio practice, art, and craft.[41]

The contrast with *Folies* takes place at every level of the interpenetration of thematic material and formal device. The highly replete (in terms of point by point, inch by inch density of material information recorded in paint) quality of the image contrasts immediately with the spacious distribution of elements in the *Luncheon*. The spectator is completely *inside* the represented space of the *Folies*, as opposed to outside of the theatrically formed proscenium space of the *Luncheon*. That the relation to the bodies, persons, in *Folies* is disoriented and inconsistent, as opposed to ordered, constructed, arranged has been pointed out repeatedly by writers as diverse as Robert Herbert and Timothy Clark.[42] The dis-

position of eyelines and of persons in relation to them and to the spectator confound our perception in a manner mimicking the confusion and multiplicity of simultaneous perceptions available within the crowded space of the bar, thus mirroring in formal structure the experience. Phenomenological, sensual, visual, this painting inverts the structure of classical representation as objectified, distanced and optical (i.e., constructed according to a set of rules and conventions, rather than through experienced vision *in situ*). (figure 2)

The *Folies* painting permits an analysis of Manet within the terms of *shock effect* discussed by Benjamin in "Some Motifs in Baudelaire." In that essay, Benjamin, seemingly unable to get a purchase on Baudelaire's discomfort with the photographic mode of image production, continually unwinds his own discourse of photography and its modernity. The technological character of image production, which Benjamin characterizes as unedited, has the brutality (Baudelaire's word) of the *Folies* painting.[43] Abrupt, convulsive with activity, the image plunges us into the very scene of its occurrence, collapsing our space with its own in a photographic continuity—but the space itself has the disjunctures of montage combined with the replete visual density of the photographic record. The work has the unabashed confrontational character of photography—there is no aesthetic distance between the viewer and the scene.[44]

This was not Baudelaire's prescription for the image of urban modern life, recollected and mediated through the memory and hand of the artist. Instead, it comes closer to fulfilling Benjamin's notion of the trace of the shock moment, the evident manifestation of experience making itself into *durée*, through the production of an afterimage, following the line Benjamin synthesized from Bergson and Freud to manufacture the model by which he could understand Baudelaire. It is in the discrepancy between the two, between Baudelaire's proposal and Benjamin's reading that we find the shift from the conception that the intersection of modernity with representational strategies should be made in journalistic (recollected) drawing to the idea that it consisted in photographic (immediate) repleteness.

These two works offer visual contrasts between what are taken to

be characteristically modern modes of representation, between Baudelaire's contemporary call for transformed images and Benjamin's retrospective historical analysis of modernity produced as the trace of shock moments.

Clark and Pollock: Divided Spaces of Class and Gender

Two important contributions to the reworking of the received tradition in art history which characterized depictions of the spaces of nineteenth-century Paris as mere picturing have come from Marxist based theory in the work of Timothy Clark and feminist cultural analysis in the work of Griselda Pollock. Their work has suggested striking correctives to entrenched conventions of iconographic and thematic analyses. Most importantly, both propose that visual images participate in the production and reproduction of categories of class and gender and do not simply reflect or depict them. Each, however, also constructs an oppositional structure through which to divide the massive field of images produced as part of Impressionist painting in order to make a case for their arguments through details of visual structure available in the privileged portion of this divided field.

My comments on their work are meant to extend their premises just slightly, so that certain forced terms of their structural analyses can be reformulated. Their work contributes to the interpretation of the urban space of modern life which was at the center of Baudelaire's work and Benjamin's rereading. It is inserted here to further the investigation of the imaginary production of supposedly real space through the conceptual strategies of visual representation. Both Clark and Pollock grant a credible existence to that literal, real space of modern life, but posit its production through the activity of painting as largely symbolic.[45] Both are concerned with the role played by these images naturalized in the cultural order encoded in these works—a cultural order embodied in the rapidly transforming space of late nineteenth-century Paris. Both argue that such naturalization provided a false image—one which offered a unified image of an in fact deeply divided city (divided by class, gender and race, though this latter is not addressed explicitly by either). Both acknowledge that this cultural sphere must be examined in terms of its fictive production as image. Clark proposes that

the role of the image must be understood with respect to the divisions of space within the city which both produced and inscribed class differences. Pollock suggests that images function to both depict and reproduce divisions of space grounded in distinctions of gender.

While the recognition that images participated in the production of an ideology of consumption necessary to and complicitous with the emergence of the culture of nineteenth-century industrial capitalism was a feature of Benjamin's analysis (and, within more strictly art historical terms, the work of Meyer Schapiro as well), the work of Clark and Pollock extends that analysis. The "space" of modernism fractures, fragments, and divides in their work: it is not a singular (ideological) space produced through representation; the space of the city becomes *spaces* and the relations among those spaces are themselves negotiated, to a significant degree, by the strategies of representation emerging in modern art.

In *The Painting of Modern Life*, T. J. Clark demonstrated the precise manner in which the thematic depiction of Parisian space in the work of Manet, Degas, Van Gogh and others, both masked and helped produce the conditions of social change affecting the real conditions of lived existence of its citizenry. As active agents in the reproduction of the social order, the impressionist paintings of mid to late nineteenth century systematically participated, according to Clark, in legitimating the transformations of the Parisian landscape. Clark elaborates on the way the work of these painters aestheticized the Haussmannization of the city on the one hand, and also offered a critique of the process through rendering the changed spaces, changed experience of that space as it was becoming divided. Clark establishes a link between Haussmann's desire to produce a city as consumable image, the role of representation, and the results of the physical transformations of the city on both the working class and the bourgeoisie. Clark is also concerned to demonstrate the way in which the particular visual character of the work of Manet and his followers was an essential component of this production. He stresses that images such as Manet's L'Exposition Universelle de 1867 (1867) do not simply depict the "circumstances of modernism" but contributed to making the circumstances that they do depict *modern* by making use of forms called "spectacle."[46]

It was through the forms of representation itself, Clark emphasizes, that modernity came to be articulated as the spectacle of leisured excursions, outdoor fetes, open streets and newly accessible suburbs.[47] The space expanded, in these depicted images of urban entertainments, views, and pleasures, and the images became the means of codifying those environs and activities as modern through the changed mode of their own production. Clark's argument demonstrates the manner in which the works of Manet, in particular, gave evidence both of the havoc wrought on the city as it became changed through the projects initiated by Haussmann, and in other instances (within Manet's work, and that of other painters) worked to conceal and naturalize that transformation through presenting the consumable spectacle of the city in terms of a consumable image. In Clark's formulation, image, as representation, became an instrument for both concealing and revealing the conflicts of class within the urban space of nineteenth-century Paris.

The important distinction between Clark's analysis and that of either Baudelaire or Benjamin, is that Clark does not presuppose the space of urban life as a given. Space does not exist to be represented according to a particular mode of encounter, but rather, the notion of space and the value which it is assigned are produced as much through the method of representation which comes to the fore in Impressionist painting as through the physical restructuring of the city. Marking the necessity for Haussmann to produce the city *as an image*, and a consumable one, Clark emphasizes the negotiating role of the work of Manet et al. in this activity. The *Exposition Universelle de 1867*, which can be examined superficially as merely recording an event, turns out, in Clark's investigation, to be an image whose specifics are both a humorous parody of the effects of Haussmann's changes and also, an agent in naturalizing their representation as quintessentially modern.

What Clark does not emphasize, though it is evident from the way in which Impressionist paintings have been received by a broad public, is that one of the most compelling aspects of these paintings is their capacity to be consumed. They provide a visual spectacle which is itself pleasurable both in its techniques of daubing sketchiness associated with modernity as antiacademic and in

its representations of the new Paris as a place of new pleasures. While Clark is fully aware of the necessity for the painting of modern life to produce consumable images, he intones against the merely pleasurable as uncritical, though such activity permits the rapid diffusion of the naturalizing effects of ideological production.[48] Clark wants the paintings to be validated on the basis of their function within a twofold critique. First they should expose the effects of transformation of Haussmann's plans and secondly they should do this through resisting the easy pleasure of consumption. Clark is wary of the way in which looking at these images could simply replicate the pleasure of looking which was central to the production of the new, modern city as a visual spectacle, and thus simply further the naturalizing effect of their prettified imagery. To support this critical line, Clark has to divide the field of images produced in the 1860s to 1880s into good and bad objects.

> Haussmann's work and its aftermath—provided painting with as many problems as opportunities. Naturally it offered occasions for a meretricious delight in the modern, or proposals in paint that the street henceforward would be a fine and dandy place. (I cannot see, for example, that Monet's two pictures of Le Boulevard des Capucines in 1873 do more than provide that kind of touristic entertainment, fleshed out with some low-level demonstrations of painterliness.)[49]

Since Clark's aim is to find a critical and insightful underpinning for the work of Manet and his followers, the idea that they might produce work which was "touristic" and taking "delight" in the modern street is dismaying to him. There are evident visual similarities between the paintings which provide this delight and the paintings which provide a more socially aware critique (Clark cites Van Gogh's The Outskirts of Paris 1886, for instance). What Clark seems to repress is that fact that it is this very (complicitous) consumability of the mass of these images of Paris—for instance, Le Boulevard des Capucines—which leverage their effectiveness. In fact, the spaces of class conflict are both concealed and revealed (in different works, but within the same historical moment). It is this binarism which makes the insights of more critical revelations significant. The construction of modern, urban space moves between the

representational strategies of critical insight and consumable pleasure. In the mass of images produced within the discursive field of Impressionism, these strategies are not always manifest in mutually exclusive terms.

Clark is intent on demonstrating the active role played by the impressionist images which structure a spectacle of modernity as the rebuilding of the city—consequently inscribing divisions of class activity and control. In so doing, he systematically excludes works whose obvious aestheticization of the optical pleasures of contemporary life *merely* (in his terms) participated in its production as consumable spectacle. The public affinity for the soft edged daubs of Renoir, Pissaro, and the garden pictures of Monet, which continues to the present, is repudiated by Clark in the name of his political critique, one in which the ethics of these aestheticizing images are read out clearly. Dismissing these works by Monet and Renoir as *frivolous*, Clark eliminates them from serious consideration, thereby delimiting the work on which he assesses modernity, omitting attention to the very features which made these works effective. This, of course, was a corrective to the generations of art historians determined to read these images entirely in terms of their aesthetic and optical values.The power of these works to be consumed, however, continues to reside in precisely that aestheticizing dimension. Thus their power to be the producing agents of the masking spectacle of an ideologically transformed urban space, promoting and legitimizing those changes in the name of the very aesthetics they embodied, depended upon the seductive quality of surface, of visual effect.

Clark therefore makes a final division between the good critical impressionist works and the merely pleasurable ones. In so doing, he posits the existence of a truth value beyond the images as the redeeming (or alternately condemning) term of validation: the truth of class relations. By setting up this opposition, and grounding its existence and valuation in terms of an external "real" convention, Clark slips away from a rhetoric of representation. In such a rhetoric, Clark's analyses can be reframed, granting these images the job of providing the very conceptual tools by which the class divisions are of society are constructed through signs (that economic relations are themselves representations) not least of all,

those of the privileged domain of painting. Thus reframed, the effective function of these images is reinforced (rather than undermined—my project here being an extension, rather than a contradiction, of Clark's position) by the persuasive force of "prettification" in reifying that image of modernity. The construction of categories of class are all the more consumable in images which seem to be unengaged with social critique or the more negative aspects of modern culture. Naturalizing itself as transparent this "beauty" of Paris as image, in actuality presenting the terms by which the city's transformation is granted value, works through these paintings with the force of great conviction.

Clark's position has come under attack for its repetition of another of the conventional critical assessments of the thematic character of the space of modernity—that in addition to being *urban*, it is *male*. The terms on which modern space was conceived, following directly from Baudelaire, are that it opens through the gaze of the male flaneur wandering at will, nearly invisible by virtue of his (male) neutrality, capable of being subject, not object, of the activity of looking essential to moving with near omniscience through those streets, arcades and plazas in which the spectacle of modern life is played out. Griselda Pollock, in her critique of this conception, offered the following counter construction. Referring to Clark's discussion of Manet's *Olympia* and *Bar at the Folies-Bergère*, Pollock says:

> How can a woman relate to the viewing positions proposed by either of these paintings? Can a woman be offered, in order to be denied, imaginary possession of Olympia or the barmaid? Would a woman of Manet's class have a familiarity with either of these spaces and its exchanges which could be evoked so that the painting's modernist job of negation and disruption could be effective? Could Berthe Morisot have gone to such a location to canvass the subject? Would it enter her head as a site of modernity as Clark defines it at all?[50]

Pollock proceeds to discuss the spatial terrain of modernity according to a binaristic model of spaces depicted by women artists and male artists.[51] Her aim is to deconstruct the privileged term of masculinity as the defining spatial experience of modernity. In so doing she engages in a curious dilemma: how to demonstrate the

gendered articulation of a gaze such that women artists can be shown to experience space, and modernity, *differently* while struggling with the fact that models of representation were received by these women painters from a tradition in which such difference (and the possibility of inscribing it) was absent. To do this she embarks on a reading of the work of Mary Cassatt and Berthe Morisot.[52]

Pollock articulates a number of different concepts of space within modernity: space as location; space as social construction with its limits/boundaries and corollary experiences; and space as the depicted illusions within representation. Pollock takes as her point of departure the assertion that the constraints of movement on bourgeois women resulted in a very different relation of women painters to the modern space of Paris than that of their male counterparts.[53] The space of modernity, she demonstrates, was distinctly different for women than for men: even when they could, in company of an escort, enter the places of entertainment, public spectacle and pleasure, which were the frequent subject matter of the paintings which served to promote the new Paris, they were constrained. First because women were never to allowed, by virtue of their conspicuous feminine identity, the neutrality of the male observer (they could never "enjoy the freedom of incognito in the crowd")[54] and secondly, because there were limits to their access to certain spaces. Women had always to be aware of their reputations, and, consequently, were debarred from those places in which women were put on display for consumption as sexual objects per se.

Pollock's fundamental analysis of modernity challenged the tradition in which the masculine view of spectacles and spaces passed for unmarked within those representations and subsequent critical assessments. She builds her argument by noting that there were other specific locations, other modern spaces, which were themselves changing, which were far more frequently the domain of women: specifically, the domestic spaces of the bourgeois home, private garden, terrace, etc. That these spaces, and the experience of them in modern terms, should be added to our understanding of the space of modernity, even, specifically, the late nineteenth-century space of Parisian urbanism, is indisputable. Pollock thus

changes the shape, and the map, of the space of modernism, while also demonstrating its asymmetry with respect to gender.

Space as location and space as social experience both serve as points of departure for Pollock's investigation of the work of Mary Cassatt and Berthe Morisot. Into her analysis she adds a final element: the discussion of the ways in which women painters' experience of their space(s) can be noted in the differently marked codes of spatial representation. Pollock insists that there are particular responses to the domestic spaces which show up as visual elements in Morisot and Cassatt's paintings—as boundaries, enclosures, demarcations of restraint on movement and experience. Pollock necessarily interprets these in negative terms.[55] In spite of the importance of this argument, the evidence in late nineteenth-century French visual images doesn't support such a clearly binaristic argument about the spaces of gender and the gendering of spatial representation. Because both Morisot and Cassatt were trained in and participated in the production of spatial forms according to conventions of image making which had been part of their training, their way of "looking" is coded by these conventions.[56] The formal values of spatial representation cannot be used as a signature indication of gender. Knowing, for instance, that the painter of Cassatt's *At the Opera* is a woman allows the painting to be read in a way which reconciles the structural elements of depiction with the assumed experience of the painter. But in fact, the picture does not insist upon such a reading a priori, nor invert the normative terms of the processes of objectification central to the activity of conventional representation. In fact, a *woman* is objectified as the central figure, exactly in accord with the norms of male painters' works. The important thematic distinction is that the woman is actively involved in looking, in constructing a social space through her own subject position, and is depicted in this role. The structuring of space around her can be read in reference to this, but the structural means are not themselves gendered.[57]

Pollock's contribution is that she insists on replacing into the discussion of the space of modern life a counterpart to the public, urban space of modernity—namely a private, domestic space. Disproportionate attention to the former has placed the latter in a marginalized position. The fact that it was largely (though not exclu-

sively) in works by women artists that such images occurred had consequences and sources in the process of art historical canonization, another area challenged by Pollock's position. It is demonstrable that these domestic spaces served as subject matter for women artists in disproportionately greater degree than for male artists. In large part this is because these were the spaces of modernity in which women artists felt at ease.[58] That these two—public, urban space and private domestic space—are necessarily interlinked as aspects of modernity is a fact which Pollock's analyses promote. But the relations between codes of depiction and specific locations as gendered is, in Pollock's work, somewhat problematic. At the heart of Pollock's argument, then, is the assumption that this gendered *opposition* may be demonstrated in formal terms within the painting practices of women artists of the time.[59] In this sense, Pollock's binaristic opposition, grounded in a validation of formal elements, falls into problems similar to those of Clark's equally awkward opposition.

Pollock's important point is that there are relations between the representation of space and the symbolic construction of gender, but rather than dividing the spaces of the literal, supposedly real, arena of modern life into masculine and feminine domains, it is important to recognize that degrees of comfort, control and familiarity in those spaces is encoded in and reinforced by those images of Cassatt, Morisot, Degas and others. In this manner the intimate space of (bourgeois) domesticity becomes a complementary space within urban modernity. Extending the space of modernity to include this domain makes a continuum of experience in which both men and women participate, but in which they participate to varying degrees and very differently. Women do function in the space of modernity, and occupy it differently, but they do not find the means of radically changing the modes of representation to indicate this difference: pictorial conventions are not so easily, quickly changed or invented. Instead, then, of reading the space of modernism as only urban, public and one from which women were largely excluded as by a barrier they could only cross as an act of transgression, it seems useful to consider the space of modernism as a continuum from intimate/private/ domestic to urban/public/social experienced by both men and women, but experienced *differently*.[60]

In conclusion, the significance of Pollock's including the domestic space of familial and intimate relations within the description of modernity is twofold: on the one hand it allows for the massive amount of drawings and paintings by Renoir, Cassatt, Morisot, Degas to be included within the discussion of *modernism*, rather than treated as some genre sideshow without historical specificity, and secondly, by this inclusion, *demonstrates* the extent to which the defining terms of modernity necessarily must include attention to changed attitudes toward and depictions of intimate spaces and the relations within them. Characterizing either domain—public or domestic—as gendered male or female, would only reinscribe in critical gloss an oppositional distinction untenable in the face of the pictorial evidence. What the evidence does suggest, not surprisingly, is that women artists tended to take more of their subject matter from the observations of interior spaces, spaces they were more likely to feel comfortable occupying and in which they spent more time. Women artists are more conspicuously the documenters of that space, but it is not their exclusive province, nor, is it the only domain in which they participate.[61] The manner/mode of depiction of these spaces is again *not* markedly different according to the gender of the artist: the image of *Woman Bathing* (1891) by Cassatt is the equal in tenderness, awkwardness and intimacy of the drawing on the same theme by Degas. (figures 3 and 4) The argument that Cassatt has not eroticized her subject, that she inscribes an intimacy without objectification only seems supportable *after* acknowledgment of the gender of the artist. But since authorship was known and itself gender coded, the effect of these representations (both in terms of their thematics of space and the formal structural elements of intimacy, or distance, or surveillance or restraint) was to produce a set of signs which promoted and reified the gendered terms in which the space of modern life was conceptualized in representation.

In the preceding sections, I have been concerned with demonstrating that the critical analysis of the emergence of modernity as a cultural form in nineteenth-century Paris has elided the depiction of the spaces of that environment with particular modes of modernism in painting, specifically, through the use of various strategies of representation. The emphasis upon such depicted space in the work of

late nineteenth-century French painters gradually gave way, in the work of Seurat, Cézanne, and Gauguin in particular, to a primary concern with the activity of depiction, with the *espace* of the canvas, as the signal feature of modernity. This shift increased the sense that the canvas had its own autonomy and that the activity of representation was independent of a relation to observation of the world, the real, or to any referent whatsoever. This sense of autonomy would become the founding principle, firm conviction, of the rhetoric of cubism and early twentieth-century abstraction. By the end of the nineteenth century, the representation of space as a literal place, as the thematically identifiable location of the urban environment, ceased to be considered the major characteristic of modern French painting. Prime place was given, instead, to the abstract concept of *espace* as the delimited domain of representation itself, and this has implications for the use of imagery in its role as a cultural construction.

Specularity, Espace, and Visual Truth

Seurat['s] . . . passion for geometricizing never deserts him— enclosed so completely, so shut off in its partition, that no other relation than a spatial and geometrical one is any longer possible. The syntax of actual life has been broken up and replaced by Seurat's own peculiar syntax with all its strange, remote and unforeseen complications. For these figures have nothing left of the life of the Boulevard.[62]

An increased attention to the activity, *seeing* as that which provided the pleasure in the public spectacle, displaced painters' attention to thematic depictions in the latter decades of the nineteenth century. The thematic attention to the activity of looking and the privileging of a notion of optical truth already flickers through the work of late Impressionism, displacing, or at least challenging, the referential representation of urban modern life. But the primary concerns with light and impression, fugitive effects, and, the distractions of leisure which dominated the work of the Impressionist painters began to change in the work of artists of the last decades of the nineteenth century. The focus on the *space represented* was

gradually reformulated to emphasize the increasing conceptual autonomy of *representational space*, or *espace*. Two painters whose work offers clear evidence of this transition, and its characterization as a step toward the insistent autonomy of the work of the Cubists, though in markedly different ways, are Georges Seurat and Paul Cézanne. In this section I will examine the implications of their work first according to the conventional lineage of its critical reception and then in terms of a strategy of representation. For both of these artists, the "truth in seeing" which they struggle to define through their painting is always evaluated according to what occurs within the limited parameters of the canvas in *its* capacity to produce a visual truth. For Cézanne that truth is grounded in nature as an ideal model; in Seurat, in the very activity of seeing. For both, painting became a space, *espace*, a laboratory of productive investigation and experiment, which had less and less relation to the literal spaces of modern life.

As an intertwining of aesthetics and ideology, this attention to seeing reveals itself as a belief in both the innocent eye and the readable image: Seurat and Cézanne believe that the visual experience is *apparent* and available as if unmediated.[63] That which represents itself as transparent, as the image, will under the claims of scientificity about to be paraded as the standard under which painting marches forward, also claim truth.[64] In terms of representational strategies, such *seeing* will be transferred to a truth in the representational operation of paint, to record the merely and completely optical version of experience. To quote Paul Valery this was: "a truth instituted, if not created, by the effort of criticism, rigor and coordination which is called Science."[65]

A new configuration of deceit emerges with this new version of transparency. The Renaissance window on the world as veritable illusion is displaced by the truth of the surface as image, and, conversely (self-consciously) of image as surface. In art historical convention, this displacement is generally presented in terms of the artists' own emphasis on the literal application of paint.[66] Subsequent to this is the recognition of the autonomy of images: that is, that their primary relation is to other images, not to any supposed real. Seurat announces this attitude in his writing as well as in his work, searching for a systematic regulation of the image: "If, with

the experience of art, I have been able to find scientifically the law of pictorial color, can I not discover an equally logical, scientific, and pictorial system to compose harmoniously the lines of a picture just as I can compose its colors?"[67]

The interest in optical truth which comes to the fore in the work of Seurat repositions the image in relation to the supposed "real" which had traditionally served as the referent. Manet's self-consciousness is considered to have prefigured this change—and thus his place as the first of the "modern" painters. He belied both the tradition of image as convincing illusion and image as representation of the real. By replacing these often mutually exclusive but sometimes overlapping conventions—both dependent upon a leap of faith into the frame of the image to take it on its own terms—Manet shifted attention to the processes and conceits of image making as essential subject matter of the work. But Manet's processes remain those of painting convention: brushwork, light effects, palette, and composition are all still constrained within the rules of image-as-illusion. The work of Seurat, both in its manifest form and in his articulation of a position, radically reworks this representational process. And the space of a *mapped* dimensional modernity becomes the *espace* of painting in a specular mode, concentrating on the activity of vision per se, on the effects and construction of the visual field within the framed domain of the canvas. The recognition of autonomy, of the possibility of self-sufficiency of images within the terms of their own construction, becomes fully realized in Seurat. (figure 5)

This attention to the construction of the surface, to the treatment of the paint at the level of the stroke/dot, and of a carefully controlled compositional strategy: all of these primary elements of Seurat's work support the usual assertion that he divorced his images from the servitude of depiction, and put them instead at the service of an examination of visual truth as the activity of seeing.[68] The points on which the concept of optical truth and the image's self-sufficiency were formulated by Seurat himself occur at the level of color and its application, the determination of harmony in composition, and the use of such devices as the golden section as a basis for visual structure. Both the mapping of the picture plane according to the schematic organization of this ideal form, and the finish

of the surface according to rules of chromatic analysis and rule-bound application of paint, worked to divorce the painting from any relation to the "real" or to the spectacles and spaces of modernity, except through the most superficial record of these spectacles as a motif (*The Circus, The Parade*, etc.).[69] The paintings took their form first and foremost within a graphic and chromatic conception. It was easy therefore to arrive at the conclusion—as many historians and critics did—that they were images first and images of something only incidentally or secondarily. Thus a contemporary of Seurat, Henri-Edmond Cross, wrote the following: "those fragments of nature arranged in a rectangle with more or less perfect taste? And I return to the idea of chromatic harmonies completely invented and established, so to speak, without reference to nature as a point of departure."[70]

The word "nature" carries a loaded value here: Cross uses it to insist on a distinction between the observed forms of natural life (landscape to cityscape) and the phenomena of optical experience to which it is opposed. In fact, natural phenomena as the arena of optical inquiry were a referent for Seurat, but, only insofar as they offered the means for representational experiment. Félix Fénéon, the contemporary critic who helped give definitive form to Seurat's aesthetic wrote of the *Grand Jatte*: "The whole thing: obviously merely a crude description in words: but within the frame, complexly and delicately measured out."[71] Within the frame: this emphasis on the bordering which separates and distinguishes the work from its surroundings, grants it another role than the mimetic, is of prime importance in the recognition of Seurat's manipulation/construction of *espace*, and its place within a rhetoric of representation.

In another essay, Fénéon wrote: "the eye is no longer solicited by anything but the essence of painting."[72] Both formal and theoretical terms are articulated in the painter's process. Seurat makes explicit his project: to close the gap in the spectator between seeing and perceiving, to insure within the terms of the painterly activity, as much as possible, that the stimulation provided results as a particular effect, and that that effect in turn transforms into a particular sensation. The validity of the canvas resided in its capacity to provide this controlled and calculated visual effect, not in its capacity

to record an impression or image. As Jonathan Crary, in *The Techniques of the Observer,* has recently detailed, by the 1840s a theoretical formulation of spectatorship had been developed (in physiology, optics and philosophy) that acknowledged the discrepancy between stimulation and sensation.[73] It was clear that a process of mediation took place within the experience of the sensate subject. This mediation had been the topic of the physiological research to which Seurat had turned for an understanding of the nature of visual experience. John Rewald underscored the interest of Seurat in the work of the "scientist and aesthetician" Charles Henry:[74]

> The course of his researches had permitted Charles Henry to establish a close relationship between esthetic and physiological problems, after he had set out to discover which spatial directions are expressive of pleasure or dynamogeny, and which of pain or inhibition. His findings were that pleasure is associated with an upward direction and with movement from left to right, while the opposite effect is achieved by moving downward or from right to left: intermediary excitations being occasioned by intermediary directions. etc.[75]

Seurat's investment in the rational subordination of the means of visual representation to a systematic investigation was integral to his realization of the potential of the canvas as an abstract space.[76] Seurat's work thus manifests two conspicuous features of modernism: the appearance of a scientificization of technique, or at least, rational basis for painting; and a conceptual basis for consideration of the canvas as an autonomous and abstract space, or *espace.*[77]

While it is certainly appropriate to discuss Seurat in these terms, and to assess the clinically derived character of his programmatic approach to paint, the manner in which this claim to optical/visual truth values participates in the emerging *spectacle* of modernity needs to be reckoned as well.

Seurat believed that there were consistent and dependable relations between visible stimuli and optical responses. Thus he operated upon his canvas with rule-bound restraint. This activity is accompanied by a rhetoric which proclaims a "truth in representing" for Seurat, but claims for other kinds of "truths" in the work of

Cézanne. Seurat's thinking had been sophisticated to an under-standing of the distinction between visual/optical activity and that of the representational surrogate whose means must be carefully controlled (not merely rendered accurate) in order to produce a constructed truth. Cézanne's concern, by contrast, was with an epistemological truth, grounded in his real faith in the presence within nature of very specific and particular absolutes, named, within his practice, as *forms*.

These truth claims participate in an increasing attention to a self-consciousness about painting as a representational practice. It becomes apparent in both Seurat and Cézanne that the image has a function to perform in relation to the supposed truth which moti-vates its production. And that function is, in each case, linked to the standard description of the progression of modern painting in which the requirements of pictorial space come to take precedence over the illusion of represented image.[78] This precedence empha-sized the functional effectiveness of material properties of visual images in their signifying activity. They came to represent the spec-ular activity of visuality as much as its capacity to record or inscribe. Seurat's *Le Cirque* is just such an image: its spaces are described as "shallow"[79] and its technique "tends to ignore depth;"[80] its figures are "dummies"[81] and its events are a pretext for a visual arrangement whose terms are set, not by observation, but by calculation. This traditional assessment, as per the phrases of Fénéon, John Russell, John Rewald and Robert Herbert above, is recast in the writing of critics interested in the cultural activity of visual art. Meyer Schapiro, and more recently, Jonathan Crary, have seen such formal measures as evidence of a rational power of sys-tematic control—an "antirepresentational formal thinking."[82]

Seurat's work can be seen as bringing into being one element of the transition from literal space to autonomous *espace*—the libera-tion of the space of the canvas from the role pictorial mimicry and into its own arena of visual activity. Cézanne, by contrast, demon-strated that paint was a medium uniquely capable of investigating the nature of visual form—through investigation of the visual form of nature. This confusion between process and reference, the truth of seeing and the truth of representing, are at the heart of Cézanne's conceptual strategies.[83] "Cézanne keeps on believing in the integri-

ty of the model."[84] The nature of visual truth which Cézanne kept at the center of his practice was distinctly different from the optical registration on a surface which propelled Seurat, but his contribution to a conceptualization of *espace* forms an important complement to Seurat's work in this discussion.

While Seurat, may be, and has been, put into relation with modernity by reading the content of his images in the referential sense: as images of the spectacle of modern life, his primary investment in verity in *process* quickly overwhelms such a reading. His painting neither needs nor depends upon its referent for its truth value to be sustained: contained within the closed circuit of optical activity of paint to paint and surface to eye and eye to mind. Content serves as vehicle, inverting the relation even as it is structured in as self-consciously referential a painter as Manet. The pointillist record of refraction plays the scientific game, apes the rational processes of laboratory, experiment, controlled conditions so dear to the late nineteenth-century mind. Art elevated itself in the process, not quite recognizing in the moment of that activity what fictions it was partaking of by organizing its own concerns in this manner, the curious conceptual opening into social space to be made by insistence on the ontological status of abstraction. Still fully convinced that science was engaged in truth, the mimicking of scientific method by art allowed artists to believe they too were engaged in pursuit of universal values. On the surface these were taken, as in Seurat's case, to be those of physiology/optics and pigment, and in Cézanne's, a peculiar leap between a belief in the abstract real and a faith in its capacity to be known and for that knowledge to be represented. For Seurat the material properties of pigment were supposedly the obsessive center of his drive to control the registration of sensation through representational means; for Cézanne, the gap between seeing and knowing, between sensation and the truth of nature was what was to be bridged through a reductive and formalized visual technique which propelled the painterly activity into a realm of self-concern only to be equalled in the activity of symbolist painters with which he was contemporary.[85]

Clement Greenberg stated that "Cézanne sacrificed verisimilitude, or correctness, in order to fit drawing and design more explicitly to the rectangular shape of the canvas." [86] Cézanne's place

within the history of modern painting is on the one hand linked to his development of a proto-abstract set of visual forms, the chiseled and reduced geometry of his observations of space and the objects it contains; and on the other, to his intense desire, passion, to, as Roger Fry wrote: of Cézanne's "search for the reality hidden beneath the veil of appearances, this reality which he had to draw forth and render apparent."[87]

The idea that visual images could present a visual truth which was *not* that of appearances, neither a realist record nor the romantic expression of sensation, but a hard, objective and investigated truth is what has allowed Cézanne to be placed so significantly in the mainstream of a transition to abstraction. The visual elements in a landscape by Cézanne (or a portrait or still life for that matter), are equidistant from either the fleeting impressions or the literal, linear naturalism or his predecessors. The arrangement of forms within the frame of the canvas, the passages of color tone to sculpt space, not objects, are articulated with an intense commitment to register the ideal, not apparent, forms of nature, and to make an image whose formalism is of the same order.[88] (figure 6)

The recognition of the picture plane as the fact of the image, as its actuality, rather than as its mere premise, is what makes the formal passages in the landscape into elements of that *espace* which is self-referentially constructed rather than determined by the visual referent from which it is derived. There is a gap in Cézanne's conception, between the reality of the landscape and the reality of the painting into which, conventionally, painters had put either the reality of appearance, pictorial conventions, or optical impression: for Cézanne these are all in the way, they are the distracting trivia which get in the way of *knowing*. Because for Cézanne, painting is a form of knowing, the image is knowledge: one in which the *espace* of the canvas can construct and reveal through visual means something which is not ever apparent merely to the eye: "painting should not represent the manifold appearance of reality, but rather should correspond to an essential quality evoked in the unity of the pictorial composition."[89] Cézanne stops short of making explicit the effect of this position on a cultural theory of knowledge and on the status of representations in such a theory given his assertions.

The concept of representation as autonomous from visual obser-

vation is a major theme in the formalist analyses posed by Roger Fry, Clive Bell, and, later, Clement Greenberg.[90] It begs the question of Cézanne's original relation to abstraction within painting to cite Greenberg's assertion that: "Cézanne's desire . . . was . . . the configuration of the picture as an object—a flat surface."[91]

But the work of Cézanne offers itself to such an analysis by virtue of his own assertions, those which struggle with the relation between compositional, formal devices which are properly the elements of the image and his grasp of the essence of nature, which always served him as both model and mentor—as source for forms and process. The model was there, but the transformation was what granted painting its integrity and autonomy, and permitted painting's conceptual function to become more distinctly defined than previously. Insofar as painting was always a conceptual *espace*, a cultural domain in its own right, it had veiled that through mimetic or representational and referential activity. Dispensing with that baggage, it began to act through its function, its operation, as an ideological formation in its own right.

The final, important paradox of faith in optical truth or truth which is only representable (and knowable) in visual form, is that it links the image to the "real" as a referent. While asserting that this is the true "image of" that referent, it is also proof positive of the activity of the spectacle. For an image which gains its verity according to its mode of production participates first and foremost in the asserting the visual as a *primary* activity. This claim to visual image as primary site dismisses any possibility of even *conceiving* of the image as a reproduction or surrogate for a visual experience already in existence outside of the frame of the picture's production.[92] The images thus created, be they postimpressionist canvases or early abstraction, bring visual material into being which then, secondarily, circulates within the larger framework of the cultural spectacle, making a unique contribution as *images* whose function and visual information are not duplicated elsewhere.

Such an image is in no way subordinate, according to hierarchies of either form or substance, to any other visual experience. Furthermore, such images reify, that is, bring into objective and concrete visual form, that which otherwise passes ephemerally through the culture as lived, but *unrepresented*, experience.

The concept of *espace* thus serves to expand the notion of the space of modernity beyond the literal, into the conceptual domain in which knowledge and experience of modern life may be presented and understood through visual means. This expansion was a feature of painting, demonstrated by the increased attention to the space of the canvas, and of the theoretical writings which struggled to articulate a foundation for abstraction in the latter decades of the nineteenth century. By assigning to representation a role in assessing visual truth which could not be filled by mere perception, both Seurat and Cézanne had granted the *espace* of the painted canvas a distinctly autonomous identity. In the early twentieth century the concept of autonomy would assert itself with ever greater clarity and vigor.

Cubism and the Specular Surface and the Visual Sign

"Furthermore, collage was the logical outcome of the Cubists' conception of their works as self-contained, constructed objects."[93]

Picasso's *Still Life with Chair Caning* is generally cited as the first cubist collage.[94] (figure 7) The work provides the material elements which serve as the basis of theoretical and conceptual possibilities unimagined within the well-articulated *espace* of the work of Cézanne or Seurat. These are conventionally identified in Picasso's work with its obvious attention to painterly surface, spatial fragmentation, visual investigations, mass-produced materials and challenges to illusionism—all the characteristic features which mark Cubism as conceptually distinct from its precedents. Both in terms of the treatment of surface and of the function of visual signs, cubist paintings and collage embody premises which were simultaneously expressed in a critical rhetoric asserting the autonomy of the image. The reviewing of this critical assessment here is oriented toward exposing the implications of the cubist assertion of autonomy.

While Cubism engaged with the concerns of postimpressionism—calling attention to the surface and frame of the canvas, and the visible, physical, optical properties of paint and form—it took a quantum leap beyond this position by extending Seurat's optical

truth and Cézanne's epistemological project into an even greater separation between referent and image. While the rhetoric of autonomy which first emerged in the writings of Pierre Reverdy, Guillaume Apollinaire, Albert Gleizes, and Jean Metzinger (to list only the few most prominent critics) was meant to support painterly work as well as collage, it was, arguably, in collage work that the challenge to illusion and the possibility of the image's full participation in modern culture as a thing in itself (rather than a representation) was carried out.

Still Life with Chair Caning, for instance, attempts to present itself as both a real object and an image, thus straddling the line between representation as referential and as fully autonomous. As an object, *Still Life with Chair Caning* participates directly in the spectacle of modernity, rather than merely recording a spectacle played out in the spaces of modern life. The character of the change from image to object, from representation to autonomous thing, is registered in the arena of the visual arts in these cubist works. They propose a distinct rupture between referent and image, which, in the *Still Life with Chair Caning*, is guaranteed as much by the rope frame as by the visual elements which it surrounds. For while the lemon, glass, scallop shell and even table top are all visible by virtue of their painted existence, the rope exists as such. It is its own referent, while still carrying many associative and signifying values. Nonetheless, the formal particulars of cubist painting—fragmentation of the visual forms into small, signlike elements, the multiple points of view, simultaneous images of movement through space and time of observation—are all coded into critical writing as elements of a *presentational*, rather than representational, visual mode. It is on the basis of these formal elements, as much as on the more evident claims of collage, that the terms of autonomy were put forth for cubist painting. The never-true aspect of this autonomy has to be addressed, and will be, but the mythic effectiveness of the claim has been strong from the very outset. Apollinaire, in 1912–13: "Let the picture imitate nothing";[95] and Georges Braque, in 1917: "The goal is not to be concerned with the reconstitution of an anecdotal fact, but with consititution of a pictorial fact."[96]

The assessment of the cubist transformation of illusionistic space can be traced to the work of later critics Greenberg: "so the Cubist counterrevolution eventuated in a kind of painting flatter than anything Western art has seen since before Cimabue—so flat, indeed, that it could hardly contain recognizable images";[97] and Max Kozloff: "We can accept the received idea that Braque and Picasso broke with the long-lived Renaissance notion of the painting as a window";[98] and John Berger: "Cubism broke the illusionist three-dimensional space which had existed in painting since the Renaissance."[99]

The aim of Apollinaire and Braque was to position cubist works within modern life on terms of equality with other objects, and, even, as in Apollinaire's insistent statements about Picasso, assert that images were primary, rather than secondary, in the formation of contemporary existence: "The great revolution of the arts, which he achieved almost unaided, was to make the world his new representation of it."[100]

Cubism plays a major part in the reifying rhetoric of the image-in-its-own-right which dominates early twentieth-century modern art which is nourished by both symbolist and postimpressionist doctrines vis-à-vis painting practice. In retrospect, it is more clear the extent to which cubist work—both painting and collage—combined the relation between scene/seen which was the focus of the painter of modern life in mid nineteenth-century terms and also at work in the concept of visual *espace*. *Still Life with Chair Caning* makes use of "real" elements to stage its claim to the status of an object, but the surface play of the painting within the collage has a far more profound significance than its quasi (and disputable) so-called rejection of illusionistic space. It allows the painted signs to function as primary, and without apology, with their own, undeniable, materiality. The rejection of reference as a *necessary* verification permits the image to function with privileged autonomy as the arena for the circulation of cultural signs. The painted elements interact with the mass-produced element of the oil cloth, itself "real" but carrying an illusion—it is present both as patterned cloth and as image of chair caning—in a game of signification. The vestiges of a referent (and of conventional pictorial depth)—the cafe table—are reduced to a play of signs whose readability does not

depend upon their arrangement within the conventional space of illusion, but upon their currency within the social domain from which they are derived.

The point is that the collage is both an image of contemporary life and a participant in it: the activity of and within the visual image is concerned with the circulation of information in visual form—rather than about the representation *of* anything in conventional pictorial terms. The old concept of a representational analogue to visual experience was jettisoned—not for a fully "real" object, but for an image which could circulate as an object (painting/collage) while challenging the visual status of illusion. Painting/collage were to be on their own terms, constructed according to their own "inner harmonies" and rules—and without relation to the external "truth" which was so important to both Seurat and Cézanne. Picasso stated, "We all know that Art is not truth."[101] And Daniel Kahnweiler: "Now the rhythmization necessary for the coordination of the individual parts into the unity of the work can take place without producing disturbing distortions, since the object in effect is no longer 'present' in the painting, that is, since it does not have the least resemblance to actuality.[102]

Thus the image has become an original, not reflective, site for circulation of information, for the activity of reification (concretization of the image of modern life) within its operation as a cultural domain. The *Still Life with Chair Caning*, then, *is* the place in which the image of experience is made—as the condensed field of fragments of real things, mass produced material, and still life painting in fragmented, newly conceived spatial terms.

However, Cubism's bid to *be*, not represent, its presentational rhetoric, so clear in the critical writing of Braque and Apollinaire, was in no way merely a bid for visual images to smack their flat surfaces up against the picture plane and collapse the illusionistic window with the frame. This rhetoric contained the assertion that a realm of visual arts activity is the primary, necessary, and in fact, *only* realm in which a particular activity, that of reification, can effectively function. The theoretical understanding of this activity was already present in practice as its critical apprehension began to take form in, for instance, the analysis of Albert Gleizes and Jean Metzinger in their crucial 1912 essay "Cubism."

> Above all, let no one be decoyed by the appearance of objectivity with which many imprudent artists endow their pictures. There are no direct means of valuing the processes by which the relations between the world and the thought of the artist are rendered perceptible to us. The fact commonly invoked, that we find in a painting the familiar characteristics which form its motive, proves nothing at all. . . . Torn from natural space, they have entered a different kind of space.[103]

The space Gleizes and Metzinger go on to describe is pictorial, self-sufficient, and elaborated by means both visual and tactile, motor and material. With continual emphasis on what they term the "plastic" qualities of the construction, they undercut the value of the illusionstic transformations of cubist practice, in favor of the in-itself value of the image as productive, a position which finds clearer articulation in the succinct phraseology of Apollinaire: "Cubism differs from the old schools of painting in that it aims, not at an art of imitation, but at an art of conception, which tends to rise to the height of creation."[104]

These statements can only be supported by the visual images if an image like *Still Life with Chair Caning* is taken in its entirety: that is, if it is not looked into, but looked at, seen as the whole and bounded object which it most emphatically is. Is it possible to extend this argument even further and argue that in cubist practice there is a recognition of the role of image as it would be later formulated by Guy Debord? In such a formulation, the standard critical assessment of Cubism, in which the image comes to stand in equal relation to the real, would be only a half measure. Do cubist images in fact come to displace the real, take its place?

Cubism does not merely demonstrate once and for all that images were mere fictions in their claims to represent the real, Cubism disposes of the real itself and shows it to be only and always available *as* representation. If so, the *Still Life with Chair Caning* is no longer just the most contemporary assertion of the terms on which the cafe table should be understood, and not, either, merely a bid for the image to exist as an object. Instead, Cubism must be seen as participating in a conception of modernity in which representation takes on the properties and ontological characteristics of

the real. In that case, the real disappears under the demonstration that it is not and cannot be other than representation.

It is with this gesture that the collage works of Cubism, the *Still Life with Chair Caning* and many other still life collages produced by Braque and Picasso in the early 1910s, assert their full force. So enormous is this claim that it disguises itself as banality, the stuff of ordinary life, for in fact, it is there, in the ordinary, the quotidian, that this interpellation of representation makes its most aggressive gesture. The operatic fictions of romanticism, classicism, even the mythic fairy tales of symbolism, all distanced themselves from the force of banality—for it is when the image serves as the site of daily reality, of ordinary life, passing as merely and only the stuff of trans-parent registration of lived experience, that it may most fully make good on its bid to displace the real. The force of the ordinary, in its capacity to make itself believable, poses more difficult challenges to the "real" than the bid to be extraordinary. So long as an image is exotic it can be dismissed as a fiction; when it becomes the ordi-nary, it functions as the simulation of the real, slipping in its surro-gate with colossal force so brazen it conceals the enormity of impli-cations by masquerading as insignificance.

There is certainly enough room in the rhetoric of Apollinaire and Braque and others to allow this concept of displacement to slip in. In that case, the *Still Life with Chair Caning* presents the new dimension of the real, not a new illusion. The rope frame which carves out the new space of actual existence renders the collage ontologically distinct in every sense from the painterly work which has preceded it. The *Still Life with Chair Caning* image delimits a new space as literally as if it were an invention of real estate. This new space is both physical and conceptual, the space of an image existing without referent and in-itself and thus being simultaneous-ly the thing and its representation. The effect of this is to push the function of the image into a social role it had, in some sense, always had, but had not had the conceptual framework to insist upon: to *be* and as such, to establish the circulatory parameters of the real as a domain of representation. The use of the ordinary materials and imagery of ordinary life intensifies the marking of this changed stature, since the very (supposed) banality of the contents is what

lets the image pass for real, become a site otherwise nonexistent. More significantly, these works emphatically signal the intensified role of image as a cultural space existing in visual form without any derivative relation to the real. It is this *espace*—in which modern life is understood only in terms of its signs—which Cubism most distinctly helps bring into being within the domain of art activity— an *espace* for which the feuilleton and illustrated papers of the nineteenth century had already laid the groundwork. It is the irrefutably nonmimetic abstraction of Cubism, however, which sustains an assertion of total autonomy essential to reformulating the high art basis for representational strategies. This does not repeat the autonomy of Greenbergian formalism, which is merely a fictive refusal to recognize the social space within which the image operates and the ideological information encoded within all representational practices, but approaches the autonomy of Baudrillard's simulacrum as the site of all experience. As in no "real" space may the letters "J-O-U" of the newspaper's title intertwine with the rays of light and edges of napkin, ashtray, and cup with such abandonment of rules of physical form, so does the image come into being as its own new space of the real in that *espace* which was once merely assumed to be an illusionistic surface.

Spectacle and Simulacrum

Guy Debord's concept of the society of the spectacle proposed a model of culture in which the space of lived experience (both literal and abstract) collapsed into image: "Everything that was directly lived has moved into a representation."[105]

Working in the urban environment of Paris which in another form and moment had served to produce the notion of representation of modern life through a representation of its spaces, the work of Debord and the Situationists struggled with a reformulation of the same issue: what model of contemporary culture could be proposed which described that culture in terms of the effective function of representation. The primacy accorded to representation in the society of the spectacle derives from Debord's assessment of the degree to which advanced capitalism has developed a condition in which life is lived in, through, and as representation. The work of Guy Debord

demonstrated that the earlier tendency within modernism—toward assertion of the image as a domain, even *the* domain, of the real—could now be more clearly apprehended and more clearly stated than had previously been the case. In this section the work of Jasper Johns and Robert Rauschenberg will be examined in relation to the propositions of Guy Debord with which their early work was contemporary. As artists, both Johns and Rauschenberg are transitional figures, making initial gestures which lead from abstraction toward pop; they signal the demise of the development of a formal, reductive trajectory of modern art as abstraction.

Debord's model of culture suggests that the line between representation and lived experience is effaced, rendered invisible. He insisted that the concept of the spectacle was not a description of "an abuse of the world of vision," or images but was instead a description of the condition of advanced capitalist culture in which economic relations become manifest as representations. It was, in fact, "the main production of present-day society," and presented a false image of unity or totality of that condition. The role of image in the society of the spectacle was primary: image is spectacle, spectacle is image, and a cultural life lived through representation itself represented the contradictions and ideological labyrinths of commodity culture. "The spectacle is capital to such a degree of accumulation that it becomes an image."[106]

The relevance of such concepts to the work of both Johns and Rauschenberg derives in large part from an analysis of the strategies of representation evident in their work in the mid to late 1950s. Both artists are clearly involved with making use of the images of mainstream commodity (American) culture and with trying to understand, in visual terms, the function of these images—and the means of their effectiveness.[107] Both build upon the concept of autonomous space of the image which had by that point become a banal fact of abstraction, and used the *espace* of the canvas to interrogate that autonomy. In so doing, they both offered profound critiques of the manner in which the presumed autonomy of modern art had come to be assured in fine arts practice and criticism—and the social role which such work performed in a culture where such images were, supposedly, above the fray of ideological activity.

Johns and Rauschenberg have very different means and distinct-

ly different ends. One conspicuous feature of this is the unique formulation each creates for the spatial strategies through which they pose the relation between image and representation. For instance, in a work like *Flag*, Johns is perceived to collapse the representation with itself, the image with its medium, the object with its image. (figure 8) In taking as his subject icons which have no possible form beyond that in which they are rendered—the flag and targets—Johns eliminates all space from the image. This gesture goes way beyond the Cubist struggle with spatial depiction, borrowing, instead, from the formal devices of abstract expressionist elimination of space. The layered Cubist collage still life retained all manner of signs of the depiction of space even if it broke with the Renaissance conventions of its illusionistic rendering, while the expressionist canvases were concerned entirely with space as an a nonreferential abstraction. Going farther, the icon images of Johns thus show the image to be a thing in circulation, to be the currency of informational exchange and not its vehicle.[108]

Johns' *Flag* functions as both a sign and as the thing signified: it is both representation and object. While this possiblity flickered across the Cubist consciousness, manifest in the *Still Life with Chair Caning* and other collages, it had disappeared again in the wave of the more conventional (if visually rich) works which had followed those early investigations.[109] The conceptual promise of that period of collage experiment is fulfilled in the work of Johns and Rauschenberg. In their work the notion of spectacle comes to full realization in visual arts practice: for there is no longer any recording of a physical space, nor even of a representational surrogate for experience, instead, the image is the place in which the spectacle occurs: is its means, its suggestion, its fulfillment. Johns' flags, for instance, mediate, in precisely the manner described by Debord: "Spectacle is not a collection of images, but a social relation among people mediated by images."[110] Johns' work signs that relation, demonstrates the existence of the spectacle while being its effective means. "I am interested in things that suggest the world, rather than suggest the personality. I'm interested in things which suggest things which *are*."[111]

The elimination of space *in* the image is the sign of the operation of the image in another space entirely, that of the social domain in

which it functions to produce and reproduce the signs through which social relations are fixed, determined, produced and reproduced.[112]

In a similar manner, though with very different means, Rauschenberg's collage works circulate the produced materials of spectacle in a virtual *espace*. Producing this *espace* as the field of the canvas onto which elements and images are literally laid, Rauschenberg creates a field which replicates the arena of the social, the domain in which images function to mediate experience as representations.

Rauschenberg's work, like that of Johns, bears no stylistic relation to the manipulated collage elements of Cubism. It is closer to the appropriative strategies of Dada with the political operation of demonstrating the social reality made in and through image production. But it is also the extreme extension and intensification of the cubist project of putting images in place in the social order as real.

In *Reservoir*, to take a lesser known example to prove the norm of his work, Rauschenberg established the parameters of artistic autonomy and function with elements whose obvious banality pushed them out of the realm of personal, artistic idiosyncrasy: two mass-produced clocks. (figure 9) These clocks, set at the time the work was begun and the time it ended, can't even tell the "truth" of that temporal extension. We have no way of knowing how they relate to the recorded passage or real time—a.m. or p.m. of the same or different days. The work represents a moment of personal activity, carved out from social domain, a reservoir of time. But the image provides few other particulars—it represents a painting or artwork and is a painting/work—it can both be and represent the way visual images produced by artists function as specially demarcated objects. It has in common with Rauschenberg's other work—the more personal *Charlene*, for instance, and the silk-screen paintings of the late 1950s and early 1960s—the feeling that the diaristic has turned journalistic and neutral. The "personal" is just the zone demarcated—like the reservoir of time—within the larger shared field of social experience. Rauschenberg's appropriative procedures document the reification of social relations in images.

Both Johns and Rauschenberg manifest the shift to a role for the artist in the society of the spectacle.

The spectacle depends upon and is produced through the image, an image which serves a crucial function for the real conditions with which it stands in relation. The notion of the "real" which is invoked in such an operation differs profoundly from the real of mimetic illusion based on optical sensations, proportions, colors and forms. The real which Guy Debord implies as the foundation for the spectacle resides in the structuring relations of power in economic terms. These are continually reproduced through the fictive—but effective—function of "images" of the produced "spectacle." Johns' play with the flag as such an image, blankfaced in his presentation of it, rejecting any ready fixing of a value in the reading by his insistent refusal of marked inflection of the image, calls attention to the ambiguity of its cultural function. Behind the flag, below it, underneath its painted surface, were the pages of newsprint onto which Johns had superimposed the hand-worked image of the icon. The sense of seepage, of the concealed under the overtly stated, plays its part here in an anti-idealist manner: the discourse of the newsprint is not universal, transcendent or perfect, but is the stuff of exchange, another level of the spectacle, created for consumption, not for disclosure. But the device of showing concealment and its operations in Johns' piece makes it an image concerned with the structural operation of the spectacle. Rauschenberg's surfaces and combines, flatbeds and transfer works, montage the heterogeneity of his experience into a space irreducible to any unity of value or meaning. They do not so much reflect the spectacle, as participate in it, showing Rauschenberg's only integrated and inextricable relation to this activity is the production of his own subject position. His image, in both expressive and identificatory terms, is made through this body of mass produced material, selected, collaged, transferred and combined.

Mass culture was already being sharply critiqued in critical theory in the immediate postwar period; the work of Johns and Rauschenberg undercut such critiques, even if unaware of them, by using the very materials of mass production to demonstrate and explore the nature of the spectacle.[113] It is not by reverting to the resistant and esoteric forms of an outmoded avant-garde that

Rauschenberg and Johns participate in the contemporary investigation of the spectacle, but by engaging with its means: by showing the degree to which the "world" was being produced only and exhaustively as image:

> The spectacle is the existing order's uninterrupted discourse about itself, its laudatory monologue. It is the self-portrait of power in the epoch of its totalitarian management of the conditions of existence. The fetishistic, purely objective appearance of spectacular relations conceals the fact that they are relations among men and classes.[114]

Both Johns and Rauschenberg still play with images, with identifiable elements of visual information readable for their iconic value as well as for their place within the circuitry of information/reification essential to the operation of the spectacle.

The push beyond that iconic realm adds a final layer of masking to the elaborate apparatus, a push which coincides in the convergence between Jean Baudrillard and Peter Halley. Debord was committed to a faith in the usefulness of articulating a political project for the sake of some actual change in lived conditions and social structure. Debord's description of the society of the spectacle contains a distinct and implicit cry for recognition of the state of things, for some intervention or at least consciousness about the "spectacle," that condition in which "the commodity has attained total occupation of social life." Baudrillard's concept of the simulacrum, however, will bear no strain of such interventionist or activist rhetoric. The simulacrum represents (and is) the condition of spectacle having achieved a degree of fictive unity within representation which is so complete as to be seamless, nightmarishly effective in its synthetic concealment.

The empty canvases and seamless fabrications of minimalism, standing as they do as the vacant signs of the commodity status of art, their capacity to be and be traded as such without any content but the value they are able to command as exchange was in some sense the end point of a certain formalist investigation of modernity. As Francis Frascina notes: "Modernism is an ideology which systematically misrepresents the real relations between the meaning of art and its practices and how and why works of art are and were produced."[115] But the formalism which returns in the work of Peter

Halley is of another order. The geometry of his cells has nothing in common with the hard edges of either Malevich's suprematism or Albers' abstraction or Stella's flat organizations of rigid space (though the strongest connection would be with Stella, and could be investigated in Stella's own interesting posture). Instead, Halley's work attempts to construct the isolated, unreal space of the simulacrum.

> The simulacrum is a place "where the real is confused with the model"; it is a "total universe of the norm," a "digital space," a "luminous field of the code." In my work, space is considered as just such a digital field in which are situated "cells" with simulated stucco texture from which flow irradiated "conduits." This space is akin to the simulated space of the videogame, of the microchip, and of the office tower—a space that is not a specific reality, but rather a model of the "cellular space" on which "cyberneticized social exchange" is based, which "irradiates the social body with its operational circuits."[116]

Halley has his reservations about the wholesale embrace of simulacral activity: "one wonders if such an endorsement is desirable."[117] Nonetheless, he allows his images to become, finally, the space of information as such, showing the image to function as the sight/site of informational configuration, both metaphorically and formally. He demonstrates that configured circuits are visually real, newly formed and regulated circuits, pathways, information routes, connections and interchanges. Here information is reduced to an inscription of relations and exchanges, as possibilities for such, and the image functions as a simulation of that realm. And the realm itself is all already simulacral, without anything but the pulse of surrogation running through its wires and conductors. This is the realm of simulation, not of spectacle. The scene/seen has become the unseen, unseeable, the represented has no grounding anywhere in any real, which has been completely undone. No longer having any premise on which to be represented, the real vanishes from view, and thus, from the presumed, presumptuous pretense to existence. Whether the work of Halley is evidence of a cultural condition or merely a symptom of a stylistic development in contemporary art remains to be seen. But the fit between his work and Baudrillard's

proposals neatly formulate a postmodern concept of simulacral space and its existence as representation.

Baudrillard's scheme of steps by which representation is transformed into simulation involves an emptying out of any possibility for the real to preexist its image until, ultimately, he asserts, there is no real at all, only its simulacrum:

> Whereas representation tries to absorb simulation by interpreting it as false representation, simulation envelops the whole edifice of representation as itself a simulacrum.
>
> This would be the successive phases of the image:—it is the reflection of a basic reality,—it masks and perverts a basic reality,— it masks the *absence* of a basic reality,—it bears no relation to any reality whatever, it is its own basic reality.[118]

While this has pointed relations to the cultural analysis of images, it is not, as Peter Halley points out, Baudrillard's intention to prescribe or describe the condition of art:

> In recent years it's become apparent that Baudrillard doesn't have much interest in the visual arts as we understand them, but that doesn't bother me at all. He's interested in what's going on visually and spatially in our culture, and that's what I'm interested in as well.[119]

Image, in fact, has such primacy in Baudrillard's work, that the issue of art per se is a moot point. Baudrillard's simulacrum presents itself as primarily a theoretical model, one which by its very capacity to come into being suggests a conception of the social space of experience. Baudrillard stops short of asserting that this model should be accepted as true, real, or universal in its capacity to accurately portray the condition of contemporary existence.

But in the trajectory of modernity, the path by which the progression of terms relates to the development of visual arts practices, a lineage may be suggestively represented in these parallels: from the mapping of space in Manet/Guys/Morisot and the desire for an image of modern life as that which is lived out in the spectacle of urbanity (public and private), through a process in which that *space* is replaced by *espace*, virtual and visual, to an engaging of the image in its social role as site and sign of the spectacle. It remains

to be seen, indeed, whether the spectacle retains its viability in the face of that simulacrum so ready, so willing, to close the circuit of exchange into a vacuum of complete self-referentiality, or whether the operation of images within a social domain can reinvent the space in which some active investigation of the operations of the spectacle may be carried out. The neatness of this sequence— space, *espace*, specularity, spectacle, simulacrum—should not serve to foster a belief in the tautological inevitability of this progression. Rather, it should prompt an inquiry: to ask in what manner and by what means the all too perfect operation of the critical machinery which slides along this track may be derailed by the active agency of images engaged in the processes of intervention— or whether the possibility of a critical practice in images is precluded by the simulacrum.

In this chapter I have been intent on interweaving the art historical discussion of the space of modernity in visual images and the conception of space as a representational activity. My assertion is that the concept of space as the place in which modernity occurs has changed fundamentally in critical thinking in the last century and a half. The space of modernity conceived by Baudelaire as literal— urban, dense, available for movement and surveillance—became transformed into an abstraction and then a simulation. Representation, which initially served to record both that space and the phenomenological sensations of experiencing it, has come to be conceived as the primary space of cultural activity. These changes occurred largely in the field of critical writing, but, they can be mapped in the field of artistic practice as well where the function of representation—*of* that space and then, *as* that space—has also been the subject of these critical transformations. The reasons for this have as much to do with the interaction of artistic practice and criticism in the culture of modernism as they do with any claims I would make for cultural paradigms. Whether culture changes, or whether we merely arrive at new ways of conceptualizing its forms and activities, the evident fact is that there is a noticeable transformation in the theoretical descriptions according to which we experience the space of modern life through the conceptual terms of representation.

THREE

The Ontology of the Object

The link between formalist criticism and modernism in the visual arts was so strongly articulated throughout the first half of the twentieth century that the two came to be perceived as almost interchangeable terms.[1] This was particularly true in the lineage traced in work of key figures like Alfred Barr, Clement Greenberg, and Michel Seuphor, whose writings attempted to systematically code the history of modern art in terms of formal and stylistic analyses. For these authors, and many who took their writings as a premise and foundation, modernism simply *was* the history of the development of self-referential and self-critical abstraction—leading to the grid and the monochrome field as ultimate end points.

This reductive and unsupportable view of modernism has been qualified and relativized—both by the research on new materials which demonstrate the truly heterogeneous nature of the field of modern visual art and also by opening up the terms on which the history and critical assessment of modernism are based.[2] The history of modernism is no longer taken to be one and the same with the history of abstraction or any other stylistic innovation.[3] Visual art that is representational, figurative, historical, or allegorical exists in

abundance, along with crafts, popular culture imagery, mass culture productions, and the works of artists well outside the mainstream. More significantly, most of this work cannot be contained within the conceptual premises of a formalist approach and the rewriting of the canonical history of modernism has offered a challenge to the basis on which art objects enter into the dynamic of interpretation.

Nonetheless, one feature of the formalist position which frequently persists in even radically anticanonical work is the belief that a work of art is equivalent to its status as an object. This is the idea that a painting or sculpture provides significance on account of its formal values, even if such consideration attempts to assess the value of those formal elements in terms of a cultural and ideologically charged context rather than according to the phenomenologically based models of earlier, less politically aware critics. The conceptual feature that unites these models (formalist analysis, cultural criticism in its apprehension of the art object as social form) is the belief that formal values are *self-evident*. Such a position is grounded in an empirical concept of the object, as an object, and in an unquestioned belief in the sensory apparatus as the reliable means of perceiving the object. Again, such positions have come under serious challenge from poststructuralist criticism which counters the rhetoric of formalism with a rhetoric asserting a dynamic process of construction of the ontology of the object.[4]

In this chapter I trace the development of the underlying premises of the formalist position in art historical discussions of modernism, beginning with the backward glances cast by later writers onto the work of Manet, whose canvases are repeatedly cited as the founding instances of self-referential visual form. The first full-blown articulation of a formalist stance, however, occurs in the work of the English aestheticists, Clive Bell and Roger Fry, for whom Paul Cézanne is the seminal figure. Various critics and theorists who were involved in the development of abstraction voiced a concern for the self-sufficiency of visual means, within so-called Orphic Cubism, Russian Suprematism, Neoplasticism in the work of a wide range of individual artists. The codification of these positions within historical accounts, specifically those of Greenberg and Barr, had a profound, even prescriptive effect on the produc-

tion of both criticism and visual arts practice after 1940. More recently, the deconstructive methodologies of, especially, Jacques Derrida have challenged the premise of visual apparency or self-sufficiency, and offer a contingent, contextual approach to interpretation.

The focus of this chapter is not the history of abstraction, but the foundation and subsequent transformation of formalist criticism. My intention is to examine fundamental assumptions about the identity of the visual image—especially as it is conceived with respect to its material existence—and then follow the development of the more complexly defined ontology (or conceptual premise for the identity of the art object). The review of twentieth-century critical literature leads inevitably from questions of formalism within the image to questions of the way the frame is assumed to bound and contain the image and grant it defining identity. This assumption found its strongest platform within the rhetoric developed to justify and explain abstraction—which was intent on establishing a basis for a visual mode which did not depend upon anything outside the picture plane. This basis downplays the historical and aesthetic circumstances of production and reception in the name of universal visual forms. This formalist stance is not merely refined and qualified by a deconstructive investigation, it disintegrates in the face of contingencies whose repression were essential to its function. The means by which a visual object obtains value, the very basis of its ontological status, are so integral to historical process, that the deconstruction of such means necessarily challenges the very basis of the formalist position. That formalism as such, the presumed visual self-sufficiency of the object, was itself a historically specific and ideologically coded formation, is the recognition that undermines its absolute and universal approach to visual form.

The assumption about the material self-sufficiency of an object of visual art which underlies the formalist aesthetic is deceptively simple, since it collapses an idea of visual perception and ontological status. The very assertion according to which a visual work is granted its identity as *extant*, as bounded, bordered, and discrete, proposes an equivalence between material autonomy and ontological completeness: what you *see* is what there *is*—and the "is" qual-

ity, the very being of the object, is thus, rather tautologically, equated with its apparent visual form (even when this quality of being is inserted into an ideological frame and the values assigned to the formal object are to be culturally coded, the assumptions about the object's apparency frequently remain).

The development of the notion of critical autonomy as ontological completeness within a turn-of-the-century aesthetics led to the development of a set of rules for apprehension of the aesthetic object. Early twentieth-century theorists of visual form believed that analysis of the interplay of formal elements within an image could be ascribed the same kind of systematic character which was, at that point, being ascribed to linguistic modes of representation. The linguistic analogy and the development of formalist aesthetics are intimately connected; both stem from an empiricist bias in the ordering of perceptual experience which is in turn coupled to a belief in the self-contained nature of representational systems.[5] The formalist character ascribed to the elements of the image was confused with the enunciation of these elements within a limited, finite system: the sense that the image *was* its so-called *forms* was easily taken for granted, and then came to be reductively inscribed not only within the tradition of formalist criticism, but within modern art history generally as a basis for interpretation (and production) of works of art.

The origins of the formalist position can be traced to the late nineteenth-century concern with the painterly surface. The sense that the canvas was a material fact was invoked to resist the illusionistic transparency of representation focused in an increasingly self-conscious attention on the formal, physical, optical character of that materiality. Supersaturated colors and investment in the capacity of color to function as a sign of the "intangible" and "mysterious" permeated the paintings of the Symbolists, especially Paul Gauguin and Odilon Redon.[6] However, the language which emerged in criticism—of Maurice Denis or Stéphane Mallarmé—to recognize and articulate this operation in no way discounted or legislated against recognizable imagery or the play of reference outside the image. Such a narrowing in the rhetoric of abstraction developed later, within the twin frames of a pseudoscientific vocabulary (mechanistic, technical, and supposedly empirical)

and that of a mystical faith in the inherent and transcendent value of form—the two tendencies aptly represented in the work of Kandinsky.

This formalism within the frame was complemented by and supported the formalism of the object as such. And a critical rhetoric emerged whose investment in the autonomy of the work in physical and sociological terms went unexamined. This rhetoric became increasingly reductive, smoothing over and denying challenges, inconsistencies, and contradictions by the mid-century modernists claiming this earlier work as forerunner. The internal richness of the formalist line belies its later fate, but not its fundamental assumptions. These are countered only in the strategies of a deconstructive methodology whose premises emerge from rethinking the metaphysical biases of the binarism which permitted the delimiting boundaries of an object and the establishment of its discrete entity from its surrounds to pass as natural.

Early Formalism and "Flatness": Manet

"Manet's paintings became the first Modernist ones by virtue of the frankness with which they declared the surfaces on which they were painted."[7] Thus did Clement Greenberg establish Manet's works, particularly citing the *Olympia*, as the initiating instance of self-referential formal flatness.[8] The genealogy of modernity may well, in specific and significant ways, be traced to the radical break with academicism signaled by Manet. But the self-conscious attention to the picture plane, which Greenberg names as the foundation of modern sensibility, is not the term on which Manet's work achieved either its condemnation or its validation by contemporary critics or the artists who returned to his canvases as continual source of visual information. Manet's position in this supposed lineage of self-referential positions is reinforced by the anthologized excerpts of critics and historians who make his canvases seem to have, inevitably, initiated this self-referential activity as a defining/founding term of modern visual art. Zola, Mallarmé, and Dennis are used as contemporary examples who are in turn anthologized precisely because they seemed to recognize in Manet the very

qualities on which later historians—Greenberg, Barr, Seuphor—could ground their own historical models of the modern tradition.

Emile Zola, writing in 1867, neatly articulated the characteristics which would distinguish so-called modern painting: the claim to its aesthetic validity on terms distinct from those of resemblance or verisimilitude.[9] Describing Manet's practice he invokes an analogy with language: "Our task then, as judges of art, is limited to establishing the language and the characters; to study the languages and to say what new subtlety and energy they possess."

Calling works of art "nothing but simple facts," Zola established a fundamental premise of the formalist line: the autonomy of the visual object. Zola's exhaustive description of the play of tonal values with which Manet achieves the striking effects in his work stresses the material facticity of the paint on canvas.

> What strikes me is due to the exact observation of the law of tone values. The artist, confronted with some subject or other, allows himself to be guided by his eyes which perceive this subject in terms of broad colors which control each other. A head posed against a wall becomes only a patch of something more, or less, prey; and the clothing, in juxtaposition to the head, becomes, for example, a patch of color which is more, or less, white.

Zola defended the use of flat masses of color, which had caused Manet's work to be derogatorily compared with the popular graphic work of Epinal, stressing the subtle play of tonality that distinguished Manet's hand. Zola mounts his argument by shifting Manet's work into the scientific and analytic domain, calling him a painter of his age, one concerned with objective, basic, and definitive principles. With the kernels of his Naturalist aesthetic already sprouting, Zola ultimately validates Manet on the basis of his capacity to render what "really" exists in the most bare and simple terms. But the link between the material fact of paint and the discrete identity of the work as a conceptual fact is what puts Zola's essay into the formalist line. The work's physical presence was taken as given, attention to it heightened, and the accounting for its effects in material terms superseded attention to the imagery as such or illusion produced. The value of the work was to be granted in nonpreferential and fully autonomous terms.

Stéphane Mallarmé's iteration of this point more clearly, nearly ten years later, became a second landmark in the critical tradition of formalism. Writing of Manet's techniques of perspective, he compared them with the "aesthetic perspective" of the Japanese, in an 1876 *Art Monthly Review* article:

> The secret of this [long obliterated truth] is found in an absolutely new science, and in the manner of cutting down the pictures, and which gives to the frame all the charm of a merely fanciful boundary, such as that which is embraced at one glance of a scene framed by the hands, or at least all of it found worthy to preserve. This is the picture, and the function of the frame is to isolate it.[10]

The equation Mallarmé makes between fanciful boundary and frame is not incidental. Conceptual autonomy and viability necessarily intertwine with each other; the economic aspect of this relation would become apparent in Picasso's blatant boasting a half century later, when he declared his canvases a kind of currency whose exchange value was relative to their size.

Material facticity and well-defined object status were two basic elements of the proto-formalist sensibility; but the final element of this formulation (especially in terms of the retrospective establishment of a critical lineage) was to put these at the service of a non-preferential visual imagery. The emphatic insistence on the physical limit and material character of the visual object thus became the basis of permission to relieve the image of representational responsibility. This was in no manner whatsoever the perception of the contemporaries of Manet, Degas, or the Impressionists who, as per J. K. L. Huysmans, saw in their work precise observations of nature sufficient to satisfy the most demanding "anatomist." It was again only retrospectively that this genealogy became traceable to the work of Manet, in the discussions of Maurice Denis, who truly put the "spots" before the "horse" of representation: "Art is no longer a visual sensation that we set down, a photograph, however refined it may be of nature. No, art is a creation of our imagination of which nature is only the occasion."[11]

For Denis the autonomy of the visual resided in what he termed the "subjective deformation" of nature—that is, the transformation of visual experience according to the exigencies of individual rep-

resentational sensibility. The artist's inner eye took precedence over adherence to the "real." This sensibility was manifest in the work of the late romantic symbolists, especially Gauguin, whose emphasis upon the expressive character of their work combined the claim to individual vision with the mystical faith in plastic properties of paint, color, form and in the work of Cézanne, whose visual transformations of natural forms became the crucial point of reference for the shift into cubist abstraction and hard-edged modernity.[12]

Denis' term "subjective deformation" is nonetheless grounded in the conventional structure of referentiality. The forms of visual experience—assumed as natural—continue to underlie the visuality of pictorial expression in Denis' conception. Refuting the validity of trompe l'oeil realism, he shifted the emphasis onto the primacy of emotional realism. The leap in autonomy granted to the image in this process resides in the stated "equivalence between certain states of mind and certain plastic signs which must of necessity translate them."[13]

The faith in the expressive, communicative, effective activity of visual forms would be more fully realized in the work of Kandinsky and Klee and in the aesthetic writings of Bell and Fry. Denis had established the legitimacy of extending discussion of plastic values without reference to the domain of the "real": "such is the power of the proportions, the colors and the forms brought together by genius, that they necessarily impose upon the viewer, whoever he may be, the state of mind of their creator" (p. 55).

But the cliché cornerstone of modernity is Denis' statement on the nature of the plastic reality of the painted form, written in 1890 in his essay "Definition of Neotraditionism": "It is well to remember that a picture—before being a battle horse, a nude woman, or some anecdote—is essentially a plane surface covered with colors assembled to a certain order."[14]

This essay is a veritable manifesto for visual autonomy, for the self-sufficiency of material presence, pictorial conventions, and painterly expression. It is this emphatic insistence upon presence, formal, apprehendable as material, which will revoke the necessity for the illusion of that other presence, the presence of the supposed referent, the real, outside but represented in the image. It will, in fact, be the materiality of the visual conceived as a self-sufficient

presence which will work to guarantee the absence of all external reference within the formalist line. This assertion of material autonomy in turn eliminates the necessity for the image to function conceptually beyond the delimiting fact of its own frame. But above all, it is the assumption that the frame, the boundary, the edge defines and delimits the field of visual activity, which was the foundation of formalist thinking.

Roger Fry, Clive Bell, Paul Cézanne: Formalist Aesthetics and Abstract Form

The move toward abstraction so marked in the painterly practices of the late nineteenth-century French painters whose work is still used to define the canonical lineage of modernism brought forth a critical rhetoric in its support which reinforced the belief in visual autonomy.[15] So strongly did the rhetoric of significant form and aesthetic experience associate the development of abstraction with the concepts of nonreferential and self-sufficient visuality, that this link came to be utterly naturalized as necessary and definitive: *that* forms were abstract *meant* that they were replete in their visual presence, directly communicative and effective. Maurice Denis' notion of "expressive synthesis" of form arranged "for the pleasure of the eye" finds its complement in the writings of the English aestheticists.

It was in response to the work of Cézanne that Maurice Denis achieved this vocabulary centered on discussion of the autonomy of mark, color, and manipulation of paint. Thus both his subject matter and his methodology foreshadowed the dogmatic terms in which a lineage of modernism would eventually come to be enunciated as a series of formal inventions: "Before the Cézanne we think only of the picture";[16] his work is "an art of concrete beauty, and our senses must discover in the work of art itself—abstraction made of the subject represented—an immediate satisfaction, a pure aesthetic pleasure" (p. 59). Original, individual, but not concerned with either the direct expression of personality and emotion nor with the natural transcription of nature, Cézanne's work offered to Denis "a touching spectacle . . . generally unfinished, scraped with a palette-knife, scored over with *pentimenti* in turpentine, many

times repainted, with an impasto that approaches actual relief" (p. 60). Terming these things "evidence of labor" Denis gave prime importance to the *facture* of the works, and to their chromatic construction of form.

Denis considered Cézanne's work, with its an antiliterary and antihistorical visuality, as part of the reaction to academically restricted subject matter. As the linguistic analogy for abstract visual form developed in the early 1910s, the resistance to literary sources would develop simultaneously. As image became language it resisted literary and extravisual references. The term "decorative" had acquired a positive connotation in the writings of George Aurier in the 1890s and Denis' praise of the visual texture of Cézanne's work partakes of this sensibility: "When he imagines a sketch, he assembles colours and forms without any literary preoccupation; his aim is nearer to that of a Persian carpet weaver than of a Delacroix . . . a negative effort, if you will, but one which declares an unheard of instinct for painting" (p. 60).

This "instinct for painting" translates into a concern with form as color, as construction, again, without referent beyond its constructed properties. Cézanne was notoriously and vocally opposed to translating his pictorial work into spoken theoretical form. By refusing to allow his painting to be contained in linguistic terms, he reinforced the primacy of visuality as such. His visual activity was dedicatedly antilinear, antilanguage oriented—as had been that of Gauguin.[17] Cézanne privileged the use of color for the construction of form, giving the two an indissoluble relation. Nothing could be farther, in visual terms, from the "ineluctable flatness" of modernity than the sculpted spaces of Cézanne.[18] The few articulations he made concerning his practice took on the quality of oracular utterances. Thus the famous phrase from his letter to Emile Bernard in 1904 "treat nature by the cylinder, the sphere, the cone" was aptly characterized by Denis as a statement in support of form as volumetric: "he never reaches the conception of the circle, the triangle, the parallelogram; those are abstractions which his eye and brain refuse to admit. *Forms* for him are *volumes.*"[19]

Clearly deployed on the surface of the canvas, the daubs of color were however at the service of an illusion of spatial form. The development of a modern sensibility bears no "ineluctable" relation

to flatness; instead, the assertion of autonomy and self-sufficiency continued to dominate the terms of visuality. In large part this project was, as Denis had stated, a "negative effort," one of defining the visual as *not* literary. Roger Fry made a significant contribution to this aspect of formalist aesthetics by driving the wedge of distinction between the two domains in his 1909 "Essay in Aesthetics."

For Fry the terms of a self-sufficient pictoriality involved a distinction between visual experience per se and the visual image as a representation. Establishing the two as distinct categories, he elaborated the terms of autonomy further than Denis' rhetoric of visual form. It is Fry's theory of visual form *in representation* which grants his work such importance within the lineage of modernism.

Briefly, Fry outlines a distinction between what he terms "actual life" and "imaginative life," valuing the latter more highly than the former. Imaginative life is more "pure and clear" than actual life, and its expression is to be found in art. Fry's work stops short of the presentational rhetoric of Reverdy and Apollinaire, and the artist on whom he draws for support is Cézanne, whose relation to representation continually equivocates between the autonomy of means and the referential search for truth.

Fry's concept of aesthetic purity and aesthetic autonomy depends upon the conviction that a representational function can be well served by visual arts. They embody what he terms visual truths, optical facts, and most importantly, aesthetic values. Intent upon championing Cézanne in his endlessly unfinished task, Fry characterized his effort as the struggle to make an "equivalence, not a likeness, of nature." Recognizing that Cézanne's work was based on a "logic of optical vision," Fry, nonetheless, worked to define his metacritical language in terms of Cézanne's *images*. Fry's aesthetics is above all, an aesthetics of self-sufficient representation—in spite of being derived from the investigation of Cézanne's discussion of aesthetic *experience* as the basis of that representation. It is from this point that the balance of modern aesthetics shifts to the image, away from the experience, firmly laying the foundation for self-sufficient autonomy.

Fry's prescription for the conditions of viewing a work of art establish a paradigm for this autonomous stance. A degree of "disinterest" is necessary to overcome the specialization of vision

which is the rote mode of processing visual sensation in everyday life. Thus the image, from the outset, is granted status as a different order of visual experience, one cut out from and distinct from the general order of visual perception. And the most damning aspect of the quotidian visual process is the assigning of visual information into a labeled category of experience so that the image value is immediately moot:

> With admirable economy we learn to see only so much as is needful for our purposes; but this is in fact very little, just enough to recognize and identify each object or person; that done, they go into an entry in our mental catalogue and are no longer seen. In actual life the normal person really only reads the labels as it were on the objects around him and troubles no further. Almost all the things which are useful in any way put on more or less this cap of invisibility.[20]

There is no stronger impulse in Fry than this desire to wrest the image free from the overriding domination of the linguistic operation which renders it invisible. To this end Fry develops a set of guidelines for examining a work of visual art in clearly formal terms—according to the rhythmic quality of line, the structure of composition, mass, space, shade, and color. All of these, he states, are essential to contemplating the work "as a whole, since if it lacks unity we cannot contemplate it in its entirety, but we shall pass outside it to other things necessary to complete its unity" (p. 85).

Fry makes clear that the exigencies of graphic form go far beyond the incidental formal qualities of nature, or of ordinary visual experience. Grounded in a phenomological belief in the apprehension of visual form, Fry's emphasized the necessity to put the visual forms of *representation* in a category distinct from that of ordinary visual experience. These visual representations were further defined as anti-linguistic; Fry privileged the visual realm as complete in-itself, as distinct, and as sufficient. Fry knew full well that that visual responses of the human organism were not merely mechanistic: the lessons of the late nineteenth-century physiologists were not lost on him. But his prescription for aesthetic form is predicated on a faith in the capacity of the *object* to contain specific properties and thus generate a particular aesthetic response: the

balance of the image must occur above the central line of the picture, the rhythm of a line must contain such and such in his laundry list of controllable features. The terms of formalism, entwined with the visual practice of abstraction, had thus found their first uncompromisingly clear articulation.

The fact that the works of art, Cézanne's paintings, which Fry was so intently examining as the basis of his proposed aesthetics, contained much more visual information than could be elaborated through a discussion of rhythmic and tonal values, would be glossed over by succeeding critical readings. Fry's essay comes to stand for and even reify a formalism in which visual referents are ignored as surely as linguistic or literary ones—in the name of what is set up as visual autonomy. The muted viewer is exhorted to experience the order and variety of visual images according to the terms of a formalist aesthetic. This aesthetic is fundamentally anti-mimetic at the same time that it is essentialist and truth-bound in its search for absolutes. For Cézanne the validation of visual truth lay in the forms of nature; for Fry they approach the domain of universal forms which transcend experiential visuality. Any relation to an external model of visual form is insignificant in his formalist aesthetics and its insistence on the unity and completeness of the image.

Cézanne was committed to nature as a teacher and with universal form as an ideal to be searched for and rendered visible. But he never engaged with representational elements for their own sake to the degree which would seem to be implied in Fry's writings. In a 1912 catalogue essay for a show of work at Grafton Galleries, Fry wrote optimistically: "these artists do not seek to give what can, after all, be but a pale reflex of actual appearance, but to arouse the conviction of a new and definite reality." It is important to realize that he has Braque, Picasso, and others before his eyes, as well as the "great originator of the whole idea, Cézanne." By that 1912 point Cézanne's position has already taken on a retrospective character, and the current state of modern art was perceived as some inevitable result of a trajectory launched by him in the past. Projecting farther, Fry wrote: "The logical extreme of such a method would undoubtedly be the attempt to give up all resemblance to natural form, and to create a purely abstract language of form, a

visual music; and the later works of Picasso show this clearly enough."[21]

By 1917, when Fry wrote "Art and Life," his tone had become more strident, saturated with a language of scientific vocabulary. In a cultural climate in which Nietzschean pessimism denounced the underlying truth claims of both technology and scientifically grounded progress, Fry resolutely and adamantly asserted the value of the scientific approach. Science, as Fry invoked it writing of the Impressionists, had the quality of pure, objective and empirical thought. The ideological character of his refusal to see the implications of this position would seep into the formalist aesthetics of Greenberg as well, for whom the embrace of a purely formal high modernism had much to do with repression. That Fry justifies the esotericism of art, its limited appeal, on the grounds of the scientific metaphor, is perfectly consistent with his refusal to see the elitist basis of his own formulations. Fry claimed the "more and more widely accepted" scientific attitude would displace the old mimetic superficiality of mere resemblance.

Ultimately, the legacy that Fry bequeathed contained an absolute faith in the object status of the pictorial image; its unity as the basis of its completeness, autonomy; and a formal vocabulary as the necessary and sufficient critical language for discussion of the visual work. Cézanne, distinguishing himself from the supposed (fictive) "pure opticality" of the Impressionists and not yet engaged with the presentational rhetoric of Cubism, functions as a figure mediating between what Louis Marin characterized as "the transparent immediacy of the look" and the "opaque mediation of signs."[22] In the play of visual form lay the final resolution of the image; but bound to nature as some unapproachable limit he could only approach asymptotically, Cézanne made clear, by that deferral, that there could be no collapse or confusion of the two domains. Real and representation remained distinct. Despite his continual sense of his inadequacy to obtain a "truth in painting" Cézanne laid the foundation for the Cubist claim to painting as a truth in itself—but even more, the critical rhetoric in which his work is discussed has positioned him in an inevitable narrative of formalist modernism.

While Roger Fry was defining the activities of visual representa-

tion in a manner designed to distinguish between the image and direct experience, articulating the elements of the mediated practice in terms which could not apply to those of perception, Clive Bell, almost simultaneously, was developing his theory of *significant form*. Bell placed equal importance on the distinction between representation and experience, and also stressed the role of Cézanne as key figure in the course of modernism as a chronological narrative.

In his definition of the aesthetic experience, Clive Bell insisted on the exchange between viewer and object as primary. He passed no injunction against the use of recognizable imagery, stating simply that representation (by which he meant mimesis and illusion) was not a bad thing in and of itself, but that it must not take precedence over or stand in place of the production of significant form. But his insistence on the appreciation and apprehension of form for its own sake makes his work into a precedent for the formalist enterprise. Insofar as this concept is his main achievement, it is important to understand why it had such potency in his eyes.

In "The Debt to Cézanne," written in 1914, Bell made clear that significant form transcended the endless repetition of quarrels over subjective vs. objective sources for imagery which had divided the Romantics from the Realists of nineteenth-century painting. He characterized the Romantic attitude as one grounded in "associations." By this Bell meant all manner of sentimental and literary connections which rendered the image merely illustrative and insignificant except in its capacity to evoke all manner of displaced stories, themes and events. Its plastic value was insignificant. Realism similarly negated the value of the image according to Bell, by having it serve as the mere registration of empirical information, obtaining value only insofar as it was capable of functioning to inscribe visual information in an exhaustive performance of ultra-mimetic virtuousity.

The metonymic chain of associations of the Romantic practice and the metaphoric duplication, redundant and repetitive, of the Realist, as characterized by Bell, served equally to displace the visual image, empty it of any value as such, especially in formal and plastic terms. As far as Bell was concerned, the Impressionists were well within the Realist camp in their tedious attempts at scientifi-

cizing and recording the processes of vision. Bell had no use for such activity, and embraced Cézanne as the radical pioneer of painterly form as form. Bell and Fry came to Cézanne with different agendas, and their formalism is in no way a reductive dismissal of recognizable visual elements within imagery. But both shift the primacy of significance onto the visual, plastic quality of the painting, stressing that its formal character and its primary significance reside in this domain. That their espousal of a concern with the formal properties of an image came retrospectively to serve the interests of a historicization concerned to see the history of modernity in purely formal terms is hardly attributable to either their methods or their intentions. It would be equally specious to hold Cézanne responsible in some causal sense for the development of completely non-referential abstract visual form.

In conclusion, the contribution of Bell and Fry was to recognize the potential of formal values in an image as autonomous from any mimetic activity, permitting full distinction between representation as such and representation as imitation. This key distinction gave rise to a critical vocabulary focused on the *internal* organization of the image. If representation was a self-sufficient activity, then its means and modes could be analyzed in terms which were exclusively formal. It is important to keep in mind that in 1912–14, when Bell and Fry were first asserting the primacy of formal values, the pictorial works they were looking at were not necessarily the "visual music" of pure abstraction, nor did they require that they be so. Fry suggested such a possibility could exist, but his point does not have the strident insistence or repressive force of Greenberg's later prohibitions.

Presentational Rhetoric, Visual Language, Formal Abstraction

The development of abstraction in the visual arts in the second decade of the twentieth century took many forms, and the theoretical positions adopted as a corollary to the visual investigation are as varied as the visual works yet have been assimilated into the rhetoric of a formalism as *presence*. Kasimir Malevich's nonobjective canvases, Wassily Kandinsky's abstract compositions and

improvisations, Robert Delaunay's orphic Cubism, Stanton Mac-Donald-Wright's synchromist experiments, Mikhail Larionov's Rayonist canvases, Piet Mondrian's emerging Neoplasticism—these are just a representative few of the many investigations of abstract pictorial means. These have in common that by the 1910s and 1920s they could take as a *given* that conviction that pictorial means are sufficient, and that the self-sufficient operation of visual elements can occur on the space of a canvas without recourse to resemblance to observations of the appearance of nature, or to pictorial conventions. In almost every other respect, each form of abstraction is as individual in its visual appearance as it is in its theoretical foundations. Each of the painters named above and, indeed, the dozens of others whose abstract canvases served as laboratory for the investigation of formal means, has been exhaustively researched and their work well documented. Situating these practices in the larger discussion of the developing concept of the autonomy of the pictorial domain sacrifices many important specifics for the sake of a representative argument. In terms of both intellectual position and formal means, the work of Malevich's Nonobjective canvases or Mondrian's attempts to find a visual language he could reconcile with his theosophical beliefs are at odds with those of Larionov's Rayonism or Franz Kupka's Orphic abstractions. While a rough chart of the forms of abstraction would demarcate zones of scientific or optically grounded inquiry, spiritualist motivations, or decorative inventiveness, these categories are not hard and fast, and the activities of visual artists often overlap their dividing lines to such a degree that, ultimately, the most useful approach to this wide spectrum of work is a case-by-case individual appreciation.

In terms of a general investigation of autonomous means, these abstract painters share one thing—a claim to immanence as an essential aspect of visuality. According to such a claim, material presence was fully equated with ontological completeness. No matter what else was to be signified by the visual elements—the manifestation of cosmic principles, geometric truths, or visual dynamism, etc.—it was on the basis of their visual existence as forms that these images exemplified a belief in the self-sufficiency of visual presence. The very concept of presence, as the manifesta-

tion of being, as replete immanence, becomes a primary foundation for the construction of these works. By giving up the overt need for a referent, they assert the capacity of visual forms to function in themselves, on the basis of their visuality, and, again, with the premise that their appearance *is* a form of presence.[23] That the self-sufficiency of pictorial means can be linked to a particular concept (appearance as presence) does not, however, restrict the terms of that relationship to a spiritual or metaphysical one. The same equation—of visual form with a self-evident condition of being—can also be found in the (pseudo)scientific inquiries of Larionov and MacDonald-Wright, and in the decoratively exuberant canvases of synthetic cubist still life.[24]

The critical rhetoric which was developed in response to Cubism is one example of the increased attention to the concept of presence and its visual forms. Both Guillaume Apollinaire and Pierre Reverdy emphasized the idea of a *presentational* art which left no doubt as to their conviction that Cubist painting had altered the inherited conventions of representational strategies. The basis for this conviction was not only that they recognized the radical rethinking of spatial and temporal relations within the cubist image, but that they were aware of the manner in which both Braque and Picasso were exploring the potential of visual material to function without prior model to produce an image whose very existence was without external referent or precedent.

> Real resemblance no longer has any importance, since everything is sacrificed by the artist to truth, to the necessities of a higher nature whose existence he assumes, but does not lay bare. The subject has little or no importance any more.[25]

and

> Cubism differs from the old schools of painting in that it aims, not at an art of imitation, but at an art of conception, which tends to rise to the height of creation. (p. 229)

Reverdy made the famous remark that one did not "represent" a baby, one "presented" it—and that the same concept of presentation should be applied to painting. The assumption of a condition

of being in this rhetoric is very clear: the notion of autonomy does not apply only to the liberation of the image from a referent, but to the very premise of its existence as such. According to this conception, a work of art, as an image, is to approach the condition of being, rather than simply perform the function of representing. No longer tied to an imitative function, the image is no longer considered to be a surrogate or stand-in for a signified value: it embodies or, more accurately, *is* that value, and its condition of being is thus conceived to be autonomous, not dependent. Such a premise depends on a belief in perception, on the idea that the visual forms may be directly apprehended by the eye, that they do not require mediation through language, interpretation, or other means. It is the fact that they function in-themselves and as themselves which is the founding premise of the concept of a painting of visual presence.

Cubist work is not, by any means, the only place where such rhetoric emerges, or where visual practices are premised on a concept of presence. If the cubist approach can be, in some sense, considered a secular and somewhat eclectic branch of abstraction, then Kandinsky and Mondrian, by contrast, can each be seen as exploring the spiritual and metaphysical premises of abstraction and as more esoterically rigorous in their visual form.[26] Between 1910 and the 1920s, both Kandinsky and Mondrian systematically reduced the visual elements they made use of without deviating significantly from the spiritual convictions that had led Kandinsky to write *Concerning the Spiritual in Art* (1910) as well as *Point and Line to Plane* (1926) or Mondrian to produce his tracts on abstraction and neoplasticism. What is interesting in the gap between Kandinsky's 1910 essay and his 1926 complex study of formal means is precisely the extent to which he came to privilege the visual forms *as* the site of those spiritual investigations.[27] *Point and Line to Plane* offers itself as a rigorous detailing of formal relations among visual elements. The subtext is that these relations of form encode cosmic universal truths—relations which Kandinsky strives to render so clearly that they will, as per his Munich writings with August Endell: "affect the viewer directly without the mediation of thought."[28] But the unifying theme of Kandinsky's practice is the modified symbolist conviction that the elements of visual form sig-

nify through an immanent presence which is replete and self-sufficient.

Mondrian's investigations into the relationship of "abstract reality" and "natural reality"—formed the basis of his discussions of plastic form. Struggling to distill a pure plastic art, Mondrian also articulated his research in both the visual form of his canvases and the critical form of his writings. The course toward abstraction, for both Kandinsky and Mondrian, had begun with the conviction that there were visual forms more pure, more universal, than those available to the eye in observations of nature. Mondrian's visual forms more quickly and more completely mapped themselves onto the surface plane of the image than did those of Kandinsky, in which the complex spatial relations are suggested by overlapping forms and varying scale. Mondrian's insistence on the abstract character of visual relations, stated as laws, clearly emphasized the autonomous character he ascribed to this picture plane:

> Art makes us realize that there are fixed laws which govern and point to the use of the constructive elements of the composition and of the inherent inter-relationships between them. These laws may be regarded as subsidiary laws to the fundamental law of equivalence which creates dynamic equilibrium and reveals the true content of reality.[29]

The inseparable intertwining of theosophical conviction and visual formal investigation in this paragraph, from the 1937 "Plastic Art and Pure Plastic Art," in no way undermines the investment in visual form as a replete presence—that is, one in which the visual elements need not refer to other visual (or verbal) elements in order to be significant—which were integral to Mondrian's expressed convictions throughout his life. The language of the 1917 "The New Plastic in Painting" evidences the same conviction, and the same intertwined themes: "The new plastic consistency of style in the manner of art begins when form and color are expressed as unity within the rectangular plane. With this universal means, nature's complexity can become *pure plastic*."[30]

Universal themes, and the rectangular picture plane, form and color as systematizable elements: Mondrian's neoplasticism results

in the rigorous study of formal relations within that bounded frame—his search for pure painting was intimately bound up with his search for a "pure reality." But the overwhelming conviction was that such a reality could take form and come into being through such means and it is this position that Mondrian's work came to occupy in the chronological account of abstraction.[31]

The examples, each particular, and each specific to the unique combination of aesthetic convictions and formal means, could be extended almost limitlessly. Mikhail Larionov's tracts on Rayonism, 1912–13, Franz Kupka's Orphic work and texts, MacDonald-Wright's 1916–17 statements on Synchromism, with their insistence on the abstract "rhythm," "fundamental laws of composition," and "nugatory" role of "natural representation"—all echo the uncompromising conviction in the autonomy of visual forms.[32] It is, in effect, the very premise of the development of abstraction, that the formal elements have the status of being, rather than representing. The basis of the formalist assertions was a conviction that the visual forms had *inherent* and *immanent* value of pure presence. At this point the concept of *espace* of the canvas, discussed above, had achieved its prominence as the autonomous space of representation.

The most serious consequence of such a conviction was in the shift it marked from a position in which representation was still considered a *mediation*—between observation and re-presentation, between observation and perception, or between construction and effect—to a position in which visual representation came to assume that its visuality asserted a pure presence, replete, complete, and absolutely self-sufficient in that plenitude.

The concepts of style and form as immanent and inherent would be (and continue to be) operative on terms which take the nature of the image as extant without question, thus perpetuating the very same equation of material existence with ontological completeness. Thus the formal characteristics of an image serve as the point of departure for its critical discussion *as if* there were no problem with assuming the object's status as such. The being-ness of the image persists in its insistence upon *being* as a transcendent category, as the implied but never clearly defined foundation of the very condition assumed as mere *presence*.

Codifying Formalism Historically and Critically: Alfred Barr and Clement Greenberg

By the late 1930s the visual forms of modernism began to be sys-
tematically codified into a periodized chronological narrative in the
work of Albert Barr, Clement Greenberg, Michel Seuphor, Meyer
Schapiro, and other writers. Of these, both Barr and Greenberg
were two whose influence was especially wide-ranging.[33] One
assumption underlying their approach was that major develop-
ments in modern art could be related and categorized according to
style.[34] Style was taken to be completely apparent and linked to a
typology of visual forms. These forms, in turn, were considered to
mark distinctions of approach which could be, literally, mapped as
the course of modernism. The model of a topos of discrete territo-
ries whose borders were distinct and identifiable as the major
strains of modern art practice was most powerfully institutionalized
in the work of Alfred Barr. His impact, as the director of the Muse-
um of Modern Art and of works within its purview, was to institu-
tionalize a visible and readily assimilable model for codifying the
early modern period. Second, the validation that accrued to works
granted legitimate status by MOMA, as a museum conceived
expressly for modern art, made its curatorial policies a strong force
in the emerging dynamic of historicization and valuation of modern
works in both aesthetic and economic terms.

Barr's famous tree diagram of the history of modern styles and
influences among movements has been the object of discussion,
often derisive, for decades, and the concept of modernism as a suc-
cession of stylistic inventions has been revised many times over. But
the notion of the object which informed Barr's methodology has
been more persistent: that of assumed inherency and presence, the
overwhelming conviction that in appearance resides meaning and
value.

Barr made the history of modern art a narrative of the develop-
ing codes of formalism. A vastly heterogeneous array of art prac-
tices and artists were synthesized into a sequential lineage accord-
ing to an agenda whose conceptual underpinnings were fixed in the
stylistic oppositions which had their most immediate source in Wil-
helm Worringer's work, *Abstraction and Empathy*, and the formal-

ist typologies of earlier German art historians. Writing in 1936 in the introduction to the *Cubism and Abstract Art* catalogue, Barr divided the development of abstract modernism into two parts. While acknowledging their overlap, in some cases even in the work of a single artist, Barr set up the binaristic distinction of stylistic difference and attached qualitative terms to it. This distinction reduced the organic, biomorphic form to being intuitive and emotional; and the rectilinear, geometric form to rational and intellectual expression. Barr did not extend his division between geometric and organic forms to the anthropological conclusions Worringer had asserted in making a distinction between *abstract* and *empathic* modes of representation. These oppositions represented the two poles of abstraction, but all of abstraction was subject to the same rules of perception, one in which the primacy of vision as such was predicated on the assumed autonomy of the visual image, an autonomy before which language was useless. Posing the question, "What is Modern Painting" in the rhetoric of an introductory catalogue meant for a very lay public, Barr wrote: "it is not easy to answer this question in writing, for writing is done in words, while paintings are made of shapes and colors."[35]

This emphasis on the taken-for-granted apparency of visual images reinforced a concept established earlier among the visual artists, Kandinsky and Klee in particular, that depended on the one hand on the development of an elaborate linguistic analogy for visual form as a "language"—systematic, self-defining, and arbitrary, but logical and functionally complete in itself—while also maintaining the distinction between visual and verbal modes.[36] This forced the terms of visuality into the direction of immanent value, of material appearance as the fact and basis of effective value.

While this reinscribed distinction between visual and verbal modes would increase in potency in the generation that followed, another point which Barr insisted upon would also come to be taken at the face value of his word for far longer than any immediate observation of the paintings on which he made his claims should have allowed: that the modern abstract artists achieved their abstraction at the price of—deliberately sacrificing—subject matter. The artist, in Barr's essay of 1936, preferred the "impoverishment"

of minimal means to the "adulteration" of subject matter: "Other painters, Kandinsky among them, turned their backs on nature entirely and painted without any subject or recognizable object at all."[37] The significance of this point is again, not merely its erroneous reductivism, but the fact that it is grounded in a fundamental conceptual error. The concept of "subject matter" in Barr is extremely reductive; for him it means conventional pictorial imagery. In fact, the abstract work of Kandinsky, to continue with the same example, is replete with meaning. The subject matter is specifically the meaning produced through the engagement of the visual elements with signifying practices outside the limits of the physical frame of the image—optical, mystical, musical, emotional, etc. The claim to inherency, which was essential to Barr's validation of the image, resided in his belief that signification *was* possible within the frame, that it could be that restricted and bounded, and that meaning could inhere in "purely" visual terms. The notion of purity as nonverbal, antilinguistic, became a keystone of the high modernist position. The relation to Fry's aesthetics is clear, and the notion of the threat posed to the image by the power of *logos*— which might appropriate and displace its value, is another theme or subtext at work.[38]

Pushing this discussion farther, Barr went on to insist that subject matter was simply "not necessary" to the abstract artist. In other words, it was insignificant, i.e., subject matter did not *signify*, did not play a part in the signifying activity of the visual work, which was to be contained, apparent, and formal, not mediated, semiotic or absent. The very concept of subject matter, because it invoked an external frame of reference, made the border of the image a permeable one, was threatening to the object status essential to the formalist line. And formalism as such was to be the distinguishing feature of modernity, its very essential character.

The concept of historical lineage and stylistic chronological succession carried with it the other unspoken and now well-criticized assumptions about the autonomous character of art in general, as a system divorced in large part from the circumstances of either its production or its effect.[39] Clement Greenberg, in his 1939 "Avant-Garde and Kitsch" and the 1940 "Towards a Newer Laocoön," sought to define a role for autonomous and "pure" painting

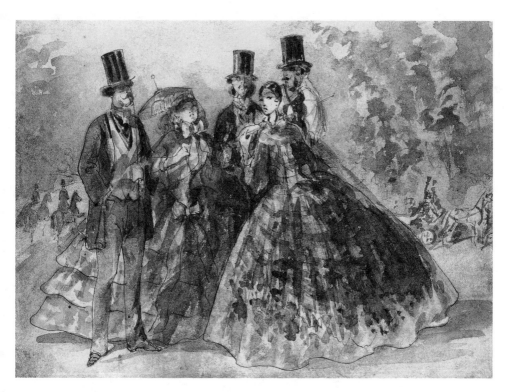

Figure 1. Constantin Guys, Meeting in the Park, 1860s.
The Metropolitan Museum of Art, Rogers Fund, 1937

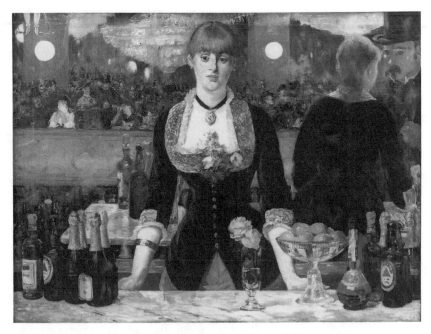

Figure 2. Edouard Manet, The Bar at the Folies Bergère, 1882.
Courtauld Institute Galleries, London.

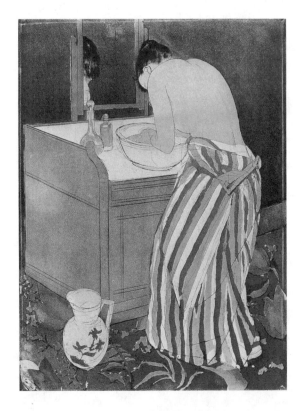

Figure 3.
Mary Cassatt,
Woman Bathing,
1891. The
Metropolitan
Museum of Art,
Gift of Paul J.
Sacks, 1916.

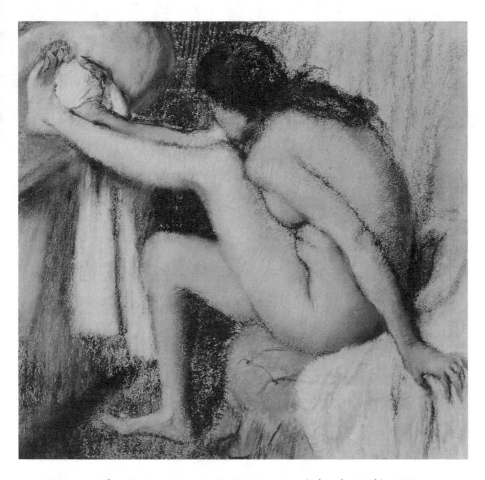

Figure 4. Edgar Degas, Woman Drying Her Foot (After the Bath), 1880s.
The Metropolitan Museum of Art. The H.O. Havemeyer Collection.
Bequest of Mrs. H.O. Havemeyer, 1929.

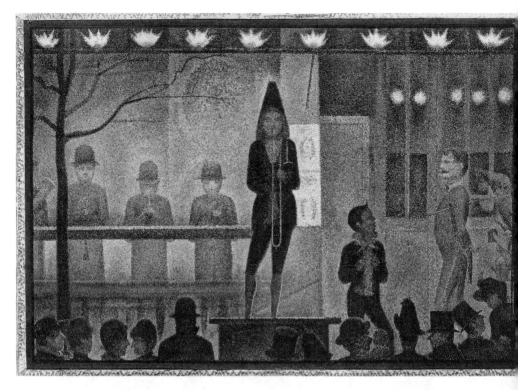

Figure 5. Georges Seurat, La Parade (Invitation to the Side - Show), 1887 - 88. The Metropolitan Museum of Art, Bequest of Stephen C. Clark, 1960.

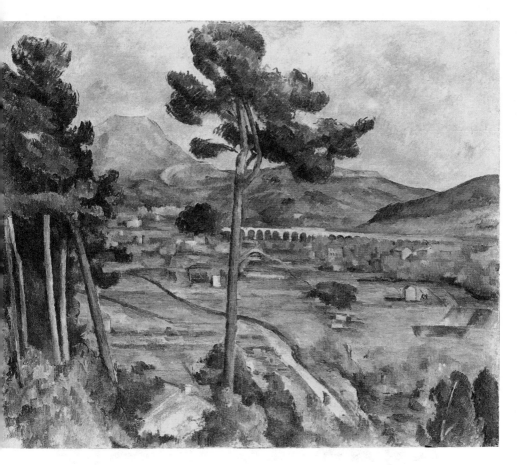

Figure 6. Paul Cézanne, Mont Sainte - Victoire, n.d. The Metropolitan Museum of Art, Bequest of Mrs. H.O. Havemeyer, 1929. The H.O. Havemeyer Collection.

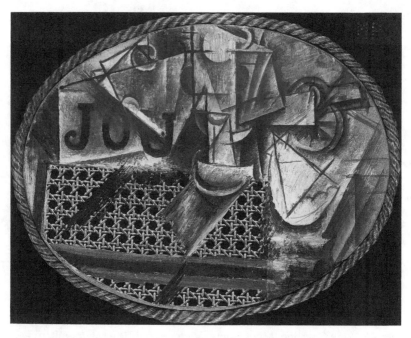

Figure 7. Pablo Picasso, Still Life with Chair Caning, 1912.
Musée Picasso. Copyright © 1993 ARS New York/SPADEM Paris.

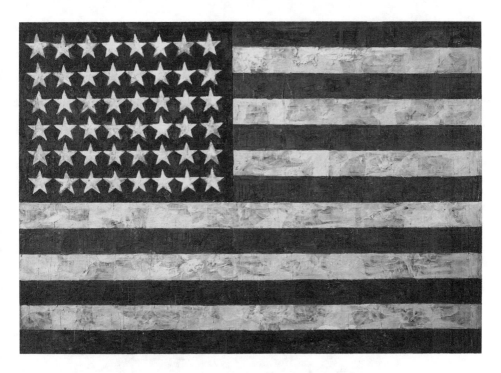

Figure 8. Jasper Johns, Flag, 1954-55. The Museum of Modern Art,
New York. Encaustic, oil, and collage on fabric mounted on plywood,
42-1/4″ x 60-5/8″. Gift of Philip Johnson in honor of Alfred H. Barr, Jr.

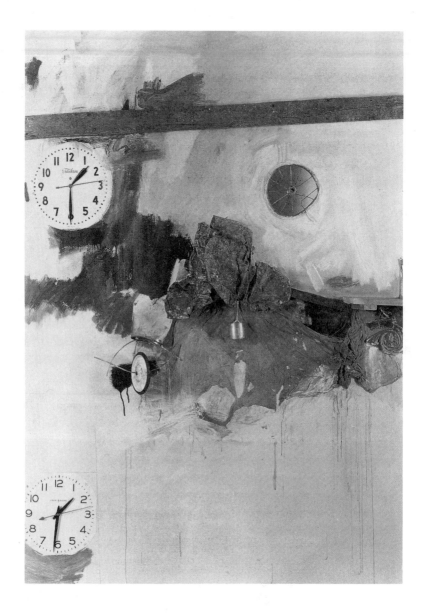

Figure 9. Robert Rauschenberg, Reservoir, 1961. National Museum of American Art, Smithsonian Institution, Washington, D.C. Gift of S.C. Johnson & Son, Inc.

Figure 10. Frank Stella, The Marriage of Reason and Squalor, II, 1959.
Enamel on canvas, 7'6-3/4" x 11'3/4". The Museum of Modern Art,
New York, Larry Aldrich Foundation Fund.

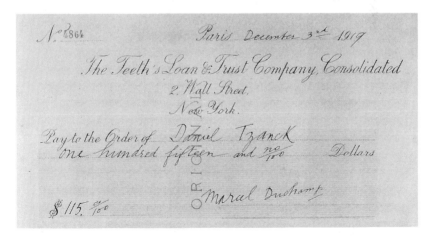

Figure 11. Marcel Duchamp, Tzanck Cheque from Boite-en-Valise,
1919. Philadelphia Museum of Art, Louise and Walter Arensberg
Collection.

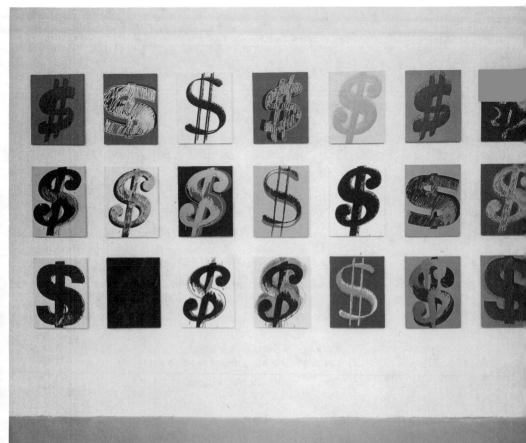

Figure 12. Andy Warhol, Dollar Signs, 1981. Photograph courtesy Leo Castelli Archives; copyright © 1992, The Estate and Foundation of Andy Warhol/ARS New York.

Figure 13. Yves Klein, Ritual for a Zone of Immaterial Sensibility (with Dino Buzzatti), Paris, January 26, 1962. Photo: Harry Shunk.

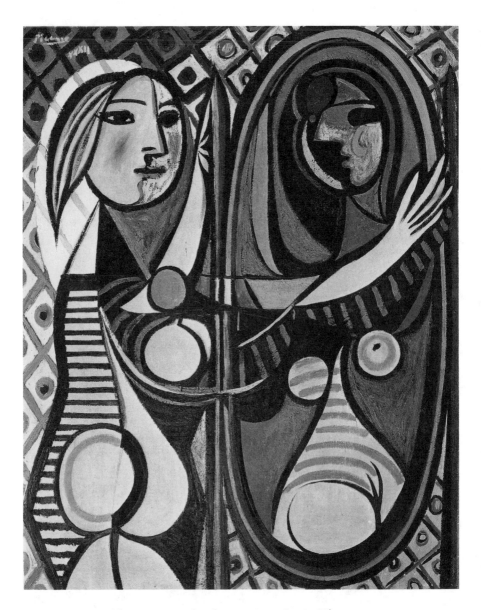

Figure 14. Pablo Picasso, Girl Before a Mirror, 1932. Oil on canvas, 64" x 51-1/4". The Museum of Modern Art, New York. Gift of Mrs. Simon Guggenheim.

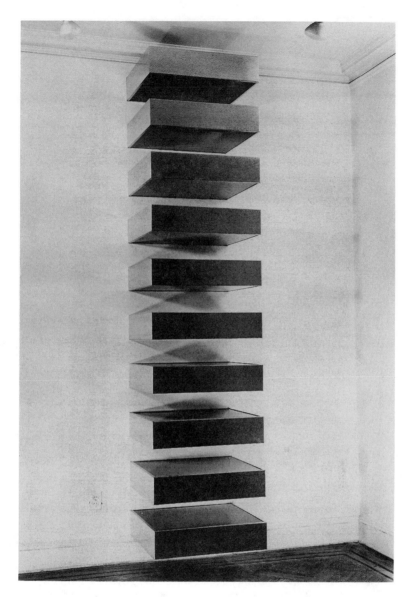

Figure 15. Donald Judd, Untitled, 1969. Photo courtesy The Pace Gallery, New York.

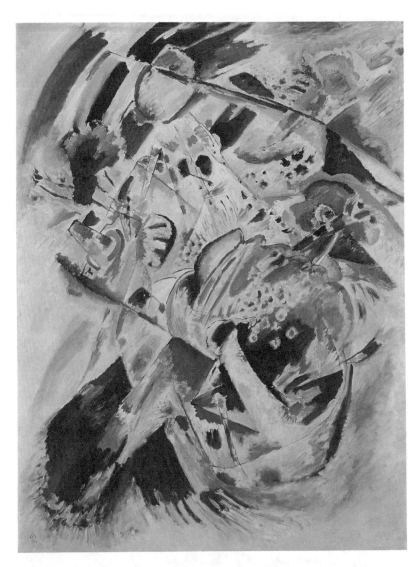

Figure 16. Vassily Kandinsky, Painting Number 201, 1914. Oil on canvas, 64-1/4″ x 48-1/4″. The Museum of Modern Art, New York. Nelson A. Rockefeller Fund (by exchange).

Figure 17. Cindy Sherman, Untitled Film Still, 1979. Photo courtesy
Metro Pictures.

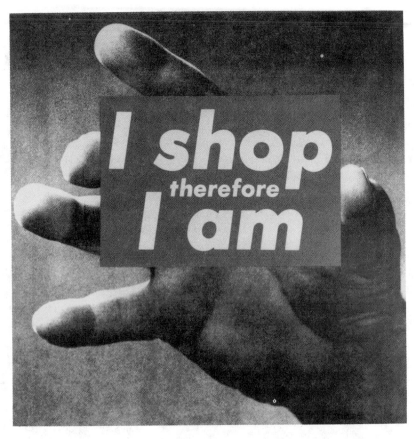

Figure 18. Barbara Kruger, "Untitled" (I shop therefore I am), 1987.
Photo by Zindman/Fremont, New York. Photo courtesy Mary Boone

which would reconcile its claims to autonomy with a social role for that definition. Citing the "dogmatism" and "intransigence" of so-called "purists" who defended abstract art as "the best of contemporary plastic art," Greenberg argued that the qualities of pure abstraction which gave this work its aesthetic value were also necessary to its service as a site within culture in which particular values could be preserved.[40] The very identity of art as a social practice and as a visual form combined in the way the formal qualities of abstraction embodied a meritorious purity, a "salutary reaction against the mistakes of painting and sculpture in the past several centuries" (ibid.). Thus the identity of art combined a social definition of the practice (and, by implication, the social role of the avant-garde in relation to bourgeois society and also, totalitarianism) and aesthetic premises.

Greenberg took stylistic development as an inevitable teleology—"so inexorable was the logic of the development that in the end their work constituted but another step towards abstract art" (ibid) and retraced the stylistic lineage of modernism, stating it as a near biblical "x begat y" genealogy. At the same time he attempted to rupture Barr's silence with respect to the instrumental effect of art as a cultural discourse. Twenty years later, however, his essay "Modernist Painting" (1965) would take the terms of formalism to their most reductive extreme, creating a prescription which would become most potent in the arguments of conservative aesthetics. The distance between these two positions can be attributed in significant part to the changed political climate: the optimism of the avant-garde for the effective intervention in social order through art had been violently crushed. The utopian dream that had been most vivid in the formation of the Soviet state had turned nightmarish in Stalin's regime of artistic, political, and intellectual repression. Though there is no stated conceptual link, the fact that the recognition of object status and formal autonomy emerge as a justifiable aesthetic position in Greenberg's cold war era writings is both an acknowledgment and expression of the impossibility for art to think its way out of cultural circumstances which had become increasingly constrained. While early twentieth-century claims (and Greenberg's own belief even through the 1930s) was that the new forms of abstraction were both evidence and instrument of radical

change, by 1960 both radical change and avant-gardism were most viable as trendy fashion terms in first world consumer culture.

"Avant-Garde and Kitsch" (1939), in spite of its determination to defend the social necessity (according to which formal innovation was radical activity and art's distinctness allowed it to assert political leverage) of the limited frame which defined the autonomous work of art, depended upon the existence of a formalist characterization. Formalism, as a descriptive tool, positioned works within a spectrum which functioned simultaneously as a map of aesthetic territory and political stance. The implication of inherent value for formal qualities, and of their stability within the codes of social contexts, could not have been more clear. The avant-garde, so-called, had become identifiable in Greenberg's writing through distinctions that made it stylistically different from kitsch. The assumption on which such characterization could be based was again that the pictorial image had a fixed object status. The very terms on which an image was gauged to be extant insured a formalist orientation to Greenberg's work, which would become increasingly rigid and increasingly dogmatic. Meanwhile, the isolation of aesthetic practice as a politically significant activity allowed the distinction between avant-garde and kitsch—and their relative values—to be legislated according to the terms of abstraction.

In "Laocoön" Greenberg rendered the reductive equation whereby the formal value of the work resided in its medium and combined with the genealogical legacy to make modernity into a succession of increasingly self-referential terms:

> Picasso, Braque, Mondrian, Miro, Kandinsky, Brancusi, even Klee, Matisse, Cézanne, derive their chief inspiration from the medium they work in. The excitement of their art seems to lie most of all in its pure preoccupation with the invention and arrangement of spaces, surfaces, shapes, colors etc., to the exclusion of whatever is not necessarily implicated in these factors.[41]

His unequivocal defense of "purism" was defined in terms of the "physicality" of the medium and its capacity to "resist" being put at the service of illusion. Again, he stressed, and naturalized, the chronological narrative, characterizing the "history of avant-garde painting" and a "progressive surrender to the resistance of its medi-

um." The easily available translation of Greenberg's insistence on these points is that the "illusion" being resisted is the monstrous face of fascism which, taking figurative form, is the deceptive and destructive image par excellence. Rejecting all forms of subject matter, Greenberg returns to the formulations offered by Apollinaire, Reverdy, and others earlier, claiming the status of "original" and nonimitative existence for abstract works.[42] He then displaces this stance into the prescriptive agenda for painting production. What is at stake is the reduction of the pictorial image to its object status, and the repression of its representational function, in the name of an ineluctable progression toward realization of the engagement with medium as the primary subject matter for art. The self-reflective, self-referential inquiry into the nature of the means of pictorial art—its "very processes or disciplines" were to be its only content (ibid.).

Realizing that the dialogue between illusion and surface dominated, in terms of the shifting parameters of such a problem, the concerns of the French and Spanish moderns, Greenberg celebrated the eventual achievement of American, Dutch, and German abstractionists whose realizations were more purely abstract. By his 1965 "Modernist Painting" essay this "art to call attention to art" became a repressive prohibition against spatial illusion of any kind on the "pristine flatness" of the surface of the canvas. The very surface, its factuality, would come to stand as a fused and irreducible sign, that of the erasure of distinction between the two sides of that other flat thing, the sheet of paper which the structuralist linguist Ferdinand de Saussure had used as his image of the structure of the sign. Greenberg collapsed signifier with signified, thus insisting on the absolute character of *presence* as the material condition of the painted canvas.

Having established that both the fictive genealogy of modernism and the privileged term of value for abstraction were grounded in the assumption that formalism had evolved toward an ever-reduced purity of means so that matter and being were one and the same, Greenberg fixed the discussion of formalism on a single issue: flatness. He proceeded to neutralize that issue so that the complex of repressive strictures it employed were mooted. Greenberg's assertion that not merely figurative representation, but

the very space into which the figure might enter, had necessarily to be repressed, strained the terms of a puritanical neo-Kantianism.[43] "What it has abandoned in principle is the representation of the kind of space that recognizable, three-dimensional objects can inhabit." In the name of "purity" (again, there are obvious ethical contradictions) he had claimed the progression of modern art as the shift from tactile to optical production. The expressionist use of somatic, gestural means belies this claim just as the spatially replete canvases of Pollock, Rothko, Newman, de Kooning belie the call to flatness by which Greenberg had struggled to repress the figure of his own failed faith in the possible space of modern utopian socialism.

Here it is Greenberg's rhetoric in "Modernist Painting" that is most revealing. He states with deceptive liberalness (deceptive because it hides the insistent, purposive underpinnings) that it was not "in principle that Modernist painting in its latest phase has abandoned the representation of objects." Any reader attuned to the symptomatic nature of the disclaimer will see a red herring in the statement of the "real principle" which follows: "abandonment of representation of the kind of space that is recognizable—that recognizable three-dimensional objects can inhabit" (ibid.). For what is repressed in the position Greenberg offers in this discussion is not merely figuration, but its very possibility, the "barest suggestion of a recognizable entity suffices to call up associations of that kind of space." In fact, this should be read in reverse, the merest bit of space calls up, for him, the figurative association—which he most earnestly wishes to repress. The broken faith of his political disillusionment (the distinct failure of the original project of the avant-garde to make a revolutionary change in the social order) forced this injunction against figuration not only because the forces of the "socialist realist" work of the Stalinist totalitarian regime dominated the figurative aesthetic, but because a figure had to be repressed, so fully that even any space into which it might enter, be suggested, as a historical fact and psychic trauma, had to be eliminated as a mere possibility. The bogey of figuration took on grotesque proportions for Greenberg, and the necessity to repress it, and with it, the referential function of a signifying practice in which the materially present image might refer to an absent signified, was so forceful that his

reading of modern art history was derived to naturalize its elimination.

Repressing figuration, Greenberg repressed for himself the figure/figurative art associated with totalitarian propaganda, and, though Greenberg had not stated it expressly, the mass produced imagery of consumer capitalism. What replaced the early utopian *politics* was an abstract *aesthetics* which, by its resistant elitism and unreadability could preserve the terms of a civilized [sic] culture. Drawing the line around the object, metaphorically and metaphysically, the character of abstraction becomes one with the form of autonomy: the ontology of the object coincided with its physical limit. T. J. Clark takes a similar line in his description of the avant-garde as necessarily autonomous for the sake of negation and resistance.[44] That both positions depend upon the same concept of the object simply demonstrates their mutual concern with the discussion of modernism in terms which belonged to the conceptual parameters of modernity itself. To move beyond that delimiting boundary requires giving up the simple oppositional terms of structuralist formalism on which it is based.

In his 1961 critique, "Clement Greenberg's Theory of Art," Clark rewrites the course of modernity as the continual concern with a "negation" which he describes as "an attempt to capture the lack of consistent and repeatable meanings in the culture—to capture the lack and make it over into form." Making this "lack" the center of the modernist project (as if there were *a* modernist project) posits the history of modernity in terms of a continual activity of inscribing absence. In other words, modernism, in Clark's assessment of Greenberg, was the active agent for protecting that which was not there, not present, in culture—a place of resistance and negation. This version functions neatly as a rewriting of the avant-garde in social rather than formalist terms (Greenberg collapsed the two, Clark wishes to articulate them as distinct, but interrelated aspects, but both rely upon a presumed autonomy in order for the former's modernism or the latter's negation to function). But Clark's proposal ignores one fundamental contradiction. To function as negation, the fundamental premise of modern abstraction, the belief in the *irreducible-ness* of the material terms of signification, which they took to be a full and replete visual presence, to an "absence."

Greenberg's endorsement of formalism had been articulated in concert with the assumptions of these modern abstractionists: modernist painting was full, it was visual, it was self-referential and in so being, it could be seen as the effective and functional arena for the preservation of cultural values. The extreme to which Greenberg had pushed the terms of formalism permitted full investigation of the material terms of the object to pass for an account of its ontological status. The formalist line was thus fully naturalized and legitimated and the trope of the genealogical lineage was fulfilled in the generational legacy of Greenberg to his intellectual progeny.

Presence Into Presentness: Michael Fried

Michael Fried transformed Greenberg's formalist prescriptions into an explicit theology of presence, thus directly articulating an implied connection between metaphysics and representation. The terms of pictorial self-sufficiency which Fried promoted were fulfilled in the works of Kenneth Noland, Frank Stella, and Jules Olitski, who, like Fried, were at a generational remove from Greenberg's original critical formulation. Fried unequivocally stated his relation to formalist tradition. He traced his stance back to Roger Fry, whose positions he aligned unqualifiedly with those of Greenberg, and claimed that such criticism was "better able to throw light on the new art than any other approach."[45] Naturalizing even further the approach to works of pictorial art through a nearly exclusive description of their color, forms, line qualities, and internal compositional relations, Fried helped solidify formalism as if it were self-evident, necessary, and sufficient as an interpretive mode. Such a method depends upon the re-presentation in linguistic description of what is taken to be absolute condition: the existence of the image as form. This form is evaluated entirely in terms of the success or failure of the checks and balances of compositional play within its boundaries. If Greenberg arrived at his reductive formalism in a rhetoric of repression and struggle, always grappling with the dialectic of social conditions, Fried had the method immediately at his disposal and seemingly took it on without the baggage of a personal history in relation to its development. He was able to apply it without relation to any sense of history whatsoever beyond the most

clichéd assumptions of progress and the most empirically absolute sense of painting's distinct and discrete identity as an object.

A change in production strategies marks one aspect of the distinction between the first generation of abstract expressionist artists (who had been of such significance for Greenberg)—Pollock and Rothko, for instance—and the second generation of Noland, Stella, and Olitski. In the latter the somatic and gestural trace in paint of the artist's hand and body movements is effaced. To consider this method of production it is necessary to recognize that this was a generation of painters whose formation had been much more codified than that of the previous one. To some extent Noland, Olitski, and Stella were the product of art school training, and of an art world environment in which the doctrines of Greenberg prevailed. They were the result of what had become a proscriptive critical stance. Their "bad" (as per Greenberg) contemporary sibling, Pop Art, made a different transformation from the confines of the expressionist aesthetic. The simultaneous production of Pop and Postpainterly work permitted the operative distinction between the two to conveniently render the works of the postpainterly abstractionists the good object against the Pop artists' bad works.

This opposition is, if not overlooked by Fried and Greenberg, at least not articulated. Yet, Fried's situating of the latter day saints of nonfigurative abstraction within the narrative of inevitable modernism depends upon his repression of such proto-Pop art activities as those of Johns and Rauschenberg. Their very genuine problematization of representation remained squarely within the modern arena, but didn't fit the formalist line as neatly.

"Three American Painters" (1965) and "Art and Objecthood" (1967) were the vehicles through which Fried's extremist rant took the terms of Greenberg's line to a dead end from which the only escape would be radical revisionism and renunciation or formulaic adherence—the choice of the postpainterly abstractionists.[46] The formalist apparatus that Fried brought to bear on painting took the critical apprehension of the object as a foregone conclusion. The object status of the works under investigation was both fully assured and absolutely necessary. Social or political content were excluded in both the image and its interpretation by this extreme of bounded delimitation.[47] But Fried's formalism shifts its tone away from con-

cerns with struggles of the medium or means and into the issue of "identity" and "presence."

Identity, in Fried's work, has both a defining function and a performative function. "What," he asks, "are the conventions capable of establishing the identity of a work as painting?" Posed this way, the question begged is of social conventions, the place of visual art in the order of objects more broadly considered.[48] But Fried turns away from the social sphere into an abstraction, metaphysical and disembodied while relying on material facticity as the basis of "presentness." Replete and autonomous, in Fried's characterization painting takes on the fully realized quality of pure presentness. Sculpture, by contrast, forces an awareness, unpleasant and interfering, of one's own presence and spectatorship. The transcendent quality of "presentness" in the painterly work is in turn granted full authority through linking its defined identity to the concept of "grace" with which it is equated through use of the verb "is." Thus grace becomes the very condition of being in a discussion that is blatantly metaphysical.

The work produced by Frank Stella in the late 1950s and early 1960s made a visual complement to the position espoused by Fried. Constructing his images, like *The Marriage of Reason and Squalor* through a self-referential system of measures, Stella made paintings whose only significance lay in the relation of the visual elements to the structure of the object. (figure 10) The width of the stretcher bar became the determining breadth of the dark stripes, which were either drawn outward from the center or inward from the edge in a steady, systematic progression. The white spaces left were a mere absence, the raw canvas, and thus could not be ascribed any value as figures or lines—they were, in fact, the ground. This inherent and self-evident apparency in visual terms was the fulfillment of the formalist line of criticism—formal in ways which Fry and Bell could have barely dreamt, in their totalized refusal of external reference.

Fried's rhetoric is also totalizing: painting is self-sufficient and replete in its visuality; absence ceases to function in the structuralist binarism of completed signification, and he insists on visuality as immanent and graspable. The underpinnings of Fried's position are phenomenological, drawing on the methodology of Maurice Mer-

leau-Ponty and his consideration of the transcendent essence of the visible. Such a methodology depends upon the paring away of all extraneous information, context, or circumstance to permit the full entity of the object to be apprehended through its visual replete-ness. Thus the being of the pictorial object is unquestioned, though its relation to viewed experience, in Fried's work, is raising the nec-essary and unaddressed specter of the spectator subject.

Fried's position has a parallel in the work of Rosalind Krauss. In "Grids," another work which by its anthologized, quoted, and cited status has come to be seen as one of the critical cornerstones of the modernist lineage, Krauss reduces modernity to that which is "what art looks like when it turns its back on nature." The now familiar notion of the materially autonomous self-sufficient image is com-bined in this essay with the conviction that visual modernity comes into being through distinction from and separation from the literary and linguistic.[49] Both critics predicate their writings in the 1960s on the claim that modernity is about the refusal of language and the fulfilled realization of presence as *inherent* to the visual mode. Greenberg, in spite of his repressive instincts, could *not* keep the repressed from surfacing—he continually pointed out what he was keeping "out of the picture" so to speak, insuring its prohibition through explicit, if incidental, mention. The surface of the rhetoric of Fried and Krauss' early essays is unmarked by such evidence. Not burdened by the same history, they were able to assert the notion of pure presence as the essence of visuality itself. Both recanted: Krauss' formalism moved into the vocabulary of a semiotic, medi-ated concept of the visual, in which the concept of presence was if not exactly anathema, at least highly qualified and problematic, while Fried's formalism expanded to a phenomenological projec-tion into the image.[50] But the terms on which formalist criticism must be undone lie in neither of these (essentially formalist) direc-tions. For both premise their interpretive methodology on the avail-able descriptive character of the object. To move beyond that would require both a critique of the metaphysics of presence and the recognition of the role of the spectator subject in production of the object of investigation. The first of these can be supplied through the work of Jacques Derrida, the second has its own lin-eage, to be discussed below.

Beyond *Form*alism: The Parergon

Warnings about the undialectical character of a positivist belief in art objects as "pure formal constructs" were evident in the writings of the Prague School semioticians in the 1930s.[51] Jan Mukarovsky's warning that art *might* be "immanent" but was *unquestionably* "dialectical" went unheeded in the headlong rush of art historical self-narrativization.[52] The standard line taken by chroniclers of modern art, Greenberg foremost among them, was that art went to objecthood through Cubism and achieved its ultimate self-realization in the high modernist apotheosis. Two fruitful lines of inquiry may be used to deconstruct the development of the formalist fiction of the self-sufficient object: one resides in the development of a fully articulated critique of the metaphysics of *presence*; the other lies in the practices of visual artists who grasp the terms on which *value* is ascribed to art objects and succinctly point out the extent to which object status is continually manipulated, manufactured, produced. The problem of presence will be discussed here; questions of value will be reserved for the following section.

The first of these lines of inquiry follows from the course of discussion to this point. The invention of visual forms whose abstract character mooted their relation to any visual referent in ordinary optical experience was one of the features of the modern period, but the claims to pictorial self-sufficiency with which these forms were critically validated tended to collapse the two discourses of the development of abstraction and the assertion of visual presence into a single inevitable trajectory.[53] These two themes need to be teased apart in reexamining this trajectory. Even within the narrow confines of the development of formal abstraction, a range of attitudes toward the structure of signification are manifest: not every (or many) visual artists conceived of abstraction as pure presence in terms of a pictorial self-sufficiency. Many (for example, Kandinsky, Mondrian, Malevich, and Delaunay) saw abstraction as pictorially self-sufficient, but bearing meaning, resonances, universal or conceptual values. The distance between these two poles—of pure presence vs. a signifying operation resonating to produce meaning beyond the picture plane—created a range of positions occupied variously by visual artists in the last century.

But in addition to the visual arts practices investigating the distinction between formalism and presence, there has been more development, within the current critical arena, of terms on which to articulate this distinction. Certainly one of the elements which marks the demise of the hegemony of the modernist program is recognition of the discrepancy between formal visual imagery and the notion that such imagery is irreducibly present through the fact of materiality.[54] The premise which permitted objects to be read for their meaning through a perceptual apprehension taken as factual has been dissolved by the realization that perception and materiality are themselves contextually mutable. The means of rethinking the object in terms of its ontology, rather than its presupposed material facticity, have been most vividly proposed in the critical tradition which builds on the work of Jacques Derrida.[55]

To begin, it seems important to examine distinctions between formalism and pictorial self-sufficiency as articulated in both critical and visual arts practices. That images were considered to have a degree of autonomy within the modern period, one which is structured (both theoretically and visually) through their attitude toward representation, is undeniable: the liberation of the image from the historical and literary narrative combines with a degree of self-conscious attention to process to break with the tradition of mimetic function. But that self-conscious self-referentiality is emphatically *not* hermetic, not defended against other aspects of signification. Neither the critical writers examined above nor the visual artists of early abstraction were intent upon banishing reference or defining an ontology of autonomy or purity.

From the point at the end of the nineteenth century when the Symbolist mania for the musical analogy pushed the visual arts to become a "pure" medium replacing *reference* with *effective expression*, the theme of pure visuality found its way through the work of various abstractionists. The move away from reference, the drive to free materiality of signification from the task of representation, was perhaps the strongest unifying element among such diverse groups as the Rayonists and Synchromists, as discussed above. The optical investigations of the postimpressionists were very differently conceived. But the two trends, one grounded in a mythos of scientificization of vision, absolute faith in the empirical

and the capacity of pigment to replicate and reproduce through provocation the sensations of a retinal experience in nonemotional and nonspiritual (certainly nontranscendent) terms, combined with a highly metaphysical search for the unrepresentable as it could be evoked and apprehended in form. In both cases the attention to materiality of signification became the focus of the visual arts practice. A near-obsessive concern with what was occurring literally on the surface of the canvas developed an acute sensitivity to stopping there, pausing at that limit and looking, returning again and again to the formal issues posed by paint as paint—not as incidental, but as imperative.

The premises of Kandinsky's search for universal essences, or Cézanne's investigations of visual truth whose adherence to nature through nonmimetic process kept the frame of the canvas permeable both for interpretation of the formal elements within it and for the referential value of visual material even when reduced to the fact of pigment are well known. The Cubist fracturing of form in representation along the lines of light and sight inverted the imperative to register optical truth and substituted the primacy of perceptual truth (that of the viewer). The symbolist dictum that "essence" must be represented, even if in a pale shadow, bleeds through Cézanne's investigations and combines with the Cubist rhetoric of creation, presentation. The image becomes the primary object, the site for experience itself: it is *immediate* because of its material existence, and *mediate* because it comes into being in full recognition of the status its fragmentary elements and their circulation in producing and reproducing signification. Replete with information about the signs of daily life, cubist collage and painting did not banish referential signification, but enhanced its possibilities—allowing fragments of the "real" to sign material facticity on two levels—as fragments of paper/cloth/tissue and as signs for them which enclose the referent within the frame of the image.

Even the most hard-edged of modern abstractionists invoked in the Greenbergian formulation of a lineage of evolving flatness can be demonstrated to link their practices to a referential frame through some activity of the visual components: whether Albers (perception and the optical experience of phenomenon of paint), Van Doesburg (form and balance, compositional factors as mathe-

matical, physical, scientific), Max Bill and Richard Lhose (the rhythm and timing of visual forms), Stanton MacDonald-Wright (harmonic principles). In examples of each of these artists' work the formal qualities of the image are carried to an extreme of nonreferentiality: form is at its most architectonic and geometric, without analogue in visual experience. These images function to *provide* an experience, which thus becomes the basis of their being perceived as autonomous and supports the retrospective claim to pictorial self-sufficiency essential to the formalist narrative of modernity. That each of these artists manufacture the basis for legitimation of their practice in terms of a discourse situated elsewhere in the culture, forcing the visual art to interact with that contextual network in order to be situated and comprehended, is a fact wished away or barely acknowledged, by certain formalist modernist critics and historians.[56] Pictorial self-sufficiency, perversely, served two ends in the history-making process: to support the concept of art as legitimate, sufficient, and self-legislating as a discourse and to support the concept of aesthetic autonomy as a necessary condition for the avant-garde function of art. That Julia Kristeva, for instance, could come to equate the transgression of aesthetic norms within the order of the symbolic as a political act (and in so doing construct her theory of avant-garde language) demonstrates the curious fate of these two distinct consequences of the claim to pictorial autonomy.[57]

A conservative approach to the history of modernism can readily repeat the stylistic inventions as if art were indeed an independent laboratory whose pictorial findings both demonstrate and guarantee its autonomy. An anticonservative approach makes use of autonomy as the guarantor of the old myth of avant-garde opposition and distinction. But the embeddedness of the terms of pictorial self-sufficiency within what Donald Preziosi terms "frames of legibility" is consequently ignored in both approaches.[58] Since it is virtually impossible to situate perception outside of the politically charged cultural network it is equally impossible to assume some abstract and decontextualized stable condition in which to perceive the supposed autonomy on which oppositional strategies of the avant-garde are supposedly premised. There is no "outside" to the political field of cultural activity—and a conservative aesthetics

which depends on autonomy to support a value assumed to be inherent and self-sufficient in a work participates actively in the production of a well-practiced ideology. The very concept of pictorial autonomy is produced through a complex of cultural practices. These grant the object legitimacy according to a fiction in which the object's status equals its material delimitation. In a so-called radical aesthetics this mythic autonomy is what permits the work to operate for the brief (necessary and determinative) moment of avant-garde activity in which appearance and intervention simultaneously coincide in the instance of the rupture of the symbolic norm. While the radical position immediately reinscribes the work within the cultural order (or disorder), it nonetheless also depends upon a belief in *form* as *inherent* and *self-evident*—at least insofar as it is apprehendable. While this is a useful position to maintain for particular ends, the premises on which it functions remain uncritical of their own undialectic positivism with respect to the object as such.

It should be clear by now that the myth of pictorial self-sufficiency has had a long career, but it is a career which has been extended by the reductive rereading of early formalism in terms of the exigencies of mid-century modernism. Refining the view of that early formalism was in part the aim of the above discussions. The further development of this discussion only emerges more recently.

The formalism of Roger Fry as it became the reference point for the high modernist formalism of Greenberg needs to be distinguished fundamentally from the structuralist formalism of Mukarovsky. The distinction may be stated as the difference between a faith in meaning or effect as inherent in the formal value of the image, and the conviction that meaning and effect are generated through codes of difference in which materiality is used to mark the elements of signification—but in which signification is not the direct communication of material properties and formal values.

Derrida's attempt to undo the premises of formalism in *The Truth in Painting* invokes the same metaphysics of difference used in *Of Grammatology* (and elsewhere in his work). In *The Truth in Painting*, Derrida pointedly aimed at the aesthetic tradition in which the conceptual binaristic distinction between *form* and *material* is demonstrated to be based on an assumption of boundedness, fini-

tude, and unity of the object. The "formality-effect" generated in the process is called into question, because it is "always tied to the possibility of a framing system that is both imposed and erased."[59] The concept of the parergon, or frame, used by Kant in his distinction between material and formal judgments, is taken up by Derrida who wishes to erode the object's inherent status. For Derrida the parergon is not the frame that permits judgment to take place, but the understanding that erases and imposes the frame simultaneously in recognition of its effects, assumptions, and predispositions. Thus the notion of difference, and its play, is to replace the concept of inherent in-itself materiality as form; materiality is thus devoid of its assumed unity (a unity of identity of material to itself which was so essential to the neo-Kantian stance of Greenberg) and becomes instead an identity generated through the play of difference.

This distinction operates as a crucial demarcation of phenomenological formalism and semiotic formalism, and, crudely put, would serve for instance to distinguish between the early writings of Michael Fried and the early writings of Rosalind Krauss. The refinement of semiotic and structuralist formalism through the deconstructive practices of Derrida took the issue of difference into a critique of the concepts of presence which had been the foundation of both phenomenological and structural operations of meaning production. Such a critique is essential to moving beyond the empirical bias which continues to promote the fictive status of the ontology of objects as equivalent to their material being.

It must be stated that the metaphysics of presence which informed the practices of high modernism allowed the fulfilled claims of pictorial self-sufficiency to be put into relation to the work of painters such as Frank Stella and Jasper Johns with which they were coincident. Stella's formal geometry deliberately manufactured visual works whose pictorial properties purportedly replicated the material status which guaranteed their existence as objects. Johns collapsed the representation with itself, apparently making the picture into the object to which it referred. The rhetoric of formalism which claimed self-realization for these works institutionalized the collapse of material being with being as presence in uncritical terms. All that is implied in referential schemata and which might intervene in the name of an implied or indicated signified is

short circuited in the Stella canvases. Johns' flag paintings were sim-ilarly in-themselves replete entities grounded in the notion of a visu-al presence, but they resonated vividly within the cultural frame in which that claim was made. The opposition between these two is glaringly apparent, the similarity which binds them, the possibility of a hermetically sealed cycle of signification which begins and ends at the borders of the work of art.

That visual information was not truth, but its opposite—a par-ticular and material specificity—without the capacity for transcen-dence out of that physical form is the basis of a rethought ontology. Reading and interpreting become continual processes of appre-hending specifics and translating them into a network of coheren-cies themselves continually reinvented. The object becomes an available index to a series of readings, each of which configure that index differently. An ontology of signification instead of an ontology predicated on the object status as bounded and physical-ly self-defining, refutes the possibility of a pure presence, substi-tuting an activity of signification in which the play of references and associations invoked by the materiality of the signifying object can be explored. There is no simple presence, no object. There is only a series of intersections, inventions, and interactions, between a materially produced and extant object whose charac-teristics are continually open to reconsideration, (re-cognition, renaming, and rearticulation) and the network of concepts permit-ting their apprehension, which are inseparable from the frame of their conception. "One makes of art in general an object in which one claims to distinguish an inner meaning, the invariant, and a multiplicity of external variations *through* which, as through so many veils, one would try to see or restore the true, full, originary meaning."[60]

Derrida demonstrates comprehensively the impossibility of maintaining the distinction between interior and exterior on which the premise of object status is based. He insists on the operation of the frame to dynamicize the exchanges between the two domains whose fictive distinction permits precisely the interactions which support that fiction. This is not tautological, but a continuation of the much earlier criticism of the metaphysics of presence con-tained in the *Of Grammatology*. There the operations of significa-

tion were subjected to the radical revision of their premises through recognition of the metaphysics that underlay them: one in which signification was a process of continual deferral of meaning in a chain of relations which was ultimately validated only by a faith in *being*, itself theological in character. By rejecting this transcendent term as the ultimate signified, Derrida forced the activity of signification to be returned to the arena of its own operation— as a reading across the play of signifying elements, each, in itself, able to sustain meaning only within a contextualizing field itself formed by these elements. The arguments of *The Truth in Painting* concentrate attention on the desires for fixity and meaning which determined the rhetorical structures of aesthetics, and also, tangentially, art history, to the extent of fixing the parameters within which the very questions which motivate interpretation are formulated. Not the least of these was the faith in the boundedness of the object:

> The chosen point of departure, in everyday *representation: there are* works of art, we have them *in front of us* in representation (Vorstellung). But how are they to be recognized? This is not an abstract and juridical question. At each step, at each example. there is a trembling at the limit between the "there is" and the "there is not."[61]

The object in this situation can no longer be described in the terms of an opposition of inside/outside, interior and exterior operations which has plagued the history of visuality through the whole of the modern period. The methodological implications of this realization are on the one hand revolutionary and on the other reassuringly familiar: they lead immediately to a recognition that the subject is the site of interpretation and the object is an excuse, though a specific and particular one whose relation to apprehension is codified already through cultural contextualizing operations. Modernity charts a shift from emphasis on the subject of production to the produced subject of representation which parallels and supports the shifted terms for conceptualizing the object. Before focusing on this final, third area of theorization, a note on the ways in which visual artists have recognized and manipulated the ontology of the object through playing with the concept of value will be used as a means to concretize the abstract discussion above.

Contingencies of Value

At the peak of his career, Picasso is reported to have boasted that he could practically use his work as currency, letting the relative sizes of his canvases function as if they were denominations of bills. The sense of value with which his authorship endowed the material form of the canvas was barely exaggerated, if at all. The commodity status of the work did reside in his signature, and the relative size, crudely put, did determine its market value. Simplistic and reductive as this analogy is, the effective function of the works as a viable form of economic exchange was defined by the place which Picasso had succeeded in occupying within the artworld hierarchy. There is no particular surprise or mystery in the way the establishment of economic value works with respect to the visual art object, and Picasso's boast was only the articulation of the all but obvious fact that at a certain point what was within the frame mattered far less than *that* there was a bounded object available for circulation and trade.

But the terms of value assigned to works of art have changed significantly during the course of the twentieth century: the late nineteenth-century unit of mobile property still functions within the quotidian activity of the art world, but the manipulation of value as an aesthetic issue has been rethought through art practices which take as their very point of departure the recognition of these operations. The notion of value as attached to the object (which is ascribed an inherent aesthetic value because of the legitimation of the artist's signature) is no longer the sole means by which a work may be strategically positioned within the value system. There is a marked change from valuation of the object as if it were autonomous to recognition of the set of contingencies essential to making that object serve as the marker of value within a system. My purpose in this section is to site a few examples by which that change can be charted.

If Picasso serves aptly as the model of the traditional artist, the modern "master" fulfilling the romantic mold, using his individuated and defined aesthetic in order to parlay it into success which could, in part, be measured by its translation into economic terms, then Marcel Duchamp has to be cited as the modern artist most self-

conscious about the construction of value in precisely those same terms. Picasso's gamble—for fame, for the exalted value of his signature as validation and the ultimate blue chip value of his stock as an artist—was the affirmation of the conventions against which his early aesthetic transgressions gained their definition. Having made his mark as the avant-garde inventor, his work became new aesthetic property, then, art property. The myth that it is the aesthetic character which grants the works value is reinforced by the supporting myth that such work is transgressive. In this case, the act of "transgression" is that of crossing a line from insignificant to significant within the economic system of art property exchange.

None of this is news, here, nor is the fact that the notion of the autonomous art object, with its internal aesthetic order, is the essential coin in the currency of value exchange. Obviously the criteria which attach aesthetic appreciation of the work contribute to the stability of this systematic configuration, and the validation of the work on aesthetic/critical terms which practice the fiction of discrete object identity legitimate the base on which the object can operate as a contained unit of economic value.

Duchamp's recognition of this, as his recognition of the conceptual underpinnings of the institutional framework of modernism, was acute and insightful. His self-appointed task, to reveal the mechanisms of modern art—both in aesthetic and institutional areas—parlayed into a play with the token quality of the art object as a piece of currency.[62] The *Tzanck Cheque*, an image drawn by Duchamp as payment for a debt, is a surrogate object for value. (figure 11) The check plays with both the representation of value and value as a representation. It calls attention to the check as money and the image of monetary value which is in fact elsewhere (the obvious play with signifying practice of course evident as well—the present signifier of the check for the absent value of its meaning and the endless deferral of closure through the circulation of the check, etc.). Duchamp sidesteps the process of aesthetic gambling, evacuates the image of anything but its stated value, and yet validates it as an item of the same order as the Picasso canvases. It is an apparently autonomous, discrete and bounded object—the piece of paper—which is legitimate on account of the author's signature (drawn on his account, so to speak), and thus able to function as a

sign of value in the same terms. By naming "value" as art's content, Duchamp made evident what was masked in the Picasso practice through the filling in from the edges of the frame with marks, forms, traces, and visual elements. Duchamp makes clear that the aesthetic elements are merely an excuse for the instance of the signature to be traded.

But revealing the mechanisms of valuation did not restructure their functional terms. Duchamp traded his own work in the same market as Picasso and made his aesthetic property through similar means—establishing that his authorial function legitimated the objects to which his signature was attached and permitted them to hold their place in the economic system. The development of the understanding of this economic function was made blatant in the unabashed publicity tactics of Andy Warhol. The complement to Warhol as a mid-century figure is Yves Klein, and the way the concept of value is configured in their works demonstrates the shift in terms through which the early modern concept of value was mutating.

In essence, both Duchamp and Picasso saw value as inherent to the bounded object, linked to its place as an object within a system of tradable property. For Klein and Warhol, the production of value shifted to the transaction of exchange. Warhol, in his dollar sign series, made explicit what Picasso had known implicitly—that the size of the canvas determined its market value. (figure 12) The distinction between Warhol's work and that of Duchamp lies in its mode of production. No longer the single unique object with signature attached, which the *Tzanck Cheque* had been, Warhol's screened and reproducible canvases did not have unique object status. In this sense they truly resembled currency which functions in relation to what it can be traded for as the term of its value, rather than for the stated value imprinted upon it. The capacity to manufacture more of the dollar sign images rendered them unstable as unique objects, and their value depended upon their capacity to continue to be traded.

Klein predicated the value of his immaterial works on the contract he made in advance of their sale. In making the "immaterial zones of pictorial sensitivity" he constructed a series of conceptual pieces in which value was dependent upon social acts.[63] (figure 13)

The systemic embeddedness of the work within the social context failed to problematize either as contingent: the one was taken as given (the context) and the other as dependent upon it for determination of value. But the contract for the immaterial gold pieces forced the realization that value was in fact *immaterial*, ephemeral and transitory in character, dependent on circumstances and social agreements, rather than on the inherent value of the object used to motivate the transaction.

Klein's intentions, it should be noted, were conservative in the extreme, and had as much to do with a belief in transcendent essence as remote from form as with the conceptual play of art economics into which his practices entered. Warhol, then, used the commodity as icon, made icons of commodities, reducing art image value to the crude value of a mass-produced object that could not be redeemed in terms of the myth of aesthetic "content" that had validated Picasso's work, or the parody of unique objects and designatory practices that had made Duchamp's activity successful. While Warhol's work signals a break with the terms of aesthetic value essential to modernity, it was the work of Jeff Koons and J. G. S. Boggs whose unabashed manipulation of transactions and criteria of value would force the issue, displacing the old notion of meaning completely with the concept of value.

The course of the trajectory is from value-as-inherent to value-as-systemic to value-as-image, which disregards any need for or recognition of stable context. The very concept of context as such, the structuralist stable frame, evaporates in the work of Koons and Boggs, both of whom call the bluff before the act.

Koons' rhetoric of the integrity of objects, of a brand of neo-Platonic fascination with form, can be almost totally discounted by attending to his mode of operation. Constructing a situation into which his work will enter through the processes of publicity, gallery system, and international art market politics, Koons made objects to put into that place so that they might stand for the transaction of value which they *enable* but do not *engender*. The exchange of value in which Koons' first sculptures, released simultaneously in an edition of three fabricated and identical copies (no original to guarantee authenticity), is the sine qua non of the postmodern inversion of the modern sense of value. Empty of all pretense to aes-

thetic invention, parodying the art object through blatant affront to the terms of taste so integral to the bourgeois art sensibility, Koons followed the transgressive act mode of entering the art system, but with an object deliberately void of content: the ultra kitsch (read, travesty of high art) figurine. It would be a mistake to ascribe too much interpretive substance to Koons' actual images, the production of a scheme through which they could operate and circulate made Koons successful by appropriation of the junk bond and insider trading techniques of the world which had launched him so meteorically in the art world. Koons' works are the floating signifiers of the Lyotardian and Baudrillardian universe, the image which take priority over a real to which it bears no relation, replacing the referent with a simulation whose existence precedes any real by which it could be questioned, redeemed, or condemned.

The work of Boggs also functions through embracing the radical doubt which characterizes the post-modern condition that is modernism's terminal state: Boggs changes his hand-drawn currency for real goods, thus embracing the counterfeit of value first hand, without mediation of artworld screen. This interception into the realm of treasury statutes has brought his work, and him, into legal difficulties, but the bluff which forces him to try to pawn off the work as viable first and redeemable afterward demonstrates that only by playing on the contingent circumstances which make an exchange possible can value be, even momentarily, established. There is no possibility for inherent value, or for systemic stability; there is no faith that a stable context through which, in standard modernist terms, a career might be made by increasing value of the artist's output. Value exists only in the moment of exchange, and only in the contingent set of circumstances into which the object enters as a vehicle for that exchange to be transacted, an excuse, merely, not a cause.

Thus the critique of the autonomy of the object as a bearer of aesthetic value, or meaning through representation, points out that the concept of being, the very ontology of the object, is itself unsustainable within any kind of universal terms. They have all evaporated, leaving only circumstances, contingent terms, transitory situations, and moments of valuation. That works of art could be, as per Boggs and Koons, created within a recognition of and in manipula-

tion of that contingency is the demonstration that the object is continually in production, being produced, rather than circulating as a delimited element within a fixed or stable system. The terms on which the object gains value and the terms on which it is considered to exist are at the farthest possible extreme from inherent value. Instead, the object's value is inscribed in the continually shifting terms of contingent production.

FOUR

Subjectivity and Modernity

This section reassesses models of artistic authorship and views spectatorship in relation to theories of subjectivity. Because the critical examination of subjectivity as a concept in visual art is relatively new, there is shift in methodology from the preceding two chapters. This section is less concerned with rereading a chronological sequence of canonical critical texts than it is with redescribing the ways the concepts of artist and viewer have been transformed in artistic practice, and in turn, the way in which these practices may be used to formulate an analysis of subject positions.

The concept of subjectivity can thus be brought to bear critically upon modern visual art in two ways: first as a means of describing the activity of the producing subject, or artist, secondly, in an analysis of the receiving subject, or viewer. Both "subject positions" (artist/viewer) depend upon a theoretical formulation of the role of representation with respect to the psychic and social construction of the individual. The vocabulary of subjectivity reframes discussions of the concept of the artist within psychoanalytic discourse. In such a discussion, the individual (artist or viewer) is not an autonomous, bounded, or self-evident entity.[1] The psychoanalytic

subject is by definition historically contextualized, constantly in formation, psychically dynamic, open-ended and complex. Most importantly for the visual arts, the subject does not preexist or exist independently of a formation through symbolic systems. Thus visual art, writing, music or any other creative form cannot be characterized as an *expression of* an existing self, but rather, are elements of the ongoing *formation* of the subject through representation. The concept of subjectivity is also premised on the idea that knowledge is mediated through representation which is always historically and culturally specific. Poststructuralist critics such as Michel Foucault and Julia Kristeva have employed the concept of subjectivity to link individuals to ideology and structures of power, criticizing the myth of the transcendent artist or individual genius and emphasizing the social constraints exercised on the construction of identity. These observations have their roots in Marxist social theory, Freudian psychoanalysis and cultural criticism and extend into the present in the work of critics concerned with gender, power, sexuality, and identity in all its interactive connections to culture. In spite of the influence of such critical positions, the image of the romantic artist has proved long-lived and tenacious.[2] The old concept of transcendent genius, of self-willed or determined individualism, and of tormented but autonomous identity are all legacies which remain attached to the image of the artist through the twentieth century. Perhaps this is because no figure embodies and promotes the fantasies and fictions of the bourgeois individual under capitalism more dramatically than that of the artist.

The deconstruction of the mythic concept of the artist and the (complementarily) passive concept of the viewer have, however, been central concerns of twentieth-century art practice and criticism.[3] Much of the art practice of the 1980s had as its stated agenda the systematic undoing of the received tradition of artistic authorship. Similarly, the concept of the viewing subject, first investigated critically in film theory, has been expanded in both art and critical practices. Issues of subject position and viewing have become central themes rather than incidental or peripheral concerns.

A gamut of positions can be mapped in the modernist concern with the role of the artist as a *producing subject*. Starting with an

unquestioned insistence on the artist as genius, original, inspired, and unique, they expand to include the idea of the artist as fabricator, as initiator of an idea rather than producer of work. Ultimately the critique of the artist leads to a critique of the notions of originality, transcendent genius and mastery which had been central to the romantic model.

The concept of the subject as producer is distinct from both the concepts of the *self* and the *artist*. These latter terms imply an intact and fully extant individual whose functions with respect to representation are conscious and direct. According to such notions the artistic works serve as *expression* of the extant self. In a theory of subjectivity representation serves in the ongoing process of production of a fictive self, as the *image* itself is always that image of unity which guarantees to the subject an illusion of its own unity. The subject as such is never complete, whole, or intact: it is split from the very outset between self/other, conscious/unconscious and makes use of representation in the continual mediation according to which it seeks its own definition.

In mapping the positions occupied by the *produced subject*, or viewer, the discussion begins with the concept of a passive receiver of optical information and develops into a psychically motivated subject whose processes of fictive self-identification serve as the very thematic focus of works of art.[4]

The concept of the subject as viewer is accordingly grounded in fundamental operations of representation, most importantly, the active role in completing an illusion of wholeness by which the subject functions. The viewer no more apprehends the image as such than the producer merely excretes it. Again, the theory of artist as self and viewer as self were both integrally linked to formalist analysis of the work of art as an autonomous and discrete object. An ontology of the object grounded in the recognition of contingencies essential to the production of meaning is integral to the theory of subjectivity.

In the discipline of linguistics, especially as it has been applied to literary analysis, the concept of enunciation plays a significant part in defining the ways in which individual subject positions may be identified, marked, and interpreted within textual practices. To transfer these concepts into the study of visual images requires a

fundamental recognition of the differences in the ways these forms are organized—and the ways in which they have been theorized within psychoanalysis with respect to subject formation. For both Freud and Lacan, the role of images and language is linked to development: the acquisition of language as a symbolic system and the experience of stages in childhood development, especially the so-called mirror stage, are both crucial to the ways in which representation functions to organize and produce the subject. Since one premise of the psychoanalytic model of subjectivity is a fundamental absence of unity (or of its possibility), the function of representation is to provide an image of unity or wholeness whose fictional forms and structures can be analyzed. While language is the primary means of representing the fictions of subject identity, visual images also function to produce a specularly pleasurable fiction of self-identity.[5] The mechanisms of enunciation within visual images have been studied far less systematically than those in linguistics and literature. Film criticism in the 1970s and '80s was one area in which the intersection of theories of enunciation derived from structural linguistics was fruitfully brought to bear on the analysis of the function and structure of visual images.[6]

However, theories of enunciation which derive from the concepts of linguistic form are only somewhat adaptable to the articulation of a theory of enunciation in visual forms. Such mechanisms as active/passive voice, of discourse markers and frames, of person, number, gender which are all coded immediately into language in recognizable form, are elusive in the visual domain. The primary enunciative methods in visual images are that of eyeline, point of view, and the theatrical framing of discourse vs. the transparent presentation of narrative. Each inscribes the subject within the structure of the image through a formal means which is in turn productive of an aspect of subject articulation. Point of view, for example, positions the viewer in a particular relation to image and indicates the point at which he or she is sutured into the depiction. Being, in effect, the place *from which* the image is (fictively) produced as a visual experience, the point of view of the subject reproduces the illusion of image production as visual mastery. Though not a "real" point of view, this position provides a fictive place, producing the subject of the image as the place from which it is articulated. Such

an aspect is especially significant in its capacity to engender iden-
tification with the image and thus, in turn, aid in the production of
the viewing subject.

These mechanisms of subjectivity become radically trans-
formed in, for instance, the large scale abstract works of mid-cen-
tury high modernism, where the very fundamental operations of
identification must be invoked, rather than specifically represen-
tational themes and devices, in articulating the production of sub-
ject positions through such work. The process of suturing by
which the subject enters into identification with the work some-
times occurs at the most primary level: identification with the
instance of viewing, the most elementary relation to the activity of
enunciation.

The center of my discussion of subjectivity in relationship to
modernity, however, will not be on the elaboration of the various
mechanisms of subjectivity within modern art practice.[7] Instead, I
will trace out, by presenting characteristic instances, the transfor-
mation of the roles first of artist and then of viewer as they become
producing and produced subject of the image.

Models of the Artist as Producing Subject

Picasso as Paradigmatic Artist

"Picasso's own Romantic belief in genius as a state of being lends
itself to the myth. with Picasso's example it is only a few steps
from genius as a state of being to the divinity of the demi-god."[8]

The well-known clichés of the image of the artist persist through
the twentieth century, and no artist has been more clearly identified
with these clichés than Picasso, as the above citation from John
Berger makes clear. Writing with respect to modern art, Griselda
Pollock commented on the centrality of the image of the artist with-
in the study of art history of the period:

The preoccupation with the individual artist is symptomatic of the
work accomplished in art history—the production of an *artistic sub-
ject for works of art*. The subject constructed from the art work is then

posited as the exclusive source of meaning—i.e., of "art" and the effect of this is to remove "art" from historical or textual analysis by representing it solely as the "expression" of the creative personality of the artist.[9]

The myth of genius is one of the most forceful legacies of the nineteenth century as a basis for legitimating the rarified artistic commodity. The art market is underwritten by a concept of the self which is bounded, intact preexisting and transcending its circumstances, drives and representations. The autonomy of the artist, like the supposed autonomy of the object, is a fiction which needs qualification: the artist is produced by and in relation to historical and social context. More significantly, the concepts of biographical narrative and individual identity which underlie the validation of artistic originality are historically and culturally determined. Picasso's image of himself, and others' of him was utterly formulaic. The monographs and museum catalogues on Picasso contain unequivocal phrases to introduce their subject: "almost all hail the genius who first broke with classical tradition and opened modern art to new conquests."[10] Or: "Pablo Picasso stands out as a leader of undisputed brilliance."[11] And: "In our age of anxiety we treasure the individuality of the artist as a precious commodity." Of which Picasso "is the artistic superstar of our era, and ultimately, a kind of living monument in the history of art . . . exemplary of the creative man."[12]

Dismantled by the critical reformulations of the last twenty-five years, the concept of the artist nonetheless persists—it is the stock in trade of catalogue copy and museum panels, not to mention the art historical monograph and gallery exhibition. It would be difficult to argue away the place of Picasso within either twentieth-century modern art history, or, within the discourses which serve to continually reinscribe him in the conventional role of "undisputed" genius. But, Picasso's own work also provides many paradigmatic examples of the process by which artistic subject production is inscribed both thematically and methodologically, rather than being the expression of the a priori, extant artist as self.

Throughout his artistic career, Picasso was concerned with the

theme of himself as an artist, as well as with the processes of trans-
formation wrought through image-making. John Berger and Meyer
Schapiro (among others) have paid particular attention to these
themes within the range of Picasso's images. In my arguments, I
move between an analysis of two Picasso works which allow the
image of the artist to be discussed in terms of the production of sub-
jectivity, and two texts which grapple with the role of representa-
tion in subject production. The first is an essay by Meyer Schapiro,
which approaches a theory of subjectivity, though within the ter-
minology of art historical language. The second text is the pane-
gyric *Success and Failure of Picasso*, by John Berger, which, in spite
of its Marxist disposition, has an unreconstructed attitude with
respect to the concept of the artist as "self." Berger provides a suit-
able referent for the deconstruction of a formulaic artist as it has
persisted in the reification of Picasso as the modern artist par excel-
lence.[13] I chose these texts because both authors are well aware of
both the cultural and psychoanalytic aspects of subjectivity, and in
spite of this, have difficulty wrenching their analyses of Picasso free
of the overriding paradigm of artistic genius.

Pablo Picasso exemplifies this paradigm; he embodied, for mod-
ernism, the very essence of artist/genius—he was a childhood
prodigy, a foreign outsider, a male whose virility was flaunted in his
biography and in his work (process and themes),whose inventive-
ness and originality were the trademarks of his productivity. In fact,
his work also traces the history of his own anxiety about perfor-
mance, in a conflation of artistic and sexual meanings of the term.
He was an artist who continually reinvented himself as potent
image through his production, using it structurally and thematical-
ly to work through this anxiety. The re-evaluation of his activity per-
mits the discussion of the chief issues pertaining to the concept of
artist as self vs. the artist as subject to be fully illuminated.

The first image with which I am concerned is one of his many
adaptations of Velázquez's *Las Meninas*, in this case, the 1957 ver-
sion in which the scale of the figure of the painter has been exag-
gerated to an extreme.[14] This is an image which focuses the role of
the artist and the construction of subjectivity within the painting; it
also functions to position Picasso within the tradition of Spanish
painting through his relation to the past master. But point by point

the differences between Picasso's version and the original by Velázquez chart the distinction between the classical model of a Cartesian subject and the psychoanalytic model of the modern subject. In the Velázquez's image the illusion of unified space is achieved in accord with the basic rules of perspectival ordering: a single point of view, horizon line and vanishing points are used to scale the figures in relation to each other and a fixed point outside the image which inscribes the viewer. An intricate system of eye-lines maps this space. In the well-known discussion of this work by Michel Foucault, he demonstrates that this work places us, the unpictured viewer, in the position of the royal couple being painted—the ostensible "subject" of the portrait and of this image. The unified set of conditions of light, space, atmosphere and position offers the illusion of unified perception to the viewing subject whose distinct identity exists outside of and distinct from the situation of viewing. The structure of power is described as a strategic function of surveillance and viewing position aligned with royal power and an intact, unquestioned sense of the self.

The Picasso image wrenches each of these systems out of synch. In keeping with his cubist style, Picasso fragments and twists the space, faceting it into areas which serve the graphic interest of his subjective construction through contrasting plane areas of light and dark. This fracturing resists recovery into a unified space, even as an illusion, and is further disrupted by a complete disregard for any regular positioning of figures within it or out of scale in relation to each other. Lacking the naturalizing illusions of spatial structure and unified light, the image functions as a deconstruction of the subjective illusion on which it was established.

Picasso divides the space through the center, graphically and dramatically crowding the figures of Velázquez's court drama into one half of the image. Busy, active, geometricized nooks and crannies of light and dark isolate the figures from each other while in the other half of the image the figure of the artist rises to gigantesque proportions, his overtly phallic brush wielded as the major sign of power. He has little presence as a closed figure, rather, appears as the charged tracing of lines of energetic activity: he never congeals into an image, rather, is depicted as the very essence of productivity. The artist dominates the spaces in the image, towers over the

depicted figures, residuals of a classical period in which the artist existed to serve them as patrons.

Thus Picasso evidences certain characteristic elements of the shift to modernity: the constitutive function of the symbolic order of image making is marked as the disruption of transparency, stressing the role of appearance, the image as site and locus. This activity situates the painter in the representational field such that painting is about and embodying a symbolic self-creation, not serving as mere self-depiction. Deconstructing the classical order through a less than incidental reconfiguration of the power structures of the Spanish monarchy, Picasso reworks the image of the artist with self-production as the central dynamic—disruptive, decentralizing, and resisting unity even as Picasso declares his potency through the structuring activity of the visual space.

This use of the image of the artist's performance and narcissistic inscription of his own activity is a recurrent theme in Picasso's work, especially in relation to his female models. In such works Picasso again serves as paradigmatic example of the strategies of deployment of male gaze and desire across the body of the female model.[15] The structure of visual pleasure functions to fragment the female body into the amplified and isolated zones of erotic excitement and gratification. The image of *Girl Before a Mirror* (1932) condenses this activity into its essential and most representative form, an enunciation of male virility and sexual prowess. (figure 14) The main theme of Picasso's work, in fact, is this preoccupation with his own performance, and the aspects of sexual and artistic life are intimately bound together in the recurrent theme of artist and model. The representation of desire through the sexualization of the female form functions as a primary mode of self-definition through depiction as well.

The returned look does not figure in Picasso's work. Apparently unconcerned with the subjectivity of the other, he plays out the continual subjection of the female through objectification. In *Girl Before a Mirror* he doubles the image, giving the woman first the depiction as "real" and secondly the depiction as "image." The transformative process of his own practice is thus doubly coded through this split imagery. In the first level of illusion she has a graphic and pictorial character which includes the distinguishing

marks of her identity—hair color, features, body type. In the second level of illusion, coded to be read *as* the symbolic within the frame of the symbolic (the image within the image), as the marked mediation of a reflection within the unmarked mediation of depiction, she exists as the drawn portrait within the image. This is a mannered conceit for revealing the "devices of painterly activity," but works to demonstrate explicitly that pictorial representation is explicitly about fantasmatic projection. No attempt is made to duplicate one image with the other, instead they function as transformations of visual material within the image. The painter controls the model with his gaze and subverts the confrontational potential of her look by subjugating it to his own representational order. Picasso here fulfills all terms of the Lacanian model—picturing the fetishized fragments, the *objet a*, which permit the male to motivate his desire without acknowledgement of either the real or the woman from whom these fetishized elements have been removed through mediation of the symbolic.

The tropes of artistic potency and its display through the fetishized activity of representation are central to Picasso's artistic drive. Much of his output can be read in terms of a compensation for male performance anxiety, from the original trauma represented by the *Demoiselles* through the continual depiction of himself as minotaur, male.[16] The continual reinscription of his "self" through this imagery functions as a continual playing out of the fantasmatic need for an image through which to fix the unfixable terms of identity. For Picasso this repeatedly involves the depiction of inscription, of drawing, painting, making of marks as the scribbled manifestation of his phallic brush and somatic guarantee of authorial authenticity.

Meyer Schapiro's 1976 essay examining the processes of self-production in which Picasso was engaged in painting *Woman with a Fan* moves subtly toward the formulation of subject production at the center of artistic activity.[17] Though it stops short of a full-scale articulation of this process, Schapiro's essay demonstrates that the compositional and iconographic changes through which that image progresses mark distinctly different phases in the function of self-conception being formulated in the representational process. The image serves a constitutive function in Schapiro's analysis, or

teeters on the verge of doing so, since Schapiro posits the transfor-
mation of the image as a self-transformation by Picasso. What is
represented is the constitutive struggle to become a self through
depiction, that is, the fictive image of self. Schapiro's vocabulary
retains the concept of the *self* as such, but his discussion implies an
understanding of subjectivity. The "self" is transformed, but remains
intact, whole, autonomous, and Picasso is the "sovereign artist."

Schapiro begins his analysis of the image by asking why the
painted version of the woman (1905) varies in its pose from the
original sketch (also 1905) with respect to her depicted posture and
hand gesture. Comparing the image to a number of other works
from 1905 and 1906, especially one in which a similar, dark stiff
female figure is pictured as the servant to a "smoothly balanced"
nude, Schapiro arrives at the conclusion that the images depict
"contending aspirations of the young artist," and that:

> We may see it [the image of the two women] as an allegory of art or
> at least as an automorph of the painter's striving; for the mirror is both
> palette and canvas and the shadowless nude is the idealized beauty
> that the artist would win and transpose to the canvas; the servant
> then is no menial second figure, but the painter himself.[18]

Returning to discussion of the *Woman with a Fan*, Schapiro terms it
"a critical moment in the development of the self," by which he
means the artistic self. Schapiro, on the one hand asserting that the
images served not merely to depict, but to construct a psychic con-
figuration, is approaching a psychoanalytic model for the function
of representation; but, on the other hand, he continues to conceive
of the "self" which is the artist Picasso as one whose transformations
have more the form of autonomous stages of an insect's develop-
ment: Picasso was "the painter of dolorous figures" and becomes
"the revolutionizer of modern art" in Schapiro's essay, as if these
entities are bounded, contained and self-defining through practice,
rather than aspects of a continual process of construction.

It is essential to recognize how persistent is the clichéd unrecon-
structed concept of the author. John Berger for instance, character-
izes Picasso as the "revolutionary" and "genius"—in spite of Berg-
er's clear recognition that these mythic terms are the legacy of nine-
teenth-century romanticism. The "success" of Berger's title is the

capacity of Picasso to fulfill the mythic image, flesh it out, live up to its terms while the "failure" is articulated in terms of Picasso's "loneliness" and personal isolation, the exile of the expatriate, and also, explicitly for Berger, the failure to commit to a revolutionary politics.

Berger's assessment, astute though it is in characterizing the retrogressive nature of the myth which Picasso embraced, is itself mired down in the same terms. He continues with an elaborate discussion of the (assumed) decline of Picasso's sexual potency in relation to a series of 180 drawings done in 1953 and 1954. For Berger the self-depiction of an old and self-ridiculing Picasso with a "young and beautiful" model is the metaphoric articulation of Picasso's failure, direct, unmediated, and iconographically interpretable in straightforward terms. Berger failed utterly, in 1965, to deconstruct Picasso except in light of his abandonment of political engagement. The problematization of the artist in terms of both poststructuralist criticism and deconstruction, and, somewhat later, feminist theory was only at that moment on the critical horizon in the work of Roland Barthes and Michel Foucault.

On the one hand, this discussion of Picasso has demonstrated the way the paradigm of the artist as self can be deconstructed through analysis of the artist's own practice. On the other it establishes the conventional, paradigmatic concept of the artist against which the twentieth-century deconstructions of that myth have occurred in both critical and artistic processes.

Duchamp and the Critique of Artistic Authorship

While Pablo Picasso can be seen as exemplary of the mythic modern artist, Marcel Duchamp is the modern artist who systematically laid bare the devices by which artistic authorship were constructed within the critical and institutional frameworks which supported modernism. After his brief early period of work as a painter, Duchamp focused on the cultural practices whereby the artist was conceptualized and legitimated. He made the very theme of his work the deconstruction of the cultural category of the artist. Duchamp's investigation does not so much reveal the substance of subjectivity, as it reveals the mechanisms by which the artistic per-

sona is rendered viable, functional, and effective through a series of devices or strategies. Duchamp's own public pose, of aloof intellectual distance, was itself part of the stance by which the internal, psychic dynamic of the individual artist was eclipsed (even denied) within his practice for the sake of emphasizing the gestures of artistic authorship. For Duchamp, it was these gestures—naming, pointing, signing—which functioned to link the artist with an object such that it became defined in cultural practice as a legitimate piece of art. Culturally based and mechanistic, focusing on gestures rather than substance in works of art, Duchamp's own practice was engaged with modernism's premises as a metacritique. Everything which Picasso embodies, takes for granted and enacts, Duchamp dismantles and critiques.[19]

Duchamp's practice was fully formulated in relation to the terms of modernism. The critique he offered was articulated by isolating various aspects of modern art activity insofar as they related to the establishment of authenticity and authority. Duchamp isolated the activities of designation and display as the essential functions of the artist. He was also fully aware of the range of activities through which media manipulation of the production of the image of the artist could be successfully managed, and his construction of personae was a self-conscious aspect of the play with notions of the artistic subject, including the critique of gender as a stable category of artistic identity.

Duchamp began his systematic assault on artistry with the 1917 submission for exhibition of the urinal signed R.Mutt. Making use of a name not his own, and rendering it in crudely dripping paint, Duchamp began his deconstruction of the function of the signature as the basis for authorship. This signature fails to signify sufficiently to assure the success of the piece in its bid for a place within the exhibition—it is apparently an artist's signature, but not linked to a recognized artistic persona. If the revelation of the "true" identity of Duchamp as the artist of this piece would have transformed the gesture (of signing the urinal) into one acceptable in (at least as a challenge to) the art world, then it demonstrates that the signature on a canvas produced in the name of art was equally suspect. After all—what did the signature mean except that it was supposed to reveal the "true" identity of the artist, and the signature was supposed to

belong to an artist whose name was recognizable enough for the signature to be the guarantor of value. This function of the signature as authenticating, as the very mark of, performative assurance of, and legal guarantor of artistic value was called into question both by the urinal and by any number of other Duchamp works.[20] The earlier discussed *Tzanck Cheque*, and the "signed" readymades, for instance, run the gamut of art objects in which at one extreme the *original* consists simply in the signature to the other at which a mass-produced and fabricated object is rendered an original through the signature.

In this latter case the activities of naming and designating come to the fore as valid art practices. The act of selection, of calling to attention, of redeeming through display—these are deemed primary activities of the artist by Duchamp's successful bid for these works to gain the status of art within the criteria of contemporary arbiters. The readymades—bottle rack and snowshovel, etc.—all depend on the validating force of artistic sensibility as something without material expression but dependent upon institutional context. The claim to making art out of an object through asserting the artist's prerogative to make the statement and validate a work through this act becomes the founding feature of such a practice.

In dealing with material transformation, Duchamp further extended the notion of artistry to include processes which the artist merely set into motion, rather than controlled, and then asserted as art through, again, the legitimating term of authorial intention. One such example from Duchamp's work serves to illustrate this activity, the *Three Standard Stoppages*, of 1913–14, in which the very concept of standard and rational conditions for measure, control and systematization are disturbed by the random pattern of the falling meter-length string. The chance action initiated by the artist is set up as a standard whose random variable activity undermines the very possibility of reading intention in form, or accepting standards as universal.

Thus Duchamp mounted two fundamental strains of critical investigation: he reduced the mark of the hand, the artistic gesture or handwriting so essential to connoisseurship and artistic expression, to its most essential, *the signature*, while he divorced the conceptual activity of aesthetic invention from any relation whatsoev-

er to expressive form. There is no trace of the artist as producing subject within the readymades, instead, the artist becomes a function, and that function is designatory, not signatory. The opposition between these two establishes, or at least makes clear, a distinction between two dominant strains of twentieth-century art practice, one of which is expressive, the other conceptual. Very crudely reduced, this split marks the distinction between the artist as a body, somatic, with pulsions and drives which make their way into form and legitimate material by forcing it to express the traits of an individual character, and the artist as intellect, thinking through form with the least amount of apparent individual expression, antisubjective and antiromantic.

It is not very difficult to recognize that the automatic techniques of surrealist drawing extend the concept of the somatic trace until they reach their apotheosis (and dead end) in the work of Jackson Pollock. The concept of artistic process as handwriting, and of handwriting as the most elemental form of self-expression, self-constitution through inscription, requires little elaboration. The functions of authorship outlined by Duchamp become fully split at mid-century between those practices which take authorship further in the somatic realm and those which take the primary term of authorship to be conceptual. This opposition is further problematized by the notions of artist as socially and culturally produced. In this domain Duchamp's activity is more limited: his model of the artist, while ironically perceptive with regard to production of works and the terms of their validation, remained attached to the concept of genius iconoclast. His stance as idiosyncratic and nonconforming, as aloof and separate from his circumstances, bears traces of a self-consciousness about the possible politics of artistic authorship mainly where he is concerned with questions of gender.

Through the persona of Rrose Sélavy, Duchamp effectively destabilized his own image as the male artist. The photographs of Duchamp in that feminine role in the 1920s blur the poles of opposition according to which gender is so firmly and comfortably fixed. Duchamp demonstrated that gender was a construction of representation across cultural categories and signs, not biologically determined. Using imagery to mediate the production of his gender

and artistic identity rendered his undermining of other aspects of authorship as authority that much more suggestive.

In his *Etant Donnés*, Duchamp's last work, the construction of gender as a primary *dispositif* for generation of voyeuristic activity is given full play, along with the clear recognition of the active function of the viewing subject in the making of the work. In this work the artist manipulates the viewer, who is inscribed in a position of Peeping Tom, eye to keyhole relation to the elements which compose a scene whose sexual innuendoes are more elusive and complicated than its gender commentary. That the body offered for specular consumption is female, inert, and sexualized and that it functions as the means of commanding attention and investment on the part of the viewer, who struggles to deal with, comprehend, or dismiss the scene, repeats the standard model of male gaze and female object which is central to western representation, but it subverts the normalizing transparency of visual imagery by forcing the viewer into a complicitous act. Tempted, one looks and looking, one sees, and in seeing, one becomes involved as producing subject, occupying the position of the artist, as organizing vision. The artist, of course, is absent, having sidestepped again, in typical Duchampian manner, the site which he was supposed to occupy in order to satisfy expectations about the authorial intention and authenticity of his work.

Reconstructing the Artist/Author: Benjamin, Barthes, Foucault

If Picasso, on the one hand, embodied the mythic artist in modern practice, and Duchamp critiqued and dismantled some of the devices by which the artist's persona and artistic works were constructed, both of them were formed within the conceptual parameters of modernism. Both were concerned with a concept of the artist as authorial subject, one capable of creating a work—whether through the conventions of brush, stroke, handwriting, or the metacritical strategies of designation and signing. For both the concept of artistic subjectivity was constrained by aesthetic concerns: determining what relation between a producing artist and an object was required for the work to obtain the status of "art." By contrast, however, there is a strain of analysis which runs through the twentieth

century concerned with the cultural production of subjectivity as it relates to artistic authorship, and with the myth of the artist as a cultural—rather than aesthetic—construction.

The idea that artistic authorship is not generated through internal genius, individual talent and idiosyncratic thinking, but through the combination of personal circumstances and social and cultural conditions for production of artistic works is a theme which has come increasingly to the fore. The concept of genius and talent as transcendent continues to come under attack by critics and historians who see the construct as ideological, rather than neutral, and as participating in a politics of oppression, rather than liberation.[21]

These positions found fertile ground in the early twentieth-century avant-garde, for instance, in the work of the Russian formalists, writers, artists, and theorists whose concern with the social function of art and language grounded theoretical critiques of representation in a cultural frame. These are, of course, fundamentally indebted to the work of Karl Marx.

The Marxist critique of individualism leads to the conviction that subjectivity is formed through social, cultural and historical forces far more than through the individuation of psychic reality or personal character. In fact, the fetishization of individualism is identified in Marxist theory as one of the traits of bourgeois culture, one of the very mechanisms which aids in the effective operation of capitalism. As a twentieth-century conduit for and interpretation of the Marxist analysis of culture, the work of Walter Benjamin has been crucial as a foundation for the writings of such important mid-century figures as Roland Barthes and Michel Foucault, who proposed a radical deconstruction of the author-function.

Benjamin's 1934 essay, "Author as Producer," poses questions which force recognition of the extent to which the artist/author is fully integrated with his or her cultural milieu. There is no possibility of transcendent production or autonomous individualism in relation to the question "in whose interest?" which underlies much of Benjamin's investigations of artistic activity. This question applies both to specific artistic practice, and to the metacritical formulation of the premises of artistic authorship. For Benjamin, the political disposition of a work is a *necessary* but never the *sufficient* condition of its production. Calling attention to the apparatus of

production which surrounds any artistic activity, Benjamin insisted that for a work to be of political significance, it must not merely produce thematically some critique of the institutional structure, it must effect a change in that structure. The problem of changing the structure of the myth of artistic originality through the production of works of art leads on the one hand to the idea of applied art and on the other to the idea of collective art. Individual artistic creation is difficult to reconcile with a radical stance, and yet, much work produced by individuals in the years just following the revolution in Russia and the revolution in Berlin attempted to do this. Similar attempts were made throughout the 1920s and '30s in Europe and the United States in an attempt to forge a socially engaged role for artistic work within the utopian rhetoric of the avant-garde.

The conceptualization of artistic subjectivity as it forms part of a radical avant-garde necessarily addresses the status of the conventions of representation. Avant-garde strategies drew part of their political critique from the idea that there was a significant relation between representational form and ideology and subjectivity. The underlying premise is that individual subjectivity is produced in relation to the cultural order of the symbolic, of representation. The role of the artist, therefore, was to question both his or her own subject position in relation to that production, and to effect a change through either the transformation of representation or its instrumental use. The individual subject was assumed to be produced through a relation to the culturally coded forms of representation—especially image and language.

According to this analysis, the artist as an individual produced by cultural conditions rather than an autonomous entity existing in some fictive "outside" of the social order radically upset many of the premises of artistic avant-gardism. If Duchamp mounted a critique of artistic production in terms of aesthetic constructs, then Benjamin's critique of the artist was fundamental to the reconfiguring of individuality as a social construct. Benjamin stopped short of effacing the artist entirely, perceiving an important role for individual practitioners.

Benjamin took as his outstanding model the figure of Bertolt Brecht. For Benjamin, Brecht was an artist who was continually engaged with laying bare the devices of the spectacle of power. In

so doing, Brecht both blocked the narcotic effect conventionally provided by the fictional forms of theater and through that disruption, tried to force an awareness on the viewer of his or her own subject position. A visual artist whose self-conception, as evidenced in a self-portrait done in 1923, can be used to explore the Benjaminian model is Lazar El Lissitzky.[22] In *The Constructor* Lissitzky, clean shaven and evidently without the trappings of the romantic artist (flowing hair and romantic clothing, for instance) presents his photographic visage in the mesh of instruments of mechanical drawing and design production. The role of the artist Lissitzky constructs in this image is of someone very much at the service of the various applications in which his abilities make him useful. The stenciled lettering, the graph paper, the mechanical letterhead with its dynamic formalist elements, and the open hand with compass all belie the handwritten subjectivity of the romantic artist. Here is an artist whose very means of expression and modes of image making are themselves embedded in the cultural context of sign systems whose historical and social specificity resist any hint of transcendence. Artist as engineer, element in the machine of production—not unthinking, but integrated and engaged. Lissitzky has not so much given up on the concept of artistic subjectivity as he has reformulated it: individuality is equivalent to an instance of expression of a social code which has the barest distinguishing trace of idiosyncratic personality. Such a formulation, and the vocabulary of "system" and "code," were central to the semiotic projects of Roland Barthes, and, with some modification, of Michel Foucault as well.

Benjamin had also been able to envision a role for the individual artist, and of individual subjectivity, even within the emerging forms of mass culture—and to project a possibly liberatory use for these forms. For instance, he embraced the film form, seeing it as potentially revolutionary; he did not see the totalizing characteristics of the medium as destructive to and repressive of individual subjectivity, but rather as a means to reach a large, collective body. Later critiques would point to the fact that both the centralized control of production in the film industry and the situation of film viewing (in which the audience has no possibility of subverting the apparatus short of stopping the projector) rendered the subject posi-

tions extremely problematic.[23] Benjamin's critique of individuality and artistic production was still grounded in faith in the possibility of strategic intervention, of art as an instrument for social change (or at least, changed consciousness) and of the artistic subject as if not unique in the romantic sense, at least uniquely situated to promote consciousness through art practice. These premises—of art as intervention and artistic individuality—would be swept away in the extreme rhetoric of Roland Barthes' 1968 "What is an Author?" and Michel Foucault's 1969 "The Death of the Author."

These two essays formulate very different terms for the conception of authorship than those previously considered. As classic texts in this discussion they have, like the work of Benjamin, been widely influential.[24] Barthes' essay challenged the idea of the author as intention and as personality, as an individual existing a priori to texts produced or independent of those texts. Barthes pointed to the fetishization of biographical information and narrative as a key to the critical discussion of an author's work, and then dismissed these as utterly irrelevant to the interpretation and understanding of those texts. For Barthes, the very being of the artist was reduced to insignificance since it was only the body of texts which were apprehendable. The author, accordingly, should be thought of as an author-function, as that which emerges from reading across a body of texts, as that which gives them a unity separate from other texts and therefore distinguishes them as belonging to a group identified with the name of the author. The insistence that authorship resided in texts, rather than in the being of the writer, also pushed the role of reader/viewer into one as active producer, rather than passive receiver.

Foucault's "Death of the Author" essay similarly rejected the idea of the primacy of artistic authorship. Foucault critiqued the very notion of individual talent, replacing it with a model of the social production of all texts and/or images. Foucault proposed that individuals are "spoken" or "represented" through the existing forms which cultural discourse takes in any given moment rather than being the willful users of language and representation. Authorship consists of the very merest act of volition, of allowing that which can be spoken to be so, rather than in shaping the form of the discourse itself. The artist or author is merely a conduit for that

which exists culturally as a set of conditions for discourse, the content of which as well as the form are regulated by unwritten and nearly invisible rules of articulation and composition. These rules are continually, subtly transformed, and, at times, change radically according to Foucault's description of rupture, but they remain largely effaced, buried within the terms according to which the discourse naturalizes itself through representation.

For Foucault, then, the history of art would be a description of the rules governing that which might be depicted and that which is legislated against either aesthetically or legally, rather than the investigation of formal terms of works by individuals whose names are linked to a body of work termed innovative within the strict confines of what is recognized as artistic practice. Discovering and articulating the means according to which such practice is itself recognized and valorized, as per the critical play of Duchamp, would instead be the function of the artist, rather than continual (re)production of the formulae of art activity. Even in such a case, the "artist" does not gain definition through originality, inventiveness, or mastery, all of which are terms accorded by the bourgeoisie to the myth of the artist which is the sine qua non of the mythic concept of individuality—the very myth which, according to Foucault, most negates the possibility of individuated activity, originality etc. by its formulaic pattern.

As a mid-century artist struggling with the problems of artistic identity, Robert Rauschenberg established his own practice through a series of gestures which take into account some of the same issues raised by Foucault and Barthes. Rauschenberg exemplifies the critique and transformation of the paradigmatic image of the modern artist. In his practice in the 1950s Rauschenberg offers a model of subjectivity which is clearly distinct from that articulated earlier in the twentieth century. There are three gestures, that Rauschenberg made at the beginning of his career, in the years 1951 to 1953, which demonstrate his engagement with the problem of establishing artistic authority in cultural terms.[25] The first of these (not chronologically) involves the historical legacy of Abstract Expressionism, and, symbolically, the legacy of modernism more broadly considered as an oppressive heritage from the generation of the

master "fathers" to the apprentice "sons" in the genealogy according to which modernism is generally written. To overcome the sense that somehow all the important aesthetic issues had been dealt with, it was necessary for Rauschenberg to "clear the slate" and make a new place from which to start—not merely a new place which either pretended to ignore that which had preceded or merely looked forward from it. The place had to be created through effacing the marks of the past, by giving himself the same space/place from which to work. For Rauschenberg this place would be one from which he had aggressively emptied out the marks of the past, reducing them to their most minimal palimpsestic trace, the mark of the pencil in the paper when all the graphite has been removed, that sculptural mark of the past, as physical trace.

To achieve this, in 1953 Rauschenberg "erased" a drawing which he begged from Wilhelm de Kooning.[26] He literally removed all the visible (though not physical) marks off the paper. The "space" made was thus apparently clear, but, in fact, not—since the physical traces of pressure into soft paper remained, forever deforming the surface. The "new" space was thus made in reference to the rules of artistic order already in place, which were being actively dismantled. At the same time, the recognition that individual activity was generational, socially positioned, and culturally determined, was marked by Rauschenberg's gesture. He was making a place within an extant system, rather by ignoring or transcending it. Rauschenberg thus marked his own relation to that system through an act of erasure, effacement, which, by its referential character, was always an incomplete clearing of space (graphic, psychic, social).

Rauschenberg's other two initiating gestures for his career and production were the construction and display of bare white canvases (1951) and the painting, making, collaging of the all black canvases (1952). In the first case, the exhibition of the works prescribes a condition in which the projection of the viewer becomes the central feature of the work. The formal values of ambient shadow and light, movement and disturbance must be read in conjunction with the viewer's own perception of the situation and imposition of meaningful value across the apparently blank space.

Emblematic of the function of art activity, of critical reading and viewer experience, this action resonates with the Barthesian concept of author function when the works are reduced to the degree zero of their being, the uninflected, denonational status of representation in which the works are equal to their instantiation of being paintings—without being painted. The situation of exhibition, of display, and of the physical fact of painting forms are all present, but the production of authorship and viewer experience are bound up in Rauschenberg's having made the situation into an excuse for viewing.

The all-black canvases engaged with the density of images already extant, of the system of representation within which the discourse of images may be conceived. Taking newspapers and collaging them onto the surface of a canvas, Rauschenberg then covered the surfaces with black paint until an effect of maximum density was achieved. In spite of their blackness, however, the images still read, still bleed the newspaper base through the surface paint. The presence of this most banal and prolific form of mass media the production of a discourse in which the circulation of ideas and language banalizes the concept of authorship out of existence as one springing from some well-spring of originality and talent, and instead, represents it as hack and formulaic in its essence. The density of the image also causes it to function as the image of all images, as the layered field representing all the possibilities of representation, all that can be represented. Here Foucault's sense of the strictures of discourse production overwhelming the possibility for original artistry are given visual form.

Rauschenberg went on to diaristic and personal works whose relation to the cultural discourse of images also offers suggestive material for discussion of the construction of authorial identity. In all of these three gestures, he had evidenced a concern with the relation between artistic production and handwritten artistic trace: erased, ambient and absent, and superdense. In the next wave of artistic production, a generation of artists intent on banishing that last physical trace of artistic authorship, the material evidence of the artistic subject, would challenge this basis for practice through techniques of fabrication, divorcing the artistic object from any indexical relation to the artist's body. At the same time, a group of

artists would return the practice of art to the very body of the artist as its only legitimate object. Both of these practices moved the conceptual premises of artistic subjectivity into new areas of inquiry through their systematic rejection of what they considered to be outworn tropes of artistic production.

Demise and Rise of the Body: Judd, Warhol, Acconci

Mary Kelly, in "Re-viewing Modernist Criticism," makes that statement that: "It is above all the artistic gesture which constitutes the imaginary signifier of 'Modern Art.' "[27] Kelly's "gesture" is a literal one, the trace of the body through the paintbrush, pen or pencil. Kelly goes on to investigate the investment in the gesture as residual image of figuration which, liberated from "perspectival representation renders . . . in the mark of the enouncing subject, an essential humanness."[28] She notes that the activity of 1960s artists who "denied gesture" presented the viewer with the loss, emptiness and absence of that accustomed (surrogate) presence of the artist and also threatened the dealer with a loss of another sort, that of the "authenticating mark."

Such discussion is typically associated with the work of the minimalist sculptors whose reliance on fabrication repressed the old traces of expressive individualism which had come to be not merely the dominant style but the substantive whole of much Abstract Expressionist work. The deconstruction of the gestural trace of artistic authorship took place through the embrace of fabrication as a means of production. The concept of authorship becomes defined in this work (as it was in the projects of Duchamp) as idea, design, and designation of a work as art. The work of minimalist sculptor Don Judd, and his aesthetic stance as stated in the key 1975 text, "Specific Objects" was to reduce the work to its most consistent and clear identity. In so doing, Judd intended to determine the least condition for art.[29] This least condition was, for Judd, the single necessary condition. Art should approach the status of the ordinary object, and the terms on which it would be distinguished as art were to be as minimal as possible. While this concept, and that of a highly reductive formalist aesthetic, are central tenets of the minimalist sculptural practice,

another feature of mainstream minimalism (I will concentrate on Judd, but similar remarks could be made with respect to Serra, Bladen, Andre and others), was its deliberate repression and elimination of the physical gesture as a material trace in the finished object.

Judd took up the technology of machine production and embraced it as an aesthetic; he also made use of the conceptual apparatus of seriality. These two combined launched a two-pronged attack on the "authenticating mark" which had traditionally linked the work to the body of the artist. There is no trace of the hand and also, no original in the complex, multiple, economy of serial production. Seriality resembles reproduction, but in fact, differs from it precisely in its lack of any original.[30] Thus artistic authorship is dismantled, first because the conventional link, the indexical trace of production, is lost in minimalist work, and secondly, because the concept of the multiple without an original calls into question the finite set of the authentic artistic object.

The artist-function in Judd cannot be constructed on material terms, at least, not according to the physical traces treasured by conventional connoisseurship. There is, literally, no handwriting to be deciphered, analyzed, and checked. The role of the artist in such a practice is to be the source of idea, and to be the means for putting a technology of production into action for the sake of achieving a particular, specific object. The nature of the object's specificity is evidence of the artist's individual subjectivity only to the extent that a body of work read across a spectrum of artistic production would be identifiable and distinct. Thus the stacked metal forms which alternate with empty space of equal size in Judd's untitled sculptures of the early 1970s are distinct from Carl Andre's flat metal squares, or Sol Lewitt's sequential grids, but could not be linked to Judd through any material evidence of gesture. As the gesture of the artist receded from sculpture, the body of the viewer came into play—Michael Fried's main objection to minimalist sculpture was the self-consciousness of one's own physicality which it forced in the viewing situation. This condition of theatricality will be discussed below, in terms of the enunciation of a viewing subject, but the discrepancy between Judd's stated intentions with respect to the production of what he termed "specific objects" and the resulting

repression of the artistic subject in the fabricated form is the crux of the critique formed in material of artistic subjectivity. (figure 15)

The specific object was to have only properties which belonged to itself; it was the extreme extension of a self-referential materialism. Thus the presence of any trace of artistic production was superfluous, external, extra rather than essential to the being of the object. On the one hand, the romantic inflation of artistic gesture within expressionist painting had become such a cliché that some reduction of claims to artistic authenticity on the basis of the gesture was a logical response. On the other hand, however, the move to conceal and render moot the artistic touch goes hand in glove with the minimalist aesthetic of a seamless productivity. An object which celebrates the lack of human flaw, human fallibility, is repressive of subjectivity at the font—it attempts to preclude the very role of representation in a constructive or constitutive function. The specific object is extremely nonspecific with respect to its relation to artistic subjectivity—it could have been made by anyone, and, preferably, was machined.

Judd wrote that "Most sculpture is made part by part, by addition, composed."[31] Such sculpture contained elements which were in relation, which had complex, intricate, and unstable order: Judd sought a stable relation of ordered elements, a fixed representation, an object status in which anthropomorphic references would be eliminated. The work was to exist as such, in itself, as a concrete form which was, fundamentally, idealist. In such a structure, issues of authorial identity could not be configured, they were, by necessity, absent and repressed.

While Judd stressed that his aim was to get "rid of the problem of illusionism" my argument is that the subtext is the repression of subjectivity under the monolithic seamlessness of corporate capitalism. This might seem a reach, were it not for the fact that so much of this work bears all the signs of the ideological frame within which it was produced—the seamless face of capital producing a sign of value which was otherwise empty. The object functioned solely and entirely through production, which made it appear as fictively autonomous and self-sufficient as the artist—who, according to Judd, should be "as independent of the surrounding society as possible."[32] The achievement of fabrication also allowed claim to a

particular object status because "almost nothing had been done" with the means of industrial production "because of the cost." Fabrication guarantees value through production at the point where it eliminates value through artistic gesture.

While Judd's work, and his aesthetic premises, are one clear manifestation of this critique of authorship in material terms, a very similar critique is raised in the work of Andy Warhol, though the look of the work, its aims, sources and aesthetic position are radically different.

Returning to a much earlier model of artistic production, that of the studio as small scale industry, Warhol cranked out multiples with the aid of a paid staff of assistants. Their relation to his work, as of Renaissance apprentice painters to their masters, was purely perfunctory. The Warhol Factory authenticated each print, poster, canvas through brand name validation. What was missing in terms of the hand was made up for in product standards.[33] Combining the old studio model with that of mass production, Warhol forged the first new version of art as industry, manufacture. The artist's product was linked, not physically, but conceptually, to the originator, as in the works of fashion designers or other signature products. In the case of Warhol there were, of course, originals—those early pieces he had hand drawn and painted, the sketches for later works, ideas, or any other scrap on which some mark of his actual hand could be detected. But such top-of-the-line originals were neither necessary to the success of the rest of the work produced nor dependent on it. They were vestigial, an unessential appendage which merely linked Warhol to some outmoded system of commodity production.

Thus, while violently opposed in terms of their apparent form and concerns, minimalist sculpture and pop art both marked the distance they had come from the body of the artist. In the case of minimalism, this was, as mentioned before, accompanied to some extent by a shift into a theatricalizing of the viewer's relation to the object's presence. In the case of pop art there is an unabashed refusal of accountability to the older model.[34]

An important transition figure in this discussion is Jasper Johns. His hand painted images of the flag from the late 1950s into the early 1960s work both to continue a gestural tradition, to demonstrate the integration of the subject with cultural conditions and cir-

cumstances, and also to approach the condition of fabricated and nonhand-made works. Johns, like Rauschenberg, ultimately remains much within the tradition of the artist as maker of originals whose gestural character is readily perceived. But the flags, especially in so far as they circulate as icons, are split from their *faktura* into a reproduced emblem of that sign of Americanism which bears such problematic associations. As Fred Orton has pointed out, the flag had many personal associations for Johns as well as public ones, and his use of it is the very precise articulation of exactly that intersection of public image and private recollection, collective identity and individual difference, which describes the subject in its fullest sense.[35] The trace of Johns' hand in the painting of the flag marks it as *his* version of *that* thing, and the articulation of subjectivity in these works sits just between the mass production of iconicity with which the Pop artists elide their subjectivity and the expressive character of the validation of gesture in its own right of the Pollock generation. Johns' body is about to be effaced, disappeared, overwhelmed by the iconic force of the imagery, but it persists, in the subtle handling of paint and the subservience with which it reproduces the precise dimensions of the flag.

Toward the end of the 1960s another artistic practice emerges which both refuses the authorial trace and simultaneously returns us to the body of the artist with a finality and certainty which raise other questions about the structure of artistic subjectivity: performance and conceptual art. Lacking matter it necessarily lacks the trace of the artist as such and yet in this dematerialization; the artist's gesture is returned to its source—the body of the artist.[36] Here again I am following Mary Kelly's argument: "It is no longer a question of investing the object with an artistic presence: the artist is present and creative subjectivity is given as the effect of an essential self-possession."[37]

Performance art relied upon the authenticating aspect of physical corporeality to guarantee the effect of the work. The conceptual premise of the work, of what constitutes work as such in the piece, is to a great degree determined by the status of the artist's body in the piece. Vito Acconci's work in the early 1970s poses a curious counterpoint to the work of the body effacing minimalist works produced in the same period.

For if the concept of subjectivity is linked to representation through the function of an image, a returned (if fictive) image through which the self seeks some affirmation of identity, then work which negates the visible trace of the self and work which does not provide an image/object with which to reflect both short circuit the subject formation, though in different ways. The first case, as per above examples of fabrication, has a repressive character, while the second case, that of performance, has a peculiar narcissism. Returned to the body as the site of the work, both its source and its object, its material and its expressive effect, the performance piece refuses any separation between self and imagined other through which subjectivity can be effected. And yet, the very effect of the kind of self-manipulation which was central to Acconci's work is to attempt to separate the body from itself, to have it function as site of subjectivity and object of representation at the same time.

Two performance pieces by Acconci from the period around 1970 were *Bitemarks* and *Hand to Mouth*. In *Bitemarks* Acconci simply, literally, bit his own arm and embedded the marks of his teeth in his own flesh. As an emblematic gesture, this suffices to extend the expressive character of the abstract artist's activity onto the artist's own body. The trace, authenticating, authorial, artistic, remains only so long as the flesh retains the imprint. Temporal and transitory, it is an image of the body on the body. The self-referential circle is broken by the temporal effect—that the mark remains visible in the flesh allows it to serve as image. The artist's body is both site of artistic activity, and its source.

In *Hand to Mouth*, however, even the concept of the trace is undermined—for Acconci stages the performance as a test of his capacity to consume his hand and arm inside his mouth rather than to mark his body through activity.[38] As a repetition of the infantile oral urges, the consuming desire for gratification, and the relentless attack on delimiting boundaries which guarantee individual identity, the work is regressive. In analytic terms, the condition of subjectivity is infantile, unseparated. But in artistic terms, the containment signals a refusal to produce and be separated from one's production. The subject is the product, and artistic subjectivity is the condition of producing. Conceptual art and performance art's attempts to make an art without products is the inverse of minimal

art's attempt to make a product which retained no trace of the artist. The self-sufficient and specific object of minimalist design repressed artistic subjectivity in so far as it was linked in any way to the body of the artist, while a performance artist like Acconci made artistic subjectivity the entirety of the work.

Both activities mark a departure from the mythic notion of the artist on several counts. By refusing the authenticating activity of the artist's body, the work of fabricated work calls into question the unity of the artist as an essential component of production. The "artist" becomes instead a series of operations, from design to production to finish and installation, all of which are coordinated according to a "vision" of an authoring individual. This individual serves to anchor this sequence of functions so that it reads with the kind of consistency which Barthes ascribes to the author-function. The delimitation of the artist's activity at the border of the body forces the question of the viewing subject back into prominence. For what is at stake is not merely voyeuristic spectacle, but the surrogate of experience achieved through identification. The performance artist is context dependent temporally and spatially, but more importantly, is bound to the sustaining structure of cultural discourses which recognize and permit the opportunity for performance in the name of art activity. That Acconci's bite marks on his own arm constitute an art activity puts the artist into dialogue with his or her own self-production as a subject, forcing the body, the site of the imaginary functions, to serve as the term which enters into symbolic discourse. The artist implodes his/her gaze in a narcissistic short circuiting of the mediating image. The role of representation is itself called up for question, and, for at least some years, is found to be one of superfluity.

Impossibility of Originality: Sherrie Levine and Richard Prince

The transformation of the conventional notion of the artist reached a watershed with the work of artists who appropriated images directly from the canon of art history or from the most banal mass media sources and re-presented them within an art context. Sherrie Levine's rephotographing of so-called "masterworks" and Richard Prince's mounting of such common image currency as the Marl-

boro man exemplify such practices. Both critique the processes of artistic production and the mythic status of the artist. The critical writing which supported such work perceived in such efforts a gesture critiquing the fundamental terms of modernist production. The role of the artist as individual, original, transcendent genius was transformed into a subject repeating endlessly the already available already made catalogue of imagery.

While Levine and Prince both focus their attack on the dominant terms of the definition of the artist, they articulate different concepts of subjectivity.[39] Levine's critique is more clearly aimed at the myth of the artist, while Prince's points toward the social production of subjectivity within the domain of representation.

Levine refused to add anything to the works she appropriated. She began with a straightforward rephotographing of well-known images by such photographers as Edward Weston, Aleksander Rodchenko, and Walker Evans.[40] Her re-presentation was as unmarked a mediation as possible. Abigail Solomon-Godeau commented: "With a dizzying economy of means, Levine's pictures deftly upset the foundation stones (authorship, originality, subjective expression) on which the integrity and supposed autonomy of the work of art is presumed to rest."[41]

It is partly in the "economy of means" that the pointedness of Levine's critique of authorial subjectivity resides. For the repression of any mark of appropriation, any clue to the act by which the images *were* appropriated, recycled and re-presented is what effectively makes them full critiques of traditional artistic production. The reworking of a Velázquez image by Picasso has nothing of this transparent process in it—such a work was always about Picasso and his self-perception as an artist within the grand tradition. For Levine, the very process of photographic reproduction was essential to these acts, because of its capacity to *pass for* an unmarked and uncoded mode of image production. Levine's work was very clear in its appropriative gesture, as was the critical perception of it: "By literally *taking* the pictures she did, and then showing them as hers, she wanted it understood that she was flatly questioning—no, flatly condemning—the most hallowed principles of art in the modern era: originality, intention, expression."[42]

Walter Benjamin, in his 1936 essay, "The Work of Art in the Age

of Mechanical Reproduction," had celebrated the photographic mode because it had the potential to subvert the auratic hold which the original had over the production of images and of art. The excess value which accrued to such an original and the effect it produced through the "aura" of its material presence, were to be neutralized by the making of multiples whose similarity to the original was sufficient to destroy the distinguishing virtues of the original image or object. In the case of Levine the relation to the original becomes a relation to originality on the one hand and authenticity on the other. The concept of originality is supposed to disappear through an act which calls attention to the infinitely reproducible nature of the image and to the proprietary claims to original formulation of the image. The notion of authenticity is subverted through the impossibility of determining the status of the image—at least through casual means. In fact the chemistry and apparatus of photography leaves all manner of analyzable traces in the material of the image. Probably the most threatening aspect of Levine's work was its destablization of the market value of the image as original, and the blatant disregard for the rules governing artistic trade in so far as they are linked to the concept of authentication.[43]

Craig Owens' analysis of Levine's work raised other issues as well. Though he acknowledged her dramatization of "the diminished possibilities for creativity in an image-saturated culture" he went on to develop his argument.

Or is her refusal of authorship not in fact a refusal of the role of creator as "father" of his work, of the paternal rights assigned to the author by law? . . . Levine's disrespect for paternal authority suggests that her activity is less one of appropriation—a laying hold and grasping—and more one of expropriation: she expropriates the appropriators.[44]

The issues of ex- and ap-propriation posed by Owens function only when the demarcating lines according to which ownership and authenticity seems to be adjudicated can be used in relation to strategies of power. Thus the act of expropriation Owens describes depends upon recognizing first that the photographic activity of, for instance, Edward Weston, depended upon *his* appropriation of the image of others. To Owens, Levine is questioning Weston's right to

perform this act without acknowledging the structure of power which such image making reflects—that of, typically, the male artist's representation of the Other who is, in turn, spoken for through this imagery.[45] This realization leads inevitably to an examination of the relations structured into representation between the enunciating subject and the subject of enunciation, the producing subject and the produced subject of representation.

Before moving on to this area of discussion, a few comments about Richard Prince will complete the investigation of artistic subjectivity. From the first readymades, those activities in which already extant objects were presented as art, the effacement of the trace of the organizing subject/artist had been established. Many early twentieth-century collage works linked the appropriative sensibility of the readymade with the conventions of a more painterly, and clearly individual artistic sensibility. The stuff of mass production—newspapers, journals, photographic reproductions—were cut, pasted, recycled. The mode in which Richard Prince appropriates images borrows from the readymade far more than from collage, in spite of the fact that the material he uses is the stuff of mass-produced images. For while collage contained both glaring evidence of individual sensibility in terms of aesthetic choices, thematic materials, organization of the physical elements and their sources as indexical links to the context of the artist's life as lived, the work of Richard Prince, by appropriating the images wholesale from the mass produced media, moots those aspects. Prince's work also differs from the collage work of an artist like Rauschenberg, whose diaristic eclecticism made his canvases into par excellence examples of the individuated instance of the culturally produced subject. The images put forth by Prince in the late 1970s, early 1980s, like those of Levine, bore no trace of the artist within their physical form. The image of the Marlboro Man, the quintessential, banal, mass-produced graphic, functioning as icon and also losing all its associative edge in the process, is represented in order to call attention to the loss of meaning it bears. The thematic possibilities for interpreting the image escalate, but also, the strategic possibilities of art/nonart questions worked out across an image whose authorship is at the opposite end of the spectrum from the masterworks used by Levine. Here the image exists as part of a shared cul-

tural field, recognized and legible for its place in that field. This is an image which "speaks" the viewer by virtue of its circulation and repetition, and the artist, Prince, merely calls attention to it as an instance. His relation to the image does not return to him as artist the designatory force of a Duchampian gesture of recognition. He is merely attempting to fulfill the role of one whose place in the cultural order of representation is integral, and whose artistry is already fully circumscribed by that position. To be an artist, then, is merely to be an enunciating subject of the already extant field of imagery, language, representation.

The dead end which such activity reaches is evident, as are the paradoxes of the denial of authorship to which names attach and through which careers are made pretty much in the same manner as they have been throughout the twentieth century. The shift in terms of artistry, however, and the fundamental reformulation of the role of the artist as well as the characteristic traits of originality and mastery have effectively diminished the viability of notions of transcendence. In addition, the emphasis on the role of the viewer, and the relation between the situation of production and that of reception achieve greater parity. Thus, the role of the artist as producing subject approaches that of instigator of situation of viewing while the role of the produced subject is more fully acknowledged and active.

The Produced Subject of Artistic Enunciation

The concept of the produced (or enunciated) subject is more elusive than that of the artistic producer. On the one hand, the produced subject is linked to the object, to the formal structures, devices and strategies which it uses to position the viewer, and construct an experience for the viewer.[46] Within the domain of literary and film criticism which developed out of structuralist and poststructuralist theory in the 1970s and '80s, the enunciated subject became an important object of analysis. It allowed the focus of interpretation to shift from the formal structure of the work to the received effect, and from an intact and autonomous concept of the work to the dynamic of interaction. The enunciated subject should be distinguished, however, from the viewer per se. The subject is a

construct, a set of positions and effects structured into the work itself. These need not be the same as the positions of a "real" viewer. An example may make this clearer: the Velazquez painting analyzed in such detail by Michel Foucault, *Las Meninas*, was particularly intriguing to Foucault precisely because of the structures of subjectivity which it contained.[47] While it inscribed the image and activity of the artist as producer, it also inscribed a position for the viewing subject. This position, a so-called enunciated subject position, was that of the omnipotent, surveillant monarch who was "positioned" outside the image though the image was constructed as if through the gaze of such a subject. The subject position enunciated by the image is thus evident in the formal structure, but is not the same as its formal structure (room, with the princess, attendants, mirrors, windows, perspectival forms and so forth). Nor is the viewer, actual viewer, required to occupy the precise subject position enunciated by the work—in spite of the fact that very few of us are royal monarchs in our viewing of the image we can take account of the subject position and at the same time remain distinct from it. Our subjectivity as viewers is defined in relation to the relations within the image, its enunciated subject, and to our own real situation of viewing—which, of course, continually changes.[48]

In this section I propose to sketch the changes in the concept of enunciated subject/viewer which can be identified in the trajectory of modern art practice. There is an argument to made for the fact that the old model of the unified subject of perspectival space continues to assert its primacy with respect to much of photographic and painterly representation. But various artists and theorists have proposed different constructions for the enunciated subject of visual representation in the course of the twentieth century. There has been so much less work done in this area of inquiry than in any of the others which I have touched on, that this will of necessity be both more brief and more speculative as a section than any of the previous ones.[49] This will be even less of a survey of critical positions than the previous section, and more of a suggestive sketch of reassessing artistic practices through the contemporary theory of representation. Once again, I use select examples, proposing a series of structurally distinct models, rather than mapping a continuous (nonexistent) line of development.

To begin, there is concept of the viewer which complements the notion of the self-sufficient autonomous object, one which assumes a viewer is an intact, autonomous and self-sufficient subject. As the discrete boundaries which isolated object from its contingencies of viewing and production are blurred, in, for instance, minimalist work, the concept of the viewer as existing a priori to and separate from the situation of viewing is called into question. The concept of the enunciated subject is what comes into play in a situation in which the "viewer" is constructed in and through the position of viewing an object.

The twentieth century begins with a decentering of the fictive unified subject of classical representation; such a gesture is associated with cubism and the fragmentation of the field of representational activity. Such a decentering is the complement to the deconstruction of the myth of the artist as well as the corollary to the reconsideration of the ontology of the object. The reciprocal relation between production of the object and production of the viewing subject increases throughout the twentieth century, and the decade of the 1980s most especially focused upon the necessity of rethinking the role of the viewing subject in relation to visual images. From the position of an old, renaissance model of the unified subject, dreaming itself into existence through a fictive identification with an image, the subject seems increasingly destablized and fragmented as the codes of representation become increasingly disruptive and contingent.

The concept of the *produced subject* comes from a synthesis of structural linguistics and Lacanian psychoanalysis. The development of this relationship and of the notions of subjectivity involved have been documented by Kaja Silverman and Jacqueline Rose, among others.[50] The very phrase *enunciated subject* gives evidence of both contributing disciplines. The concept of enunciation develops as a means of analyzing the structures of language to understand how they make and position a reader through mechanisms in the text. The reader is not merely the passive receiver of the text, but is constructed by it. The notion of the subject as a formative dynamic derives from Lacanian psychoanalysis, and though the role of subject/artist and subject/viewer are not the same, structurally speaking, the drives which make the relationship of viewer to text

originate in a similar need for fictive identification with an image, and with the symbolic order through which the "speaking" subject is constructed.

The processes of identification which motivate the viewer to engage with the image occur at two distinct levels: identification with the *fact* of viewing, most simply, the fact of looking at the image, and, identification with that which is *depicted* in the image, the theme or events (when they exist). The classic model of perspectival space permitted both levels of identification to function—the viewer was able to progress rapidly from first to second, and the very transparency of the representational strategies was designed to make the viewer forget the instance of viewing.[51] Twentieth-century modernism calls increasing attention to the instance of viewing and blocks the secondary identification either through formal and conceptual means or by the evacuation of a representational scene from the work. Thus the issues of enunciation of the subject in abstract modernism are distinct from those of representational or figurative imagery in which the subject is positioned in relation to the spatial and narrative structures.

The basic activity of subject production is described in psychoanalytic terms by Jacques Lacan, whose description of the mirror stage, discussed above in relation to the activity of the artist, is even more powerful in accounting for the effect of images in the viewer. For where the artist must move beyond the mirror stage into play with the symbolic order of representation, the viewer remains more securely within the stage of the *imaginary*, identifying with the situation of viewing as well as with the unfolding thematic depiction (where there is one) of the viewed imagery. For the viewer the activity of looking replicates the scopic pleasure of the infant in the developmental stage of the mirrored fiction of unity. Again, one may identify with the *what* that is being shown, or simply with the *fact that* it is shown.

That the processes of subject production become thematically and structurally central to late twentieth-century art activity is reflected in the increased concern with these issues in the critical field. A developed discussion of these activities, in which the psychoanalytic model of subject production combines with the linguistic analysis of the mechanisms of enunciation—position, point

of view, framing and so forth—occurred in feminist film theory in the 1970s with the work of Laura Mulvey, Elizabeth Cowie, Stephen Heath. The synthesis of the linguistic and psychoanalytic models into a powerful tool for understanding the effective function of representation had originated with French critics a decade earlier, such as Roland Barthes and Michel Foucault, and combined the analytic tools of such linguists as Roman Jakobson and Emile Benveniste with the psychoanalytic work of Freud and Lacan.[52] The feminist critique of the patriarchal nature of representation exposed the centrality of gender difference to the issues of subjectivity in a manner which, again, gets explored through artistic activity as much as through critical theory.

Though it may seem specious to trace the decentering of the viewing subject back to the work of Edouard Manet, the place of Olympia in the literature on the enunciation of viewing positions makes it beg, at least, for mention at the beginning of any analysis of subjectivity and spectatorship within modernism. The frank gaze of Olympia, as she looks out of the frame, broke the spell of the renaissance convention of a spectacle presented for the viewer's unabashed and unacknowledged pleasure. Olympia is hardly alone, winking angels, knowing saints, ancient sages and coy lovers have caught the gaze of the viewer for as long as there have been images in which they could be depicted. But Olympia's gaze has taken on a mythic place within the literature of modernism, it has become, even "a notorious symbol of modernism" itself.[53] Why? Her frank gaze confronts the viewer, violating the contract of representation in which the image is displayed for the viewer's pleasure without any marked reference to that activity. The innocence of voyeuristic specularity is lost forever to the western artworld. The conventions of unified space, and of the positioning of the subject with respect to the picture plane such that the image coheres into a unity, are respected, but the complicitous illusions are beginning to be accompanied by a laying bare of devices. It is this combination of elements which marks the Olympia's gaze as such a striking instance within modernism—because it is both confrontationally cool, returning the viewer to a position of acknowledged exteriority, and because it occurs within a work whose own self-consciousness of the construction of painting has begun to be a visible aspect

of the subject matter and structure of the work. The viewer cannot simply be lost in the illusion of depicted space and voyeuristic spectacle, but is made aware of the constructed artifice of the work, of its existence as a painting, on a surface, and of the activity of viewing as an active rather than passive activity.

In another work by Manet, the *Bar at the Folies Bergère*, discussed above with respect to its construction of space, there is an anticipation of the fragmentation of point of view within the image which becomes such a central concern of Cubism. As mentioned, the image offers a series of fragments which may be the result of temporal disunity, of spatial dislocation, of collage of sketched elements, or of the deliberate attempt to subvert the reassuring unification offered to the spectator by the image. The position of the reflection of the man in the mirror, whose gaze seems to be the one into which the viewer is to enter, cannot in fact be reconciled to the placement of the dominant female figure. She is seen from a point of view not occupied by the man whose reflection we see. Thus the gaze is split, already, between that of the fictive male, typical viewing subject, and that of some other viewer, not identified within the image. Furthermore, the reflection of the woman in the glass is out of scale with her relation to the space, and thus inscribes yet another gaze within the representational strategy of the image. That a figurative image could, would, split the conventional unity of the subject in such blatant violation of the traditional regime of perspectival organization on the one hand lays bare these conventions and on the other subverts them in a manner which announces the fracturing of the subject as a component of the modern sensibility.

Decentering the Subject: Representational Disunity and Fragmentation

In modernism in the visual arts a succession of inventions function to call attention to the activity of enunciation of images and of the production of an enunciated subject: "Cubism subverted the founding unity of the subject in its 'natural' understanding of the coherence of 'objective' reality."[54]

The fracturing of space as a device for fracturing the subject is most eloquently taken up in the work of the cubists, whose prob-

lematization of the unified subject is emblematic of modernity. Rejecting the unity of viewing position and viewing moment which had served to keep the illusory subject intact, the space represented in cubist images fragments the positions for the viewing subject. The process of reconstitution of the illusion of identity provided by a unified image cannot occur in the same way with the faceted perspectival imagery of, say, Picasso's 1912 *Still Life with Chair Caning* as with a still life by Clara Peeters or William Harnett. The cubist image denies the primary need for illusory unity which motivates the scopic drive. If the mirrored image is what provides the fictive image of the subject as a whole, then the fragmented image offers only a situation for continual construction. The cubist image resists an easy closure, and the viewing subject is compelled to engage in an active process of viewing. The enunciated subject of the cubist image is without doubt fragmentary, but struggles to reintegrate the visual elements into a consistent system of ordering which, finally, allows them to be read in unifying terms. The viewer cannot, however, reconcile the fragments into a single image, nor a single moment or position of viewing. The cubist image *is*, however, produced as the experience of a single point of view, sensibility, or subjective stance.[55] But the enunciated subject is necessarily always in a condition of fragmentation.

Still Life with Chair Caning, for instance, makes a classic case study. The plane of representation positions the viewer above the table or chair seat which is caned; the glass, lemon, napkin and other elements of the still life arrangement, are presented in front of the viewer, as per the conventions of still life. But these conventions are, as per the cubist mode, shattered by the dispersal of the objects across the surface into a series of fragments which intersect with each other through a sequence of planes of light and space (rendered as hard lines and edges or distinguishing themselves as light/dark areas of depth and proximity). The viewer then has, from the outset, to deal with several different systems of ordering space, none of which neatly conform to a perspectival unity. Thus, simply with respect to viewing positions, the subject enunciated by the image is fragmented. In addition, there is the tension between reading and seeing which is characteristic of collage—the experience of a phenomenally present visual image with its colors, dynamics, and

movements, or the experience of apprehending the referred to and absent meaning of the letters "J-O-U" as they, also, play their own game of spatial illusion, sitting on top of the picture plane but also hooking back into its spatial devices.

The visual coherence of the classical mode of representation is negated and the viewer is confronted with an image which regresses the subject back into the stage of the imaginary—one in which the viewing experiences have no external referent against which to be checked.[56] It is in the process of reunification of those cubist fragments that the "I" overcomes its negation and becomes an "I" as the fiction; thus the developmental scenario is inverted: the illusory fracturing within the image forges an (equally illusory) image of wholeness within the reconstructed referential "whole" of the image with which the viewer seeks to identify. In attempting to recuperate the fragments of the cubist image into a single, unified situation of viewing/experience, the viewer finds the only "whole" to be one which is fragmented—the fragments belong to the same universe, even to the viewer, but they cannot be reunited into a single viewing position. That perspective was a fiction— because it brought the world into being as a unified image as if that were a "natural" condition—is the most striking aspect of this cubist fragmentation. This was a fiction created through a subject position, a device for visual unification. It might be made use of again after the cubist dismantling, but it could not pass as "natural" again.

The Critical-Paranoiac Method: Dali

The techniques of Cubism largely follow one classical convention, however, which is that the elements of the image are displayed as if without marked attention to the presence of the viewer. There are exceptions, of course—the flagrant *Demoiselles* glaring out from the canvas and so forth—but by and large the cubist frame still presents the image as a consumable spectacle, and as a set of signifiers functioning within the field of the viewing subject's symbolic order.

But the concept of the "paranoiac hallucination" which Salvador Dali proposes as central to his painterly practice, is not so simply contained as a spectacle of display.[57] Around 1929–30 Dali

attempted to articulate a paranoiac aspect of visual representation.[58] This method was particularly useful for production, since it permitted the artist to hallucinate freely in the process of painting, allowing any spot or stain to develop into an image itself.[59] The image which results, however, offers an enunciated subject which is split according to a different structure than that of the cubist painting. For if the cubist work fragments spatial positions, it does so largely within a single subject's vision or sensibility. Dali's method proposed a continual opening up within the unified space of a viewing position of a whole sequence of returned, solicitous, or provocative gazes. Rather than participating in the fiction of voyeuristic display or the confrontational acknowledgment of the viewer, the work inscribes paranoia as its central operation by gazing back from a sequence of unexpected positions, or proposing a multilayered reading of a single configuration. The effect which Dali sought was of a paranoid hallucination in which one was both viewer and viewed simultaneously.

In Dali's method, which he termed the "paranoiac-critical" the work elicits the gaze of the subject through a series of seductive sleights which attempt to trap the viewer in a continual recycling of hallucinatory identification. More importantly, the paranoiac image continually registers the scrutiny of the unsolicited gaze. In a painting such as *The Great Paranoiac* (1936) the image functions as the site of a continuous series of menacing and disturbing glances. These threaten the unity of the image through dispossession, a continual displacement: the viewer cannot fix the place from which the image originates its gaze. Thus it refuses any stability as an image providing fictive unity for the viewer. An uncomfortable proliferation of eyes, of forms squirming with prescient consciousness, of awareness of the force of being looked at, apprehended, animates Dali's canvases of the early 1930s. These images don't merely look back at the viewer, but look back as if prompted by a sense of the threatening force of the viewer's own gaze. The image is at risk, under paranoid attack, continually, in a registration of the avaricious desire of the viewing subject to appropriate the image. The hallucinatory sense of one's own consciousness being already there, present in the image, receiving one's gaze permeates these canvases, causing the viewer in turn to look over one shoulder, as

if the gaze were coming from without, only to realize that the generating source of the paranoiac look is his or her own gaze.

The paranoid-critical process splits the subject through the returned look of the image—which is produced as if in acknowledgement of a look already given, thus forcing the subject into confrontation with the already-there compulsion of its viewing. This is an extreme condition, obviously, and the paranoiac subject of surrealism is relentlessly split and split again precisely along the lines of its own sight, the paranoid hallucination of its own look—not returned, but already present on first glance, acknowledging the self as other in the paranoiac hallucination of the image. Projected paranoia finds its justification in the realization that in fact, the look *is* acknowledged—and anticipated, in an uncanny affirmation of the prescient gaze.[60]

Schizophrenic Subject: Jameson and the Perpetual Present

The possibilities for fragmentation of the subject within figurative work can thus be examined in terms of the fracturing of the *space* of the subject, and of the *look* of the subject. But it may also be fragmented through the dispersal of material across the plane of discourse in a manner which cannot be recuperated into a unified plane of reference. Here the collage work of Rauschenberg provides a useful example. In *Retroactive I* (1964) the various elements of the collaged and transferred image are dispersed over the plane of the canvas. There is unified space for the viewer, each image has its own set of perspectival conditions. Thus the unifying position vis-à-vis the picture plane is absent, as is the evident unifying theme of pictorial narrativity. However, the images are *readable*, legible as bearers of culturally rich and personally suggestive associations: Kennedy, pointing emphatically, the pointing hand repeated in the doubling of this emphasis, the astronaut against the dark background of space, construction workers partially obscured by the painterly drips, erasures, rub-outs and repaintings which mark this as a canvas, individuated and hand done in the manner Rauschenberg himself had parodied in his *Factum I* and *Factum II*. Finally, an image of fruit on display, upside down, and of a naked female dancer in ecstatic gyration—all these elements, as well as geomet-

ric blocks of color providing formal structure to the image all exist within its space and yet without clear relation to each other. A meaning may be made, and the activity of a continual play, a dance of deferral of closure into fixed, stable meaning, is part of what gives the image its compelling interest. But at the level of reference, beyond the most general "current events," the image does not unify into a readable meaning. The referent is a world of events which are themselves heterological, and the subject enunciated in the image is thus not fractured (a term which presupposes an originary unity) but schizophrenic. It cannot be unified in the conventional sense precisely because the subject is not conceived here as bounded by its corporeal and psychological limits, but rather, in relation to the cultural processes of enunciation in which it is embedded.

The concept of the schizophrenic subject which exists in the present, unable to synthesize a meaningful sequence out of the stream of images, events, signification which assault him or her has been proposed as a working model by Gilles Deleuze and Felix Guatarri in *Anti-Oedipus* (first published in 1972).[61] This discussion has been taken up by Frederic Jameson, who describes the schizophrenic condition as one in which signification is reduced to "a rubble of distinct and unrelated signifiers."[62] According to Jameson, the schizophrenic experiences only the present, and each element in the present is unique and discrete. The incapacity to integrate elements or to form a homological field of reference disperses the subject, rendering any fictive unity impossible. Rauschenberg's collages from the late 1950s and early 1960s disperse their elements in such a way that they cannot be unified either visually within the frame or referentially outside it. They form a heterological field of elements which produces a schizophrenic subject of enunciation— diffuse and incapable of identifying with itself as an image.

Abstraction and Subject Enunciation

Up until this point, I have dealt with the effects, various strategies within figurative work on the production of subject positions. The analysis of abstraction requires a different approach, for the process of identification with the image is through the situation of viewing, rather than with the elements depicted.

The dispersed fields of activity painted by Kandinsky in, for instance, his 1914 *Painting #201* (figure 16) pose another problem in the enunciation of the subject position, as will the large canvases of the abstract expressionists. The total absence of perspectival registration of spatial relations removes one of the fundamental mechanisms by which a viewer makes an identification with the image: the subject's inscribed relation to the image's original station point, or constructed ideal viewpoint. The dispersal of activity across the picture plane, without any relation to any fixed station point, offers no privileged spectator position from which to occupy even a fictive spot of control and mastery. The subject is adrift in a field of representational elements which refuse to coalesce as the fictive image of unity. In this situation, the subject is enunciated only with respect to the instance of production, of the whole canvas as a kind of screen projection. This dispersal offers only a primary identification for the subject which is immediately frustrated at the secondary level. Identifying with the situation of viewing, the subject sees only a "self" which is dispersed, diffused and fragmentary and only recuperable into a whole within a rhetoric of abstraction. Faced with this image of dis-unity, the subject enunciated by a canvas such as Kandinsky's abstraction remains fragmentary, schizophrenically unbounded in relation to the very image to which it looks for the returned affirmation of its unity.

Not surprisingly, it is precisely this rhetoric of unboundedness and the transcendent sublime to which it is attached, which manifests itself in accompaniment to the large scale works of abstract painters such as Mark Rothko, Barnett Newman and Clyfford Still. The refusal to depict or offer the image of a unified subject in their work (beyond that provided by the unity of *style* which signals to the subject that an identification with the site of viewing is still fictively whole) forces the issue of enunciation into recognition of its operation as the *instance* of the viewing experience. The issue of scale, in the presence of canvases which exceed the limits of the cone of vision, devolves on the problem of somatic identification— and somatic identification is the state of the imaginary for the subject, fundamentally fragmented and fictive. Rothko's canvases are able to absorb the viewing subject into their productive apparatus at a level where they just fill the field of vision, but are containable

within it. The disintegrating boundaries threaten to dissolve corre-
spondence with those of the individual's visual/perceptual field.
Consequently, the iconic value of their unboundedness becomes a
visual trope for the experience of an ambiguous and unresolvable
boundary/definition of the "self" which is produced in that viewing
experience.

By contrast, the work of both Still and Newman was designed in
terms of its capacity to overwhelm, to absorb the viewer/subject
into a field of perceptual experience in which that impossibility of
establishing or maintaining a boundary is an a priori condition of
the production of the work. The thematics of alienation, angst
and transcendence are essentially trivialized in contrast to the force
which destroys the unified field in which subjectivity could be pro-
duced, overwhelming the terms on which its mechanisms of fictive
illusion functioned. The subject, then is not merely enunciated as a
viewer, but as one whose potency and self-identity vacillate
between subordination to the outsize scale and identification with
it. The mechanisms of enunciation in abstraction thus work on for-
mal terms: the physical traits of the image position the viewer and
permit certain activities of identification through the articulation of
those formal elements. Unity as an image of bounded wholeness,
however, is negated, and acknowledgement of this in the viewer
works out as another level of negation—the "yes, but" which rein-
serts the subject into the situation of viewing.

Theatricalization of Subjectivity: Morris, Fried

Michael Fried's 1967 essay "Art and Objecthood" was written in
response to minimal sculpture which it condemned as *ideological*
and damned for being chiefly about the definition of a position
Fried termed *literalist*. Scorning this literalism as empty and rhetor-
ical, Fried stressed the manner in which the work of sculptors like
Donald Judd and Robert Morris insisted on the *objecthood* of the
work. In so doing it called attention to itself and worse to the view-
er's awareness of it in a manner which was theatrical rather than
transcendent. The self-consciousness forced onto the viewer by
this work, which Fried noted in such pejorative terms in this essay
cracked the smooth surface of the mirror in which subject identifi-

cation had been possible in conventional terms. Minimalism did for sculpture what the look of Manet's Olympia had done, symbolically, for painting—it acknowledged its own acknowledgement of the presence of the viewer as an integral aspect of the work's existence. Citing and paraphrasing Robert Morris, Fried wrote: "Whereas in previous art 'what is to be had from the work is located strictly within [it],' the experience of literalist art is of an object *in a situation*—one that, virtually by definition, *includes the beholder.*"[63]

The size of these works and their "theatricality" distanced the beholder: "It is, one might say, precisely this distancing that *makes the beholder a subject* and the piece in question . . . an object."[64] The disquieting effects produced in the viewer (Fried) by minimalist sculptural works were in part due the fact that they brought every aspect of a situation into the work—the viewer's body, the room, the lighting, etc.,—so that the defining boundary of the work was lost in an important conceptual sense. The art/nonart distinction could not be sustained, and the work as a production of situation and a viewing subject was anathema to Fried, though he recognized and articulated it. Declaring that it was the imperative of "art to defeat theater" Fried distinguished between the concepts of *presence* and *presentness*. Presence engaged in theatricality—the self-conscious calling to attention of circumstances of viewing while "presentness" was the condition of art, a state of occupying a "continuous and perpetual present" which was the condition to which art should "aspire." The infamous closing line of this essay, "Presentness is grace." discloses all the theological underpinnings of Fried's unabashedly conservative position.

The presence of the subject and the circumstantial character of the art object and experience threatened the transcendent value of art defined as the embodiment of "quality." The very contingencies which so threatened Fried were in fact the conditions which engaged the minimalists in the turning point from modernism. The dissolution of the autonomous object through insistence on circumstantial perception necessarily brought the role of viewing subject to the fore. The viewing subject, however, has necessarily to be understood here within the psychodynamics of an experience in which the uncomfortable primacy of somatic awareness keeps any

fiction of unity from being returned to the viewer from the observation of her or her visual field. The escape into transcendence which Fried so desperately desired, and which he found blocked by the physical insistence of minimalist sculpture upon the situation of viewing, is itself a fiction. The transcendence was precisely that fiction of unity which an image returned to the infant, the image which provided the idea of a self which was, of course, not the self, but an illusion. By insisting on that split, between illusion and somatic awareness (itself fragmentary and desiring the image of unity as a means of guaranteeing identity) minimalist work inscribed the subject in the continual attention to this split situation of viewing.

Thus, the point of the work of Morris (Judd, Serra, and Bladen) was not *merely* on the instance of viewing, or on the *fact* that the viewer was present as an essential aspect of the work. Each of these artists had in their work specific thematic and artistic concerns, among them the articulation of subject position as a specific issue, not a generalized one. Thus the work of Don Judd in the *Untitled* piece of 1965, for all its dependence on perceptual conditions, does not determine the same relation of power as did the *Tilted Arc* of Serra. In the first the viewing subject exists in a kind of parity of scale and mass, in the second, is clearly thwarted and forced into reconsideration of the space as social and cultural as well as physical. Minimalism brought an awareness of such interrelations of power and positioning as part of the activity of representation, of art, of aesthetic strategies. Artists would begin to address this issue through the further exploration of the production of subject positions as a central focus of both thematics and structure of their work.

The Situation of Enunciation as Thematic Focus: Graham and Barry and the Vampiristic Subject

The installation and performance works done by Dan Graham in the 1970s took subject positioning and enunciation as their thematic focus. The extent to which Graham's work manages to eliminate all but those elements which pertain to the situation of viewing and production moves his work beyond minimalist literalness to

a distilled conceptual theatricalization, one in which the subject must function as a kind of desiring machine to drive the work.

The 1974 "Present Continuous Past(s)" serves as a paradigmatic example of the use of the viewing subject as both producer and product of the work. A video monitor whose image is received in time-delay transmission from a camera displays to a viewer the image of that viewer several seconds earlier. The camera, in the same space as the monitor, faces a mirror, and records the space, the mirrored reflection and the monitor, all in delayed time. As Anne Rorimer noted,

> The critic Friedrich Huelback in an unpublished text on Graham's video work, affirms that "perception is not only an (active) function of the subject but also an essential condition of subjectivityThe subject reaches himself not by perceiving but by being perceived, or rather, by seeing that he is being observed as an object."[65]

Specificity of viewing circumstance, focus on the viewer's existence as subject, and positioning the viewer in the work so that that act became thematic focus: these points defined Graham's practice in the 1970s and established the groundwork for thematically more expansive pieces which pursued these fundamental issues in their cultural and social frameworks. But also, as the subject becomes the central focus of his work, and the activity of subject production was what was enunciated, the notion of a schizophrenia dropped away. Graham's work was not constructing a permanently dispersed field of fragmentation, but a dynamic of recycled perception and "self" perception which motivated his work.

Graham's work also made clear that understanding the operation of subjectivity was an essential aspect of any kind of politically motivated strategic intervention for art. He considered this to be particularly true if such intervention was to have an effect within the order of power relations as they are structured in and reproduced in representational systems. The machine which drives such work is a subject which Judith Barry termed the *vampiristically* engaged subject, one which has a fundamental need to sustain the illusory apparatus and continually feed the circle/cycle linking identity and desire through the apparatus of display and seduction.[66]

Barry directly articulates the concept of the vampiristic subject in her 1985 work *Vam p r y*, developing the issues raised in the 1980–81 video piece, *Casual Shopper*.[67] Barry's concept of the subject is in distinct opposition to the schizophrenic subject which had come to the fore in the writings of Jameson (and also Jean Baudrillard). The schizophrenic subject, as we have seen, is endlessly fragmented and refracted across a surface. Baudrillard dissolves the body of such a subject, thus negating the possibility for the individual to sustain the conflict and split essential to identity. Barry returns the body, insists on the body, and proposes that the vampiristic subject is one engaged in endless and consuming (but somatically grounded) spectatorship.

By creating installations which address the contextual structuring of subject positions within the social codes of architecture and display, and taking both the subject's body and spectatorship into account, Barry focuses her critique of ideology through operations of subjectivity. Taking this structuring practice, rather than its re-presentational mode of production through conventions of pictorial structure, provides an elusive "object" for investigation. Making the *structuring* circumstances of subjectivity one element of her focus, Barry calls attention to the manner in which most conventional modes of representation conceal this apparatus. There is a strong distinction between the "laying bare of devices" of early modernism, with its structuralist biases, and these deconstructive strategies for calling attention to the ongoing dynamic of constitutive processes within their psychic and cultural conventions.

Barry takes these issues into an investigation of the relation between subject production and the production of history. Barry's works, such as *First/Third*, in which the talking heads of third world immigrants appear in disembodied projection on the walls of the installation site, are concerned with narratives of displacement and disempowerment. Barry's subject is a subject embedded in and inscribed by history, made in the narratives of power which position us each in relation to the dominant structures of language and ideology. Barry's subject grapples with the specular (and spectacular) production of images of power which efface specific histories

which the artist attempts to project, in replay of a fantasmatic scene, in the work.

Complicity and Instability of Gender Positions:
Sherman and Kruger

"Throughout representation there are abundant—even preponderant—forms in which the apparatus works to constitute the subject as male, denying subjectivity to woman. Woman, within this structure, is unauthorized, illegitimate: she does not represent, but is, rather, represented. Placed in the passive rather than active role, as object rather than subject, she is the constant point of masculine appropriation in a society in which representation is empowered to construct identity."[68]

The recognition that the viewer's subjectivity was gendered and that the experience of individuals within the symbolic order of cultural life was determined, defined and limited by gendered identity, became thematic matter for works of art in the 1980s. The examination of the ways in which representational modes were themselves gendered, and involved the construction of gendered positions of power with respect to viewing, to objectification and subjection, had been articulated, again, in the feminist film theory of the 1970s and '80s. The advent of so-called postmodernism in the visual arts (and criticism) is inextricably bound up with the development of the feminist critique of the masculinist and patriarchal terms of modernism.

The above quote from Kate Linker's 1983 essay, "Representation and Sexuality," recapitulates the themes which dominated the feminist critique of representational practices. The centrality of gender to the construction of subjectivity, and the problems of creating a subject position for women accompanied the explorations by visual artists of the terms of gender and production.

In 1979–80 Cindy Sherman made a series of photographs of herself. She functioned as both subject and object of her own gaze, fixing herself as the fantasy object of clichéd imagery in which the woman's existence is always subject to a patriarchal order of power. The sense of fear, of apprehension, of anxiety of her first

Untitled Film Stills exposed the continually lurking presence of the gaze of the male subject behind the classic film narrative which moves forward through objectification of the female body.[69] (figure 17) That representation was about subjectivity and that subjectivity was gendered with respect to positions involved in the very objectification (or rendering into a signifier within the symbolic order) of the "other" in gendered terms was the conceptual focus of this work and the critical writing with which it was contemporary.

Sherman explored the possible destabilization of subject positions through a subversion of the norms of their gendered character. By continually recycling the subject/object relations through the mastering lens of the camera Sherman destabilized the normative conventions according to which the objectified image of the woman was fixed through the male gaze, and substituted a narcissistic process of subjective self-production with all its compelling obsessiveness.

Sherman's work, typically discussed in terms of the supposed critique it makes of the conventions of female objectification as the fetishized focus of the male subject, is more subversive when considered as the fulfillment of the fully articulate feminine subject typically denied even possible existence by psychoanalytic literature.[70] Sherman, in her fetishization of herself as object of continual play solicits her own gaze, coyly defers response, and thus returns again and again to the inscription of herself as fictive object. The identities constructed are of course illusory, fundamentally so, but exist as an activity mirroring the process of the subject's ongoing self-production and endlessly deferring any closure on identity. That Sherman's work constructs and repeats this operation and that it does so independent of any "other" so that she serves as both the object of her own look, the signifier of her own symbolic representation, refutes the necessity for woman to be positioned as object within the process of subject formation, and demonstrates her capacity to be the instrument of the construction of a subject position.[71]

By contrast, the work of Barbara Kruger explored the ambiguity of gender in its relation to subject positions rather than assuming its

a priori dependence on the biological gender of the viewer. Kruger successfully managed to render the inscription of gender unclear through both visual and linguistic means, and to call attention to the necessary complicity of the subject in the production of meaning and value.

Kruger makes use of imagery which is, frequently, fragmentary. Cut through with bands of red and white lettering, the images have superimposed on them phrases which make use of first and second person pronouns which do not carry any gender specificity. The viewer/reader thus puts himself or herself into a position with respect to both the statement and the image according to a set of decisions which mark a relation of power. In the Kruger image, *I Shop Therefore I Am* the gender of the first-person speaker cannot be confirmed through any evidence in the image. (figure 18) The hand which holds the card up to the camera has no visible evidence of gender coding—no jewelry, no nail polish, no clothing help fix the neutral hand. The obvious play on the Cartesian phrase, with all of its masculine associations, is parodied by its recasting into an activity which has overwhelming feminine associations in late twentieth-century American culture. But in fact, the "I" of "I Shop" is indeterminate in its gender. "Kruger uses a term with no fixed content, the linguistic shifter (I/you) in order to demonstrate that masculine and feminine in themselves are not stable identities, but subject to exchange."[72]

The recognition of gender terms has thus shifted in Kruger's work from determination to production, from realization of the gendered practices of representation to the production of gender as an aspect of power and subject position. That the production of gender involves complicity, and that the subject enunciated is not gendered a priori but according to the activity of that production, forces attention to the active role of such complicity with the replication of power/subject relations. By leaving unmarked the position to be occupied, and yet, making clear that a relation of power is described, Kruger engages the subject in an act of self-definition. Domination, subjection, subordination, abjection—all are positions to be occupied not necessarily in accord with gender, but definitely in complicity with the rejection of or acceptance of a partic-

ular relation to power. Kruger manages to render ambiguous the roles assigned with respect to gender while marking the assumptions about the normative order of power relations in a historically patriarchal society. The viewer produces a subject position in relation to this work which demonstrates resistance to or complicity with that normative order.

FIVE

Following the Received Tradition: A Note in Conclusion

By using the term *modernism* to bracket the work discussed in this book, I have deliberately stretched a point. The assumption that there is, at some indefinable moment in the twentieth century, either a radical or gradual break with the modern tradition is generally accepted, along with the term *postmodern* to designate the later period. Whether or not this assumption can be supported (and in fact, I believe it can in terms of the conceptual and aesthetic basis for artistic practice), there is a persistent legacy of modernism in the terms on which historical and critical work has been conceived. Those terms are changing rapidly, and have been doing so for some time, but formalism, periodization by styles, and the concept of the avant-garde are slow to yield to the relativized, contextualized, and differential processes suggested by more recent critical thought. This book was intended to make a contribution toward the reconceptualization of the modern tradition, not by rejecting that received tradition, but by regarding it from a different perspective. Whether or not this work has succeeded in offering insights into modernism in visual art and criticism by suggesting an examination based on representational strategies, is up to the reader.

There are, however, many things this book did not do which would further the territory of exploration I am interested in helping open up, but which lie far outside the borders of the themes I used to organize the arguments here. In stating these, my intention is not to lay down a plan or program of future work, my own or that of others, since it may well be that this agenda, like the work of these essays, will itself be rapidly historicized and surpassed. Instead, my thought is merely to sketch in very summarily the wider network of ideas within which the arguments about formalism, the object, subject, and space were contextualized.

For instance, the much-vaunted demise of the concept of the avant-garde leaves a void in the formulation of the terms of art as a political act. The premises on which form does or does not participate in ideological practice, as representation, as communication, as an instrumental means of changing institutions, policies, or power relations is being rethought in relation to contemporary cultural formations. The current high profile status of art concerned with cultural difference may ultimately make a structural impact on the institutions and effects of art, but it is rather too soon to anticipate whether this will be the case. The relation of art to the image-making power of mass media have changed so radically in the late twentieth century, and media has itself become so differently positioned in the culture that the simulacral may indeed really threaten to consume all critical discussion by its seamless seductive fascination.

Intimately connected to the question of whether art can serve as a political or alternative discourse in contemporary life is the status of fine art in an age of visual culture. The premises on which fine art is distinguished from commercial art or forms of popular entertainment need to be articulated in terms of sites, institutions, demographics, and effects as well as in terms of a blind faith in formal values or the shibboleth of quality. The nature of art as work, its function in representing a form of rarefied production also plays a part in these concerns, as do the sociological factors of taste, market strategies, and the construction of consumer desire for art as an experience or form of property.

Another area this book did not touch on, which would probably have provided the most logical complement to the themes it did

address, is that of the role of institutions in the development, dissemination, and preservation of modernism. This includes museums and galleries, but extends as well to the social history of criticism, academic art history, and contemporary theory. These ideas, however, are not original with me, and there is, fortunately, a wide field of interesting and critical scholarship in which this work is being taken up. I only hope my contribution provides a suggestive point of departure or reflection for some of my peers.

NOTES

A note on sources: In many cases the sources of quotes cited here are anthologies and secondary materials. There are two reasons for this—one practical, one strategic. The practical reason is that it is in such reproduced versions that the materials are most readily available for pedagogic purposes. The strategic reason is to underscore the fact that this book is not concerned with research but with the received tradition, and with the conventions according to which modern art has been characterized. It is therefore not incidental that the works cited here are the anthologized excerpts—it is *because* they are anthologized and regularly referred-to works that they are central to my discussion.

1. Reviewing Modernism: An Introduction

1. For discussions of Clement Greenberg's politics and positions, see Francis Frascina, ed., *Pollock and After* (New York: Harper and Row, 1985); and Serge Guilbault's *How New York Stole the Idea of Modern Art* (Chicago and London: University of Chicago Press, 1983).

2. Greenberg is invoked in relation to his own mythic construction of modernism in diverse texts, for example: Margot Lovejoy, *Postmodern Currents* (Ann Arbor: UMI, 1989); Linda Hutcheon, *The Politics of Postmodernism* (London and New York: Routledge, 1989); *Postmodern Documents*, ed. Lisa Appignanesi (London: Free Association Books, 1989); *Postmodernism—Philosophy and the Visual Arts*, ed. Hugh J. Silverman

(London and New York: Routledge, 1990). In addition, note the way the words *Greenberg* and *modernism* are interchanged in essays in the anthology *Art After Modernism*, ed. Brian Wallis (Boston: Godine, 1984).

3. There are twenty years of references here, but to concretize my point, a few outstanding references include: Elizabeth Baker and Thomas B. Hess, eds., *Art and Sexual Politics* (New York and London: Collier Books, 1973); Roszika Parker and Griselda Pollock, *Old Mistresses: Women, Art, and Ideology* (New York and London: Routledge and Kegan Paul, 1981); Hal Foster, ed., *The Anti-Aesthetic* (Port Townsend, Wash.: Bay Press, 1983); Donald Preziosi, *Rethinking Art History* (New Haven and London: Yale University Press, 1989); John Tagg, ed., *The Cultural Politics of Postmodernism* (Binghampton: Current Debates in Art History, 1989); Raymond Williams, *The Politics of Modernism* (London and New York: Verso, 1989).

4. Even within the mainstream, one can find an eclectic list of publications from the last decade: *Third Text* (London), *Representations* (Berkeley), *The Journal of Decorative and Propaganda Art* (Miami), or *Art Papers* (Atlanta); the work of a critic like Lucy Lippard, most recently in *Mixed Blessings* (New York: Pantheon, 1991); a series like the DIA publications, e.g., *Remaking History*, eds. Barbara Kruger and Philomena Mariani (New York: DIA, 1987); or even responses within mainstream journals to an exhibition like the Museum of Modern Art's "High/Low" in 1990.

5. A few references as a point of departure include: Dick Hebdige, *Subculture: The Meaning of Style* (New York: Methuen, 1979); Jim Collins, *Uncommon Cultures* (New York and London: Routledge, 1989); Frederic Jameson, *Postmodernism, or The Cultural Logic of Late Capitalism* (Durham: Duke University Press, 1991); Andreas Huyssen, *After the Great Divide* (Bloomington: Indiana University Press, 1986); Marjorie Perloff, *The Futurist Moment* (Chicago: University of Chicago Press, 1986); Jacques Derrida, *The Truth in Painting* (Chicago: University of Chicago Press, 1987); John Tagg, *The Burden of Representation* (Amherst: University of Massachusetts Press, 1988); Michael Newman "Revising Modernism, Representing Postmodernism," in Appignanesi, *ICA*, 1989; Yves-Alain Bois, *Painting as Model* (Cambridge: MIT Press, 1991); Rosalind Krauss, *The Originality of the Avant-Garde* (Cambridge and London: MIT Press, 1985).

6. For example: Corinne Robins, *The Pluralist Era* (New York: Harper and Row, 1984) Richard Hertz and Norman Klein, eds., *Twentieth-Century Art Theory* (Englewood Cliffs: Prentice Hall, 1990) and the journals, *October* and *Screen*. Additional confirmation of this point can be found in publications from conferences in the last decade, such as Serge Guilbaut, ed., *Reconstructing Modernism* (Cambridge: MIT, 1990) and Benjamin Buchloh, Serge Guilbaut, and David Solkin, eds., *Modernism and Modernity: The Vancouver Conference Papers* (Halifax: Press of the Nova Scotia College of Art and Design, 1983); but such notions are the stock in trade of

the pages of *Art in America, Afterimage,* or the *New York Times* "Arts and Leisure" section—just to invoke the full spectrum.

7. By "modernist autonomy and unity" I mean to invoke the discussion of modern art as autonomous which stretches from Greenberg's late 1930s essays to, most notably, the discussions of Peter Burger, *Theory of the Avant-Garde* (Minneapolis: University of Minnesota Press, 1984) and Renato Poggioli, *The Theory of the Avant-Garde* (Cambridge and London: The Belknap Press, 1968; originally published 1962), and exists within the work of T. J. Clark, "Clement Greenberg's Theory of Art," and Michael Fried, "How Modernism Works: A Response to T. J. Clark" (both in Frascina, *Pollock and After*), and even Raymond Williams (*Modernism*, 1989), even if only to come under attack.

8. I use the term *modernism* to refer to activity in the visual arts and the term *modernity* to refer to the cultural condition or period; this is fairly standard for both the term modern and postmodern; see, for instance, Francis Frascina and Charles Harrison, eds., *Modern Art and Modernism* (New York: Harper and Row, 1982).

2. The Representation of Modern Life: Space to Spectacle

1. The word *reproductive* here is meant to invoke the Marxist (particularly Althusserian) concept of the role of representation in not merely producing, but also replicating, ideology.

2. Such varied texts as: Robert Rosenblum, *Nineteenth Century Art* (New York: Harry Abrams, 1984) notes Baudelaire's description of Guys' work as "vignettes of fashionable modern city life." p. 279; Kathleen Adler and Tamar Garb, *Berthe Morisot* (Oxford: Phaidon, 1987), "he [Baudelaire's modern artist] makes the modern city his territory." p. 80; and Charles Baudelaire, *The Painter of Modern Life and Other Essays*, ed. Jonathan Mayne (London: Phaidon, 1964), introduction.

3. Certain themes in the essay appear in earlier critical writings on the Salon of 1845 and subsequently; "The Painter of Modern Life" was written in 1859, first published in 1863. Rosenblum, *Nineteenth Century Art*, p. 279, suggests that by the publication date of this essay, Baudelaire could have found a fulfillment of his prescription in the work of Manet, especially *Concert in the Tuileries*. This seems to me to be typical of the disregard for the specifity of Guys' work—and Baudelaire's understanding of its representational mode—in Baudelaire's proposals for an image of modernity.

4. Baudelaire, *The Painter of Modern Life and Other Essays*, p. 13. For the French original see Charles Baudelaire, "Le peintre de la vie moderne," *Oeuvres*, vol. 2 (Paris: N.R.F., 1938).

5. David Frisby, *Fragments of Modernity* (Cambridge: MIT Press, 1986)

has several long discussions of this aspect of Baudelaire's work, especially in relation to Walter Benjamin's reading of it.

6. Anne d'Eugny and Rene Coursaget, *Au Temps de Baudelaire, Guys et Nadar* (Paris: Les Editions du Chêne, 1945), make this point, emphasizing Baudelaire's own words that he desired to "Glorifier la culte des images (ma grand, mon insigne, ma primitive passion)," p. 7.

7. William Sharpe, *Unreal Cities* (Baltimore: Johns Hopkins University Press, 1990), discusses these figures.

8. The concept of the eternal, linked in Baudelaire's phrase to the ephemeral, is, I believe, more properly to be read in relation to Baudelaire's conception of *beauty* than his conception of *modernity*. Readings vary: P. G. Kolodny, *The Painter of Victorian Life*, ed. C. G. Holme (London: The Studio Ltd., 1930), makes this point while Anne Coffin Hanson, *Manet and the Modern Tradition* (New York and London: Yale University Press, 1977), for instance, searches for the eternal and universal even in the work of Guys in order to justify the equation of modern life with eternal values, while Frisby, *Fragments*, and Sharpe, *Unreal Cities*, emphasize the fugitive.

9. Charles Baudelaire, *Constantin Guys* (Paris: Editions Nilsson, 1925), p. 17, emphasizes emphatically Guys' sense of the "scene spontanée."

10. Baudelaire, *The Painter*, pp. 4–5.

11. The work of Daumier, by contrast, with its humanistic themes of human foibles and weaknesses, translates readily into such terms. John Canaday, *Mainstreams of Modern Art* (New York: Holt, Rinehart and Winston, 1959), p. 96, provides one such characterization of Guys.

12. For a published collection of Guys' images: *Constantin Guys, L'historian du second empire* (Paris: Les Editions G. Cres, 1920).

13. Claude Pichois, *Constantin Guys: homme singulier* (Paris: Editions Arnoud Seydoux, 1983), p. 12, "son concept de la modernité. . . celle de la rapidité et du fugitif."

14. Baudelaire, *The Painter*, p. 5.

15. Sharpe, *Unreal Cities*, p. 46: "the poet's identity appears endangered by his specular appearance."

16. Jean Paul Dubray, *Constantin Guys* (Paris: Les Editions Rieder, 1930), p. 53, notes Guy's desire to "draw everything."

17. Claude Roger-Marx, *Constantin Guys: 1802–1892* (Paris: Les Editions Braun, 1949), p. 6, "everything is transformed."

18. Baudelaire, *The Painter*, p. 9.

19. Charles Baudelaire, *Art in Paris 1845–1862* (London: Phaidon, 1965). Reprinted in Alan Trachtenberg, ed., *Classic Essays in Photography* (New Haven: Leete's Books, 1980), pp. 83–90.

20. Ibid., p. 85.

21. For one discussion of this, see Griselda Pollock, *Vision and Differ-*

ence (New York and London: Routledge, 1988), the chapter "Modernity and the Spaces of Femininity."

22. Meyer Schapiro, "Courbet and Popular Imagery," notes that Baudelaire "despised realism." *Modern Art: 19th and 20th Centuries* (New York: George Braziller, 1978), p. 64. Originally published in *The Journal of the Warburg and Courtauld Institutes* 4 (1941): pp. 164–191. Anne d'Eugny, *Au Temps*, p. 13, also notes Baudelaire's hatred of realism.

23. Walter Benjamin, "Paris, Capital of the Nineteenth Century," *Reflections* (New York: Schocken Books, 1986), pp. 146–162; and "On Some Motifs in Baudelaire," *Illuminations* (New York: Schocken Books, 1969), pp. 155–200; these essays were first published in 1938 and 1939, respectively.

24. Frisby, *Fragments*, and Susan Buck-Morss, *The Dialectics of Seeing: Walter Benjamin and the Arcades Project* (Cambridge: MIT, 1989) are two recent sources that both contain extensive bibliographic references to Benjamin and the secondary literature.

25. Benjamin takes his point of departure from Baudelaire's address to the reader at the beginning of *Les Fleurs du Mal*, and reads Baudelaire's work in connection to the demise of both the status and production of lyric poetry.

26. Buck-Morss, *Dialectics*, p. 23, also notes the contemporaneity of Benjamin's project with the surrealists' fascination with the city; Breton's *Nadja*, for instance, was published in 1928, and the surrealist group's recovery of Eugene Atget's photographs of nineteenth-century Paris provided an inspiration for their work.

27. Benjamin, *Illuminations*, p. 156.

28. Benjamin arrives at this point in his discussion through an examination of Baudelaire's projection of an ideal or expected reader. Discussing the demise of lyric poetry in terms of the changed audience relation to poetic form, Benjamin forges a link between this demise and the changes wrought in urban life by capitalist division of labor.

29. Benjamin, *Reflections*, p. 158.

30. See especially Buck-Morss, *Dialectics*.

31. Benjamin, *Illuminations*, p. 163.

32. Benjamin, *Illuminations*, p. 176

33. Frisby, *Fragments*, p. 211, from Benjamin's *Das Passagen-Werk*, p. 1034.

34. Frisby, *Fragments*, p. 228, cites Benjamin's phrase "the gaze of the alienated person."

35. Benjamin, *Illuminations*, pp. 156–157.

36. In assessing Benjamin's efforts to construct a "prehistory of modernity," Frisby details the historical and political elements of the telos in which Benjamin is able to make use of and rethink Baudelaire's position.

Bringing a citation from Adorno to bear upon his argument, Frisby cites the following passage from "Charakteristik Walter Benjamins" which demonstrates the extreme degree to which the photographic image has displaced Baudelaire's subjectively recollected image in Benjamin's argument: "to abandon all apparent construction and to leave its significance to emerge solely out of the shock-like montage of the material. Philosophy was not merely to have recourse to surrealism, but was itself to become surrealistic. . . . To crown his anti-subjectivism, the major study was to consist only of quotations." Frisby, *Fragments*, p. 188.

37. The full quote reads: "He [Baudelaire] indicated the price for which the sensation of the modern age might be had: the disintegration of the aura in the experience of shock." Evidently, not without cost. Benjamin, *Illuminations*, p. 194.

38. Benjamin makes a point, at the beginning of "On Some Motifs" of the apparent paradox of the daily newspaper in this regard: it presents itself as a source of information but, in fact, isolates that information so that it cannot provide insight into the structure of the lived experience of the reader.

39. Canaday, *Mainstreams of Modern Art*, p. 159.

40. There is considerable breadth in the interpretations of the character of lighting in this work: Canaday, *Mainstreams of Modern Art*, p. 162, states that Manet manages "to reveal the image as the eye might receive it on one brilliant flash of light." David Bomford, Jo Kirby, John Leighton, and Ashok Roy, *Impressionism* (London and New Haven: National Gallery of London and Yale University Press. 1990–91), p. 23, note that Manet's painting "had retained the conventions of studio lighting." Robert Herbert, *Impressionism: Art, Leisure, and Parisian Society* (London and New Haven, Yale University Press, 1986), p. 170, terms the effects in this painting the result of desire to "put the human figure in a natural light." Finally, Beatrice Farwell, *Manet and the Nude* (New York and London: Garland, 1973), p. 209, simply reads the space behind the figures as naturalistic, as if it were an observed, real space.

41. Rosenblum, *Nineteenth Century Art*, pp. 282–283, details the relations between this painting and the many traditions and works from which Manet is quoting or borrowing.

42. George Heard Hamilton, *Manet and His Critics* (New Haven: Yale University Press, 1954), p. 250: "For the literal minded, there are some puzzling discrepancies in the composition." Hanson, *Manet and the Modern Tradition*, pp. 185–187, discusses the image as if it were all of a piece, unitary and consistent. Novelene Ross, *Manet's "Bar at the Folies Bergère" and the Myth of Popular Illustration* (Ann Arbor: UMI, 1980), p. 5, discusses the placement of the mirror in relation to the angle of reflection. Herbert, *Impressionism*, p. 80, notes the same shifts in the angles of mirror and

reflection. T. J. Clark, *The Painting of Modern Life: Paris in the Art of Manet and His Followers* (Princeton: Princeton University Press, 1984), pp. 248–250, discusses the illogical relation of the spaces.

43. Benjamin's shortsightedness with respect to the medium of photography was to term it "unmediated," as the objective, transparent, technological reproduction of visual experience.

44. Eric Darragon, *Manet* (Paris: Fayard, 1989), p. 389, notes that in contemporary reception the work was characterized as a "fantasmagorie picturale," thereby emphasizing its disorienting character.

45. This contrasts strikingly with the usual account of Manet's "picturing" of the world of Parisian society: see in particular Herbert, *Impressionism*, in which Herbert dismisses Clark's analyses in favor of the standard terminology; also, note the far more neutral character of Theodore Reff's characterization of Manet's images of modern Paris, *Manet and Modern Paris* (Washington, D.C.: National Gallery and Chicago University Press, 1982); or, for very standard treatment, Jean Selz, ed., *The Dictionary of Impressionism* (London: Eyre Methuen, 1973).

46. Clark, *The Painting*, pp. 9–10, discusses his use of this word, and its specific derivation within the work of Guy Debord.

47. Clark, *The Painting*, p. 15.

48. Clark notes that he doesn't want to do away with the idea of Impressionism as the "painting of light," but to qualify this by contrast, to again, the norm of art history in which Manet was characterized as "reducing all visual experience to terms of pure light." Canaday, *Mainstreams of Modern Art*, p. 186.

49. Clark, *The Painting*, p. 70.

50. Griselda Pollock, *Vision and Difference*, pp. 53–54.

51. Pollock is not the only scholar to do this, but her methodolgy and intentions are different. She is not merely offering a description of the way spatial themes are divided into male/civic/public and female/domestic/private, but is demonstrating the way in which the formation of gender is related to the division of space, as well as to other systems of control, differentiation and constraint which construct that difference and then are reworked/reproduced in representation. The habit of characterizing the themes of Mary Cassatt and Berthe Morisot's work as "feminine" is about as old as any scholarship on them, it is the interpretation put on the term "feminine" which is continually being redefined. See: Adler and Garb, *Morisot*, p. 93: "Modernity meant something different for women than for men. The world of the boulevards and the life of the demimonde being inappropriate and inaccessible subject matter for women artists, the contemporary world they represented is that which they experienced." By contrast, an older work by G. Wildenstein and Marie-Louise Bataille, *Berthe Morisot* (Paris: Les Beaux Arts, 1961), p. 12: "Femme toujours, elle trouve

son climat favorable dans un interieur ou un jardin familier" or the much older, Monique Angoulvent, *Berthe Morisot* (Paris, Editions Albert Morance, 1934), p. 16: "le dernier artiste elegant et feminin."

52. See also her earlier study, Griselda Pollock, *Mary Cassatt* (London: Jupiter Books, 1980).

53. Adler and Garb, *Morisot*, 1987, argue similarly; Anne Higonnet, *Berthe Morisot* (New York: Harper and Row, 1990) also describes Morisot's resistance to limitations on her movements and activities; in addition, see Kathleen Adler, "The Spaces of Everyday Life," pp. 35–44, in *Perspectives on Morisot*, ed. T. J. Edlestein (New York: Hudson Hills Press, 1980).

54. Pollock, *Vision and Difference*, p. 71.

55. My point is that the negative emphasis is a late twentieth-century one. I am not convinced that the distinctions between *Exposition Universelle de 1867* by Manet and the *View from Trocadero* by Morisot (1872) can be distinguished on the basis of the female figure's relation to boundaries; *that* the places from which these works are constructed is different, as per Kathleen Adler, is indisputable, as are the implications of this fact. The visual evidence—similarities in male and female painters' structure of spatial relations doesn't divide along gender lines. For instance, the spatial positioning of the adult woman in *The Railroad* by Manet and in *On the Balcony* by Morisot belie the attempt to use the placement of women in front of barriers as a female painter's way of evidencing her sense of restraint.

56. It has, traditionally, been their "touch" which has identified them as feminine; e.g. Angoulvent, *Morisot*, 1934, "legereté."

57. Though infuriatingly reductive, the following statement about the space in this image can be supported: "The composition as a whole is typical of a formula developed in the late sixties by Monet." Charles S. Moffat, *Impressionism*, exhibition catalogue, comps. Anne Dayez, Michel Hoog, and Charles Moffat (New York: Metropolitan Museum of Art, 1974).

58. This point is also made by Adler and Garb, *Morisot* but, to reiterate, Pollock seems to stress her late twentieth-century resistance to this.

59. Pollock is, always, pitting her work against essentialist constructions of femininity.

60. See Nancy M. Mathews, *Mary Cassatt* (New York: Harry Abrams, 1989).

61. The visual evidence is abundant: *Mary Cassatt*, Adelyn Dohme Breeksin, catalogue raisonee (Washington, D.C. Smithsonian Institution Press, 1970) and Nancy Mowll Mathews and Barbara Stern Shapiro, *Mary Cassatt: The Color Prints* (New York: Harry Abrams and Williams College Museum of Art, n.d.).

62. Roger Fry, "Seurat's *La Parade*," *The Burlington Magazine* 55 (December 1929): 290.

63. I invoke a link between ideology and aesthetics here because of the tendency, especially within the lineage of formalist criticism (Fry, Bell, Greenberg) in dealing with the work of the neo-impressionists, to depoliticize its forms in the name of a scientificized aesthetics. The reading of the work of, for instance, Seurat, so that its relation to the conditions of capitalism, also has its lineage—a notable early example being that of Meyer Schapiro, "Seurat," in *Modern Painting*, pp. 101–110.

64. There are many aspects to the mythologizing of Seurat's engagement with science, and as this is not, precisely, my topic here, I won't detail them. But they range from the idea of Seurat as optical scientist to Seurat as exemplar of the "rationalization of labor," and trace a change from regarding painting-as-science as laboratory control over pigment to painting scientifically as an aspect of rationalization.

65. John Rewald, *Post-Impressionism: From Van Gogh to Gauguin* (New York: Museum of Modern Art, 1956), p. 99.

66. Bomford, *Impressionism*, p. 83, cites the famous quote by Monet to Lilla Cabot Perry: "When you go out to paint, try to forget what objects you have before you—a tree, a house, a field or whatever. Merely think, here is a little square of blue, an oblong of pink, here a streak of yellow, and present it just as it looks to you."

67. Cited by John Rewald, *Post-Impressionism*, Seurat; *L'Art Moderne*, April 5, 1891.

68. See for instance Norma Broude, *Seurat in Perspective* (Englewood Cliffs, N.J.: Prentice Hall, 1978).

69. One could argue that these become ideal categories as well in Seurat—they are not so much specifics, as types of experience which provide the colorful artifice of visual display which offers an opportunity for the flattened designs Seurat is pursuing.

70. Rewald, *Post-Impressionism*; Henri-Edmond Cross of Seurat, p. 130.

71. Félix Fénéon, "The Impressionists," p. 37, in Broude, *Seurat in Perspective*; also in *Félix Fénéon: Oeuvres*, ed. Jean Paulhan (Paris: Gallimard 1948). First published as "Les Impressionistes en 1886" Ville Exposition Impressioniste, *La Vogue*, June 13–20, 1886, pp. 261–275.

72. Félix Fénéon, "Neo-Impressionism," p. 41, in Broude, *Seurat in Perspective*, 1978. English translation from Linda Nochlin, *Impressionism and Post-Impressionism 1874–1904: Sources and Documents* (Englewood Cliffs, N.J.: Prentice Hall, 1966), pp. 110–112. First published as "Le Neo-Impressionisme," *L'Art Moderne*, Brussels, May 1, 1887, pp. 138–139;

73. Jonathan Crary, *Techniques of the Observer: On Vision and Modernity in the 19th Century* (Cambridge: MIT, 1990).

74. The phrase is borrowed from Norma Broude, *Seurat in Perspective*, p. 1, who notes the place of Henry in Seurat's work and the critical literature.

75. Rewald, *Post-Impressionism*, p. 140

76. Broude, *Seurat in Perspective*, p. 1, states: "Seurat turned his attention to the prophetically modernist concept that the emotional content of a work of art may be established and conveyed in exclusively abstract terms, through predictable and measurable combinations of color, value and line."

77. The link assumed between Seurat and "science" is so all pervasive that almost any random textbook mention will serve here: John Canady, *Mainstreams of Modern Art*, n.p.: "Georges Seurat based his art on impressionism's bright, broken color, but he disciplined it relentlessly into myriads and myriads of tiny dots applied with scientific calculation." Werner Haftmann, *Painting in the Twentieth Century* (New York: Praeger, 1968), p. 34: "By subjecting the structural elements to an exact analysis, Cézanne and Seurat came to conceive of the picture as an organization of rhythmic coloured forms, so preparing the stage on which things could be transformed into form." These are two specific examples, but also, see John Russell, *Seurat* (New York: Praeger, 1965) pp. 258–259; or John Rewald, *Seurat* (New York: Harry Abrams, 1990); or Robert Herbert, *Georges Seurat 1859–1891* (New York: Harry Abrams and the Metropolitan Museum of Art, 1991), p. 4; and so on.

78. Clement Greenberg, "Cézanne and the Unity of Modern Painting," in Judith Wechsler, ed., *Cézanne in Perspective* (Englewood Cliffs, N.J.: Prentice Hall, 1975).

79. John Russell, *Seurat*, p. 258.

80. Alain Madeleine-Perdrillat, *Seurat* (Geneva: Skira/Rizzoli, 1990), p. 191.

81. Fénéon, "Neo-Impressionism," in Broude, *Seurat in Perspective*, p. 41.

82. Jonathan Crary, "Seurat's Modernity," *Seurat at Gravelines*, ed. Ellen Wardell Lee (Indianapolis: Indianapolis Museum of Art with Indiana University Press, 1991), p. 61. Crary's argument reiterates Meyer Schapiro's—that Seurat is modern by virtue of his relation to a social, cultural milieu in which rationalization is the dominant mode.

83. Cézanne's place in the development of abstraction has been established, disputed, relativized, and refuted all in turn—and his place within the development of formalist art history will be discussed in detail in the next chapter.

84. Jean Helion, "Seurat as Predecessor," 1936, cited in Broude, *Seurat in Perspective*, p. 8. Originally published in *Burlington Magazine* 69 (July 1936): 4–14).

85. In fact, Gauguin forms the important third element here—in his liberating of color from either a referential or optical mimetics or truth he engages with the phenomenological effect of color, rather than its representational function, thus completing the conceptual bases on which abstraction in the twentieth century is conceived: a bounded, limited

espace of the canvas; autonomy and idealism of form; and a phenome-nololgical belief in the apparency and visual plenitude of color.

86. Clement Greenberg, "Cézanne and the Unity of Modern Painting," in Wechsler, ed., *Cézanne In Perspective*, pp. 323–330. Originally published in *Partisan Review*, May–June 1951.

87. Roger Fry, *Cézanne: A Study of His Development* (Chicago and London: University of Chicago Press, 1989), p. 36. Originally published London: Hogarth Press, 1927.

88. Wechsler, *Cézanne in Perspective*. p. 8: "Cézanne had set for himself . . . to come closer to perceived reality through radically new means."

89. Wechsler, p. 6.; speaking of Bernard and Denis' attitudes toward Cézanne, early in their critical writing about him.

90. See chapter 3.

91. Greenberg, "Cézanne and the Unity of Modern Painting," in Wechsler, *Cézanne in Perspective*, p. 137.

92. A coda to this discussion could be developed in attending to the work of Redon and Gauguin. The contribution of this symbolist sensibility to the work of the cubists is less canonically inscribed in the narrative of art historical modernism, though in literary modernism the legacy of symbolism is fully acknowledged. The supersaturation of pigment, faith in the capacity of color to function through its visual presence, to be both materially replete and capable of inducing transcendence: these are dominant features of the symbolist enterprise.

Redon and Gauguin define the range of symbolist practice, one inward and abstract, magical, mystical, dreamlike, and decadent; the other exotic, projecting its dreams onto the strange world in order to paint them back into the canvas as if the paintings were paintings from observation, not projection screens of fantasmatic images manufactured to elicit or stimulate the production of dream in the image. Real as dream, dream as real, both engage with the material of paint as means and medium, endowed with properties inalienable and unsubstitutable, inherent and essential for the formulation of a fully operative fantasmatic domain.

93. John Golding, *Cubism: A History and An Analysis* (Boston: Boston Book and Art Shop, 1959), p. 105.

94. Jean Clay, *Modern Art 1890–1918* (New York, Paris, Lausanne: The Vendome Press, 1975), p. 237; and Golding, *Cubism*, p. 104.

95. Albert Gleizes and Jean Metzinger, *Cubism*, from *Cubism*, ed. Edward Fry (London and New York: McGraw-Hill, 1966), p. 106. Originally published as *Du Cubisme* (Paris: Figuiere, 1912).

96. Braque, "Thoughts and Reflections on Art," in Herschel Chipp, *Theories of Modern Art* (Berkeley and Los Angeles: University of California Press, 1968), p. 260. Originally published in *Nord-Sud*, Paris, December 1917.

97. Clement Greenberg, "Modernist Painting," *Modern Art and Mod-*

ernism, eds. Francis Frascina and Charles Harrison (New York: Icon Editions, Harper and Row, 1982), p. 6. Originally appeared in *Art and Literature*, no. 4 (Spring 1965): 193–201.

98. Max Kozloff, *Cubism/Futurism* (New York: Icon Editions, Harper and Row, 1973), p. 51.

99. John Berger, "The Moment of Cubism," *The Sense of Sight* (New York: Pantheon, 1985), p. 176.

100. Guillaume Apollinaire, "Cubist Painters," in Chipp, *Theories of Modern Art*, p. 232. Originally published as *Les Peintres Cubistes: Meditations Esthetiques* (Paris: Figuière, 1913) and in a first English translation by Lionel Abel as *The Cubist Painters: Aesthetic Meditations* (New York: Wittenborn, 1944).

101. Pablo Picasso, "Statement," 1923; Chipp, *Theories of Modern Art*, p. 264. Originally published as an interview with Marius de Zayas, "Picasso Speaks," *The Arts* (May 1923), pp. 315–326.

102. Daniel Kahnweiler, "The Rise of Cubism," in Chipp, *Theories of Modern Art*, p. 256. Originally published in *Der Weg Zum Kubismus* (Munich: Delphin, 1920) and in English, Henry Aronson, tr., *The Rise of Cubism* (New York: Wittenborn Schultz, 1944).

103. Albert Gleizes and Jean Metzinger, "Cubism," in Chipp, *Theories of Modern Art*, p. 211.

104. Apollinaire, "The Cubist Painters," in Chipp, *Theories of Modern Art*, p. 227.

105. Guy Debord, *Society of the Spectacle* (Detroit: Black and Red, 1983), section 1, n.p. Originally published in 1967 by Editions Buchet-Chastel, Paris.

106. Debord, *Society of the Spectacle*, section 34.

107. The switch of emphasis to American artists here only parallels the (albeit dubious) emphasis on the New York School in studies of art since 1945.

108. The notion of currency here deliberately suggests both the notion of exchange value, of a signed value capable of being substituted for any/all other values and also of an image value, a quality that inheres as the inscribed mark of value—as in the face of a bill or coin, that which designates its place in the system of exchange.

109. As from the outset I have made clear, this is not in any way an exhaustive investigation of all the representational strategies of modernism: the work of the surrealists begs to be addressed in regard to this discussion, especially that of Cornell and Magritte for their investigation of sign/image relations and thing/object depictions. But the more literal and/or conventional aspects to the spatial strategies of Surrealism were what kept it from offering a useful additional point for discussion within the theme of the space(s) of modernity.

110. Debord, *Society of the Spectacle*, section 4.

111. Johns, cited in Richard Francis, *Jasper Johns* (New York: Abbeville, 1984), p. 21.

112. Max Kozloff, for instance, writes: "Certainly what had been symbol in art he remakes into sign," Francis, *Jasper Johns*, p. 9.

113. For instance, Max Horkheimer and Theodor Adorno, *The Dialectic of Enlightenment* (New York: Continuum, 1990), was first published in 1944 but obviously the condemnation of mass culture has a huge body of literature attached to it—as well as does the counter position in support—from this point onward, as well as back into the debates that gained momentum in the Russian formalist and constructivist investigations.

114. Debord, *Society of the Spectacle*, section 24.

115. Francis Frascina, *Pollock and After* (New York: Harper and Row, 1985), p. 17.

116. Peter Halley, "The Crisis in Geometry," *Collected Essays* (Zurich: Bruno Bischofberger Gallery, 1987), pp. 102–103.

117. Halley, "Nature and Culture," *Collected Essays*, p. 71.

118. Jean Baudrillard, *Simulations* (New York: Semiotext(e), 1983), p. 11.

119. Giancarlo Politi, "Peter Halley," *Flash Art* 50 (January/February 1990): 81–87.

3. The Ontology of the Object

1. As late as 1976 even a critic with the deconstructive stance of Victor Burgin still conflated modernism with formalism and both with Clement Greenberg, identifying these as a well-known tradition. *The End of Art Theory* (Atlantic Highlands, N.J.: Humanities Press International, 1986), p. 1.

2. The project of critiquing modernism has been undertaken from many points of view. The work of John Tagg, Lisa Tickner, Carol Duncan, Francis Frascina, for instance, proposes a rethinking of the old modernist line in terms of theory, historical materials and evidence, and ideological stance; see also notes for chapter 1.

3. But abstraction is still frequently considered to be the one thing *unique* to modernism; see, for instance, remarks in, again, textbooks: Sheldon Cheney, *The Story of Modern Art* (New York: Viking Press, 1945); or Edward B. Henning, *Paths of Abstract Art* (New York: Harry N. Abrams, 1960); or, more recently, Norbert Lynton, *The Story of Modern Art* (Englewood Cliffs, N.J.: Prentice Hall, 1990; first published by Phaidon, 1983).

4. Historians, more than critics, have investigated the changing status of the object within the field of perception, social milieu, audience, etc., as per the work of Norman Bryson, Natalie Kampen, or Donald Preziosi. But the writings of, for instance, Peter Schjeldahl, Thomas McEveilly, Lucy Lip-

pard, or Carter Ratcliff, however insightful, provide exemplary instances of the way the formalist assumption persists across a wide range of critical positions.

5. Structural linguistics is the paradigmatic instance of the representational system, one which is self-sufficient, finite, and arbitrary. But the use of the linguistic analogy in early twentieth-century discussions of abstraction forges the link—since the assumption is that the elements of a visual system may function within the same kind of boundaries as a self-sufficient, self-defining domain. The attempt to systematically *order* that visual experience—the work of Kandinsky and Klee in their Bauhaus period, for instance—has the same rational, structuralist sensibility in spite of the other aspects of each of their approaches. The assumption was that visual perception, and visual phenomena, could be understood and reduced to systematic representation through empirical observation and experiment.

6. On the one hand, such language and practice were emphatically antimaterialistic; that is, they were set in clear opposition to the rational, scientific, and instrumental and in support of the transcendent, mysterious, and occult. But the effect was to engage Redon and Gauguin in a thorough investment in color as such, color freed from allusion or naturalistic reference. The paradox of Symbolist practice, poetic and painterly, is that it calls clear attention to the materiality of signification in the name of transcendence and mysticism. This attention is one of its legacies to the work of early twentieth-century abstractionists, especially those, who like Kandinsky, were inclined to spiritual valuations of visual representation.

7. Clement Greenberg, "Modernist Painting," *Art and Literature*, no. 4 (Spring 1965): 193–201.

8. Greenberg is not at all alone in this assessment; it is one of the truisms of the history of modern art. For example, Sam Hunter in *Modern Art*, ed. Charles McCurdy (New York: Macmillan, 1958), p. 15: "For Manet the control of painting became preeminently and exclusively pictorial, and purely aesthetic values rather than anecdote began to play a dominating role in the creation of the work of art."

9. Emile Zola, "Une nouvelle manière en peinture: Edouard Manet," January 1, 1867, *Revue du XIX Siècle*; excerpted in Frascina and Harrison, *Modern Art and Modernism*, 1982. Note that, again, this is the excerpt from Zola's work that survives into anthologies on account of this retrospective critical emphasis.

10. Stéphane Mallarmé, "The Impressionists and Edouard Manet," *The Art Monthly Review* 1 (September 30, 1876) 4:117–122; again, excerpted in Frascina and Harrison, *Modern Art and Modernism*, 1982, p. 41, but with a serious misprint, pointed out to me by Joel Isaacson: "merely fanciful" is reprinted in this excerpt as "merely financial."

11. Maurice Denis, "From Gauguin and Van Gogh to Classicism,"

L'Occident (May 1909); excerpted in Frascina and Harrison, eds., *Modern Art and Modernism*, p. 53.

12. Gauguin's own writing, his letters, on the subject of his work spell out his search for visual forms that would be removed both from nature as a model and from literary means. Above all, it was to be the mystical character of painting that was to shine forth, through purely visual means, and resist other explanation or other reference except the spiritual.

13. Denis, "From Gauguin," in Frascina and Harrison, *Modern Art and Modernism*, p. 53.

14. Maurice Denis, "Definition of Neotraditionism," *Art et critique*, August 23 and 30, 1890; reprinted in Herschel Chipp, *Theories of Modern Art* (Berkeley and Los Angeles: University of California Press, 1968), p. 94.

15. This statement is deliberately polemical: the contemporary use of such a "lineage" is indeed highly circumscribed but, nonetheless, is most conspicuous in the work of theory oriented writers in the so-called neoformalist camp. Yves Alain Bois' *Painting as Model* (Cambridge: MIT Press, 1990), for instance, unswervingly and unrepentantly adheres to such a lineage.

16. Maurice Denis, "Cezanne," *Burlington Magazine* 16 (January 1910), pp. 207–219 and (February 1910), pp. 275–280; originally published in *L'Occident* (September 1907). Excerpted in Frascina and Harrison, *Modern Art and Modernism*, p. 58.

17. "You see, I although I understand very well the value of words—abstract and concrete—in the dictionary, I no longer grasp them in painting. I have tried to interpret my vision in an appropriate decor without recourse to literary means and with all the simplicity the medium permits: a difficult job." Paul Gauguin, letter to Andre Fontainas, March 1899; cited in Chipp, *Theories of Modern Art*, p. 74.

18. David Carroll and Edward Lucie-Smith, *Movements in Modern Art* (New York: Horizon Press, 1973). On p. 13 they date the advent of modernism with Cézanne's *The Bathers*—in part because the picture surface is in large part presented as "a flat area of paint."

19. Denis, "Cézanne," in Frascina and Harrison, *Modern Art and Modernism*, p. 61.

20. Roger Fry, "An Essay in Aesthetics," first published in *New Quarterly*, 1909; excerpted in Frascina and Harrison, *Modern Art and Modernism*, p. 80.

21. Roger Fry, "The French Post-Impressionists," first published in 1912; *Vision and Design* published 1920; excerpted in Frascina and Harrison, *Modern Art and Modernism* 1982, p. 90.

22. Louis Marin, "Cézanne, ou risque de la philosophie contemporain," *Cézanne ou la peinture en jeu* (Aix en Provence: Musée Granet, Colloque tenu à Aix en Provence, June 21–25, 1982), pp. 67–92.

23. The point here is that the structure of signification in classic semiotic terms depends on a link between a present signifier and absent signified and, at another level, can link a present sign with an absent referent. The concept of presence as sufficient is contrary to the semiotic construct, except insofar as it has, as was pointed out by Jacques Derrida, a theological basis in the ultimate belief in Being as a form of presence.

24. While I would hesitate to attempt to assign the complexities of abstraction to the categories he describes in a definitive or final way (and so would he), the three "paths" to abstraction described by Edward Henning were: 1) the structured quality of rational arrangement; 2) the decorative quality of engagement with a sensuous surface; and 3) the expressive quality of colors and lines put at the service of signifying inner feelings. Edward B. Henning, *Paths of Abstract Art* (New York: Harry N. Abrams, 1960), pp. 7–8.

25. Guillaume Apollinaire, "The Cubist Painters," in Chipp, *Theories of Modern Art*, p. 222. Originally published as *Les Peintres Cubistes: Meditations Aesthetiques* (Paris: Figuiere, 1913).

26. For instance, as per Werner Haftmann's formulation: "Beginning in 1905 the great goal was an art that would express human inwardness without recourse to metaphors drawn from the outside world. The essential was no longer to reproduce objects, but to make the picture itself into an object which, through the resonance inherent in its construction would awaken a feeling similar to that aroused by the things and processes of visible nature." *Painting in the Twentieth Century* (New York and Washington: Praeger, 1965), pp. 134–135

27. See Rose-Carol Washton Long, *Kandinsky: The Development of an Abstract Style* (Oxford: Clarendon Press, 1980); Kenneth Lindsay and Peter Vergo, eds., *Kandinsky: Complete Writings on Art* (Boston: G. K. Hall, 1982); and Clark V. Poling, *Kandinsky: Russian and Bauhaus Years 1915–1933* (New York: Solomon Guggenheim Museum, 1983).

28. See Peg Weiss, *Kandinsky in Munich: The Formative Jugendstil Years* (Princeton: Princeton University Press, 1979), p. 31, for discussion of this development.

29. Piet Mondrian, "Plastic Art and Pure Plastic Art," in Herbert Henkels, *Mondrian from Figuration to Abstraction* (London: Thames and Hudson, 1987), p. 17. Originally published in *Circle: An International Survey of Constructivist Art*, eds. Ben Nicholson, Naum Gabo, and Leslie Martin (London: Faber and Faber, 1937).

30. Piet Mondrian, *The New Plastic in Painting*, 1917, in *The New Art— The New Life: The Collected Writings of Piet Mondrian*, ed. and trans. by Harry Holtzman and Martin S. James (Boston: G. K. Hall, 1986), p. 34. Originally published in *De Stijl*, October 1917–October 1918.

31. See Hans L. C. Jaffe, *Piet Mondrian* (New York, Harry N. Abrams,

n.d.); *Piet Mondrian 1872–1944*, Robert P. Welsh and Joop Joosten, exhibit catalogue (New York: Solomon R. Guggenheim Museum, 1971); Kermit Champa, *Mondrian Studies* (Chicago and London: University of Chicago Press, 1985); Them Threlfall, *Piet Mondrian: His Life's Work and Evolution* (London: Garland, 1988); and Michel Seuphor, *Piet Mondrian: Life and Work* (New York: Harry N. Abrams, n.d.).

32. Stanton MacDonald-Wright, "Statement on Synchromism," 1916, cited in Chipp, *Theories of Modern Art*, p. 320. Originally published in the catalogue of *Forum Exhibition of Modern American Painters* (New York: Anderson Galleries, March 13–25, 1916).

33. Obviously, both Barr and Greenberg were important; their influence continues to be felt within the institutions of criticism, museum work, and the broad public sphere concerned with the history and critical understanding of modern art. But other names could be added—and certainly the influence of Meyer Schapiro within the realm of art historical study of modern art has to be heavily weighted.

34. None of this discussion is meant to be derogatory to Barr or Greenberg; Barr was using the tools he had learned in the formal study of art history at Harvard. See Alice Goldfarb Marquis, *Alfred Barr: Missionary for the Modern* (Chicago: Contemporary Books, 1989), for a description of Barr's education.

35. Alfred Barr, *What Is Modern Painting?* (New York: Museum of Modern Art, 1943). p. 5.

36. Patricia Railing, *From Science to Systems of Art* (Forest Row, East Sussex: Artists Bookworks, 1989).

37. Barr, *What Is Modern Painting?*, p. 25; and Alfred Barr, *Cubism and Abstract Art: An Introduction* (New York: Museum of Modern Art, 1936).

38. The anti-logos, anti-language basis of "pure visuality" took its earlier point of departure with the break from academic conventions of history painting, or painting with literary or allegorical precedents. Freeing painting from this illustrative role had been a clear feature of "modern" art from the mid-nineteenth century onward—with many antecedents within Romanticism.

39. See Francis Frascina, *Pollock and After* (New York: Harper and Row, 1985); also, Michael Newman, "Revising Modernism, Representing Postmodernism," in *Postmodernism: ICA Documents*, ed. Lisa Appignanesi (London: Free Association Books, 1989), for such critiques.

40. Clement Greenberg, "Towards a Newer Laocoön," *Partisan Review* 7 (July–August 1940), 4: 296–310. Greenberg makes the point, in the very first paragraph, that "abstract art, like every other cultural phenomenon, reflects the social and other circumstances of the age in which its creators live" though the bulk of "Laocoön" is taken up with tracing the development of the purity of the painting medium.

41. Clement Greenberg, "Avant-Garde and Kitsch" (1939), in *Pollock and After*, ed. Francis Frascina (New York, Harper & Row, 1985), p. 23. Originally published in *Partisan Review* 6 (Fall 1939), 5: 34–49.

42. Greenberg: "The avant-garde poet or artist tries in effect to imitate God by creating something valid solely on its own terms in the way nature itself is valid, in the way a landscape—and not its picture—is aesthetically valid; something given, increate, independent of meanings, similars." "Avant-Garde and Kitsch," p. 23.

43. Greenberg actually says: "Representation, or illustration, as such does not abate the uniqueness of pictorial art, what does so are the associations of the things represented." The problem, strangely, was not the things, but the fact that they "call up associations of that kind of space," i.e., three-dimensional and illusionistic. "Modernist Painting," *Art and Literature*, no. 4, (Spring 1965), pp. 193–201.

44. T. J. Clark, "Clement Greenberg's Theory of Art," in Frascina, *Pollock and After*, pp. 47–64. First published in *Arts Yearbook*, no. 4 (1961),

45. Michael Fried, "Three American Painters: Kenneth Noland, Jules Olitski, Frank Stella" (Cambridge: Fogg Art Museum, Harvard University, 1965), p. 4.

46. Michael Fried, "Art and Objecthood," *The Great Decade of American Abstraction*, ed. E. S. Carmean Jr. (Houston: Museum of Fine Arts, 1967), pp. 77–87. The very beginning of this essay contains a distinction between minimalist (literalist is Fried's characterization) art and "modernist"—against which it distinguishes itself. The "modernist" work was the good object of postpainterly abstraction—the abstract work which defined the "great decade." The very fact that Fried uses the work "modernist" to designate only those works that fit his formalist line demonstrates his conflation of aesthetic value with his particular writing of history.

47. Again, at the outset of "Art and Objecthood," Fried terms Minimal Art "ideological" by contrast to "modernist" art.

48. In fact, this *is* the question posed by Donald Judd in "Specific Objects," *Contemporary Sculpture* (New York: The Art Digest, 1965) as well as in Judd's pratice and that of the minimalist sculptors—Robert Morris, Richard Serra, Carl Andre, etc. This question is also fundamental to the work of Jasper Johns beginning in the mid 1950s and continuing up through the period in which Fried was writing.

49. Rosalind Krauss, "Grids" (1978), in *The Originality of the Avant-Garde and Other Modernist Myths* (Cambridge and London: MIT Press, 1985), pp. 8–23.

50. My remark here is based on hearing Fried speak about his methodology—which he described as getting "inside" of a painting to rearrange and then pulling back "out."

51. My statement here is almost a paraphrase of statements in Victor

Burgin's 1976 essay "Modernism in the *work* of art," in *The End of Art Theory* (1986).

52. Jan Mukarovsky, "Art as Semiotic Fact," written 1934, first published in 1936, reprinted in *Semiotics of Art*, eds. Ladislav Matejka and Irwin Titunik (Cambridge and London: MIT Press, 1976), pp. 3–10.

53. Barr and Greenberg both grapple with this issue, since, evidently, much of the work they are looking at is both abstract and representational. Priority was given, in their work, but even more, in that of Fried and Krauss, to the abstract character of these images while a narrowing focus of selection privileged the nonobjective strain of modernism over that of figurative, surreal, or representational modes.

54. Think of the abstractions of Peter Halley or Sherrie Levine or David Diao or Ross Bleckner, for instance, as countering, in different ways, the myth of pure presence in abstract art. Each of them depends on the history of modern art as the context against which their work becomes significant.

55. I am separating out the discussion of the mutability of the object from the question of reception by the viewer, which is the topic of the last section in this work.

56. When it is paid attention, it is often in the most simplistic way—for instance, "modern art" became a banner to fly in the face of the history of fascism in the recent "Degenerate Art" exhibition; but the relation between abstract form and the culture in which it was received went unexamined.

57. Julia Kristeva, *Desire in Language* (New York: Columbia University Press, 1980), much of which was first published in 1979 as *Recherches pour une semanalyse* (Paris: Editions du Seuil) and *La Revolution du langage poetique*, first published in 1974 (Paris: as a Doctorat d'etat).

58. Donald Preziosi, *Rethinking Art History* (New Haven: Yale University Press, 1989).

59. Jacques Derrida, *The Truth in Painting* (Chicago: University of Chicago Press, 1987), p. 67.

60. Derrida, *The Truth*, p. 22.

61. Derrida, *The Truth*, p. 28. One discussion of the concept of the parergon applied to specific works of art is Stephen Melville's "Not Painting: The New Work of Sherrie Levine," *Arts* 60 (February 1986), no. 6: 23–25.

62. The Duchamp bibliography is endless: see Thierry DeDuve *Nominalisme Pictural: Marcel Duchamp, la peinture et la modernité* (Paris: Editions de Minuit, 1984); Rudolf Kuenzli and Francis M. Nauman, eds., *Marcel Duchamp: Artist of the Century* (Cambridge and London: MIT Press, 1989); and the forthcoming work by Amelia Jones, with her critique of his "author-ity."

63. See Pierre Restany, *Yves Klein* (New York: Harry N. Abrams, 1982); and Yves Klein, *Selected Writings* (London: The Tate Gallery, 1974).

4. Subjectivity and Modernity

1. For those unfamiliar with the concept of subjectivity and its place within the disciplines of psychoanalysis, semiotics, cultural theory, and criticism generally, Kaja Silverman's *The Subject of Semiotics* (Oxford and New York: Oxford University Press, 1983) still serves as a good introduction.

2. See Seyla Benhabib, "Epistemologies of Postmodernism: A Rejoinder to Jean-François Lyotard," *New German Critique*, no. 33, 1984; 103–126; she sketches out the disintegration of the Cartesian model of the individual brought about through recognition of both social and psychoanalytic forces in the work of Sigmund Freud and Karl Marx. The Cartesian model, she proposes, which conceived of the individual ego as autonomous and "self-transparent" gave way before the recognition that it "is controlled by desires, needs, and forces" which are historical, social, and psychic.

3. One area in which these critiques have been most powerful has been in the area of feminist theory. As useful point of departure see Griselda Pollock, "Artists Mythologies, Media Genius, Madness and Art History," *Screen* 21, no. 3 (1980): 57–96. She cites Frederick Antal as her touchstone for this critique.

4. The concept of the subject central to modernism has to be understood as a split subject. Split because the terms of subjectivity must necessarily be discussed as both a producing subject and a subject produced: as maker of work and as viewer. Split again because the very nature of the modern subject is a split subject: not split according to the old Cartesian model in which the world is held up for doubt by the reasoning intelligence, but split because the very processes which serve to constitute subjectivity are theorized in modernity as predicated on a fiction. The fiction is that of identity and unity, in which the individual struggles constantly to represent himself or herself as a whole. This is the split of the psychoanalytic subject, whose attachment to the visual image through scopic drives and pleasures has its original incentive in the mirror phase of formative development. There the infant, seeing itself as an image, struggles to constitute itself as whole through the process of recognizing that image as its self. The image is not the subject, but the function of representation, to represent the fictive wholeness, has been fully established as a psychic pattern.

5. Whether images may function in this way depends on whether they can function to advance the subject beyond the realm of the *imaginary*. For this to be asserted requires that images function not merely as *instances* of recognition of the fictive unity of the subject, but as articulations of distinct and specific subject positions, relations, and fictive identities.

6. The work of Christian Metz, Raymond Bellour, Roland Barthes, and the writers who organized *Screen* magazine, *Camera Obscura*, *m/f*, and *Discourse* took this project on.

7. The distinction I am making is that rather than analyzing the formal mechanisms and structures of visual images in the late nineteenth and early twentieth century to propose a structuralist/psychoanalytic reading of their means of subject formation, I will pull back to a more metacritical position and describe the ways in which the role of the artist and of the viewer have been theorized in practice. Some bits of the analytic project will necessarily show up here, but that is not my focus.

8. John Berger, *The Success and Failure of Picasso* (New York, Pantheon, 1980), pp. 13–14.

9. Pollock, "Artists Mythologies," *Screen* (1984), p. 58. Pollock goes on to list the ways in which the study of art history is organized around this individual production—the catalogue raisonne, monograph, exhibition etc.

10. Pierre Cabanne, *Pablo Picasso: His Life and Times* (New York: William Morrow, 1977), p. 1.

11. Roland Penrose, *Picasso, His Life and Work* (New York: Icon, Harper and Row, 1958), p. 1.

12. Mary Mathews Gedo, *Picasso: Art as Autobiography* (Chicago and London: University of Chicago Press, 1980), pp. 1–3.

13. John Berger, *The Success and Failure of Picasso*.

14. The suite of these versions of the Velázquez image could be analyzed as a whole to chart the vicissitudes of Picasso's struggle with his ego—just as the sequence of images of painter with model have been traced in Berger's work as a chart of his struggles with libido and potency.

15. See Carol Duncan, "Domination and Virility in Vanguard Painting," reprinted in *Feminism and Art History*, eds. Norma Broude and Mary Garrard (New York: Icon, 1982). pp. 293–314.

16. See Gedo, *Picasso*, though Gedo has a conventional approach to autobiography.

17. Meyer Schapiro, "Picasso's *Woman with a Fan*," *Modern Art: 19th and 20th Centuries* (New York: George Braziller, 1978), pp. 111–120. Originally published in *Archaeology and the Humanities* (Mainz: Verlag Philipp von Zabern, 1976), pp. 249–254.

18. Schapiro, "Picasso's *Woman*," p. 116.

19. The Duchamp industry is a major one, and the amount of critical literature that continues to be produced on his work is overwhelming. But, for recent work focused on issues of artistic authorship, see Thierry de Duve, *Nominalisme Pictural: Marcel Duchamp, La peinture et la modernite* (Paris: Editions de Minuit, 1984), and Rudolf Kuenzli and Francis M.

Naumann, *Marcel Duchamp: Artist of the Century* (Cambridge and London: MIT Press, 1989); the latter has an especially useful bibliography. Amelia Jones has made an extensive study of the way in which Duchamp has been "postioned" within postmodern discussions of gender, sexuality, and artistic authority (forthcoming from Cambridge University Press, 1993).

20. I am not trying to suggest that the issues raised by the R. Mutt urinal are exhausted by this discussion of the signature.

21. The feminist community has mounted one such attack, and the work of Roszika Parker and Griselda Pollock, *Old Mistresses*, or of the publication *Heresies*, or even of Germaine Greer's *The Obstacle Race*, all address issues of social position in relation to the myth of genius to come to grips with the relative absence of women artists of stature within the history of western art. An aggressive attack on artistic originality was, of course, a major feature of the 1980s in the work of artists like Sherrie Levine, discussed at length below. But the critique goes through twentieth century Marxist theory in art history in the works of Frederick Antal, T. J. Clark, Janet Wolff, Lisa Tickner, John Tagg, Linda Nochlin, and many others.

22. There are many others, of course, but I cite Lissitzky on account of the striking iconography of his self-portrait.

23. Some of this critique is formulated in the work of Max Horkheimer and Theodor Adorno; other aspects of it came with the writing of Jean Louis Baudry, Christian Metz, and Stephen Heath.

24. The secondary literature taking up both Barthes' and Foucault's positions is enormous, especially in the late 1970s and early 1980s in literary criticism. I remember it was very fashionable in the late 1970s in the poetry scene in California to deny the existence of individual authorship— we were supposedly all just manifesting "instances" of a social code of production.

25. The phrase "cultural terms" here is meant to imply that these gestures point out, in a manner similar to that of Duchamp's work, the limits of what Foucault would have termed the "discourse" of art at this particular historical moment.

26. Although the erased drawing was done in 1953, and chronologically follows last, Rauschenberg had conceived of the project earlier and had had difficulty persuading de Kooning to give him a drawing.

27. Mary Kelly, "Re-Viewing Modernist Criticism," *Art After Modernism*, ed. Brian Wallis (Boston: MIT Press and David Godine, 1984), pp. 87–103. Originally published in *Screen* 22, no.3 (Autumn 1981).

28. Kelly, "Re-Viewing," p. 90.

29. Donald Judd, "Specific Objects," *Complete Writings 1959–75* (Halifax: The Press of Nova Scotia College, 1975), pp. 181–189. Originally published in *Arts Yearbook* (New York), 8 (1965).

30. See *October* 37 (Summer 1986): special issue "Originality as Repetition" devoted to papers from College Art Association session "Multiples Without Originals." Edited by Annette Michelson and Rosalind Krauss.

31. Judd, "Specific Objects," p. 118.

32. Judd, "Imperialism, Nationalism, and Regionalism," in *Complete Writings*, 1987, p. 136.

33. This isn't to imply that Warhol didn't supervise the images, didn't worry and work them through or have a profoundly individual relation to their selection etc.—he did. I am speaking of the *material* terms of production.

34. The well-known brush mark paintings of Roy Lichtenstein parody the abstractionists' attachment to the signature handwriting of expressive gesture.

35. Fred Orton, in an unpublished paper delivered at Barnard College in New York City in the spring of 1991.

36. The early Happenings, especially in works by Jim Dine and Claes Oldenburg, took the expressive movements of abstraction into a spatial arena. The throwing of paint and dripping free for all of physical gestures parodied and extended the abstractionists' activity.

37. Kelly, "Reviewing," in *Art After Modernism*, p. 95.

38. The one aspect of *trace* I don't touch on here, but which begs to be addressed, is that of the photographic record—which serves every purpose from essential to incidental in the work of conceptual and performance artists.

39. Levine and Prince do not, needless to say, exhaust the list. Some improbable people get construed in these terms, for instance, for an analysis of Anselm Kiefer as an artist critiquing originality, see John Gilmour, "Original Representation and Anselm Kiefer's Postmodernism," *Journal of Aesthetics and Art Criticism* 46, no. 3 (Spring 1989): 341–350.

40. Levine's work had a clear feminist agenda to it. See Laura Cottingham, "The Feminine De-Mystique: Gender, Power, Irony, and the Aestheticized Feminist in 80s Art," *Flash Art*, no. 147 (Summer 1989): 91–95.

41. Abigail Solomon-Godeau, "Living with Contradictions," *The Critical Image*, ed. Carol Squiers (Seattle: Bay Press, 1990), p. 62.

42. Gerald Marzorati, "Art in the (Re)Making," *Art News* 85 (May 1986): 91.

43. For another discussion of Levine with respect to photography, see Margot Lovejoy, "Art Technology and Postmodernisms: Paradigms, Parallels, and Paradoxes," *Art Journal* (Fall 1990): 251–265.

44. Craig Owens, "The Discourse of Others: Feminists and Postmodernism," *The Anti-Aesthetic*, ed. Hal Foster (Port Townsend, Wash.: Bay Press, 1983), p. 73.

45. These questions of enunciation, of who "speaks" through the image, who is "spoken for" were taken up more exhaustively in the writing and photographic work of Martha Rosler. Her work, as that of Levine, Barbara Kruger and others, forced the recognition that authorship was as much a construction of power relations as it was a situation of production.

46. The most familiar formal structure is the perspectival ordering of space, which assumes a station-point, or the origin of the image in a subject's position. An example of a device would be a window ledge, or open drawer, orienting itself at the edge of a frame to the viewer and thus positioning her/him in relation to the image. An example of a strategy is the coy or solicitous look of a figure within the image, as, indeed, patterns of eyeline and gaze often map a subject position for a viewer independent of perspectival space.

47. Michel Foucault, *The Order of Things* (New York: Vintage, 1970). First published in French in the early 1960s as *Les Mots et Les Choses.*

48. Anamorphic images provide a particularly striking example of this discrepancy since the "subject position" of the anamorphic image is distinctly different from that of the image within which it is embedded.

49. The very concept of the enunciated subject of visual representation has, strangely, barely been touched upon. Victor Burgin, Michel Foucault, Norman Bryson, and Judith Barry are some of the critical theorists who have done systematic work in this realm.

50. Kaja Silverman, *The Subject of Semiotics* (Oxford and New York: Oxford University Press, 1983) and Jacqueline Rose, *Sexuality in the Field of Vision* (London: Verso, 1986).

51. See Theresa Cha, ed., *Apparatus* (New York: Tanam Press, 1984), an anthology of film theory,

52. Gerard Genette is another writer whose study of narrative was particularly useful in discourse analysis.

53. Theodore Reff, *Manet: Olympia* (London: ALlen Lane, Penguin Books, 1976). p. 17.

54. Victor Burgin, *The End of Art Theory* (Atlantic Highlands, N.J.: Humanities Press International, 1986).

55. I make this point because I see a striking distinction between cubist painting, cubist collage, dada collage, and the later collage/fragmentation of Robert Rauschenberg. Ultimately, the first set of practices has a homological subject (both produced and producing) while the second is, I would argue, profoundly heterological and ununifiable.

56. Lacan's concept of the *imaginary* is one in which the infant does not perceive itself as distinct from the world, but part of an undifferentiated whole which is coextensive with its own body.

57. Dali's work in this area is linked to his association with Jacques Lacan, whose doctoral thesis was *On Paranoiac Psychosis and its Relations*

with the Personality. Dawn Ades, *Dali and Surrealism* (London: Thames and Hudson, 1982), suggests that they arrived independently at some of the same ideas, then became aware of each other's work. She cites 1932 and 1933 publications on paranoia by Lacan—first the thesis and then an article in *Minotaur*, "The Problem of Style and the Psychotic Conception of the Paranoiac Form of Expression." See also Patrice Smith, "Dali et Lacan dans leurs rapports á la psychose paranoiaque," *Cahiers Confrontation*, no. 4 (Autumn 1980), pp. 129–136.

58. *Dali by Dali*, trans. Eleanor R. Morse (New York: Harry N. Abrams, 1970).

59. Ades, *Dali*, ch. 4, "Painting and the Paranoiac-Critical Method," pp. 119–150.

60. Ades, *Dali*, pp. 119–120, discusses the *Paranoiac Face* painting published in *Le Surrealisme au Service de la Revolution*, No. 3 (December 1931); she also discussed Andre Breton's 1936 essay "The Dali Case," in which Breton states: "His great originality lies in the fact that he has shown himself strong enough to participate in these events as actor and spectator simultaneously, that he has succeeded in establishing himself both as judge of and party to the action instituted by pleasure against reality" (p. 120). See also Carlton Lake, *In Quest of Dali* (New York: Putnam, 1969); and Meryle Secrest, *Salvador Dali* (New York: Dutton, 1986), the section "The Conquest of the Irrational."

61. Jean-François Lyotard, Arthur Kroker, and David Cook are also sources for this model.

62. Fredric Jameson, "Postmodernism or the Cultural Logic of Late Capitalism," *New Left Review*, no. 146 (July-August 1984): 59–92; and *Postmoderism, or, The Cultural Logic of Late Capitalism* (Durham: Duke University Press, 1991).

63. Michael Fried, "Art and Objecthood," *The Great Decade of American Abstraction*, ed. E. A. Carmean Jr. (Houston: Museum of Fine Arts, 1974) p. 79.

64. Fried, "Art and Objecthood," p. 79.

65. Anne Rorimer, *Pavilions* (Munich: Kunstverein, 1988) p. 22.

66. A number of artists, such as Hans Haacke and Kryzsztof Wodiczko, take up the themes of subjectivity that Graham proposed and shift the concerns into specific cultural domains of subject/power relations. Haacke and Wodiczko both make use of and call attention to the iconography and invisibility (or its naturalization through imagery) of power. They also explore the enunciation of subject positions in the institutionalization of art in museum context, the representation of ideological emblems such as civic monuments and statues. Wodiczko's projection of historical icons onto facades and buildings which have come to stand for imperialism, power and militarism, force the viewer to reread the circumstances and sites in use.

67. Judith Barry, *Public Fantasy* (London: Institute for Contemporary Art, 1991).

68. Kate Linker, "Representation and Sexuality," *Art After Modernism*, ed. Brian Wallis (Boston: David Godine and MIT Press, 1984), p. 393.

69. The writing of Constance Penley, Sandy Flitterman-Lewis, Janet Bergstrom, and Elizabeth Lyons, as well as Elizabeth Cowie and Laura Mulvey, were the points of departure for this critical investigation in the late 1970s and early 1980s.

70. The concept of lack on which the dynamics of gendered positions determine subject relations, as conceived by both Freud and Lacan, denied the possiblity of a replete female narcissism, and, of course, a feminine subject of either enunciation or desire. See my article, "Visual Pleasure: Feminist Perspective" in *M/E/A/N/I/N/G*, no. 11 (Spring 1992).

71. In Lacan's psychoanalytic narrative of gender, women suffer lack, i.e., they lack the phallus, the primary signifier, and thus must continually function as the sign of that absence and become a signifier herself. This version of gender and subjectivity was taken up without question by a whole generation of feminists, who considered it an adequate means of explaining the structure of masculinist representation.

72. Craig Owens, "The Discourse of Others: Feminists and Postmodernism," *The Anti-Aesthetic*, ed. Hal Foster (Seattle: Bay Press, 1983) p. 77.

INDEX